Monet

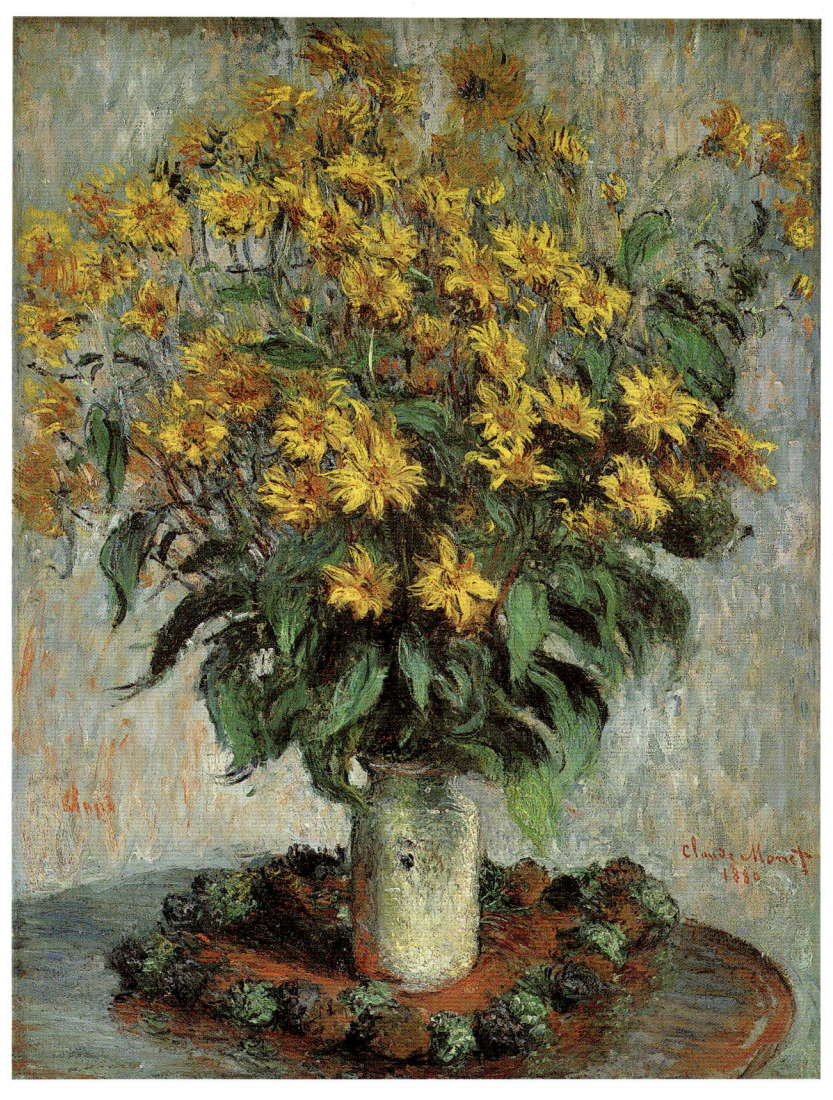

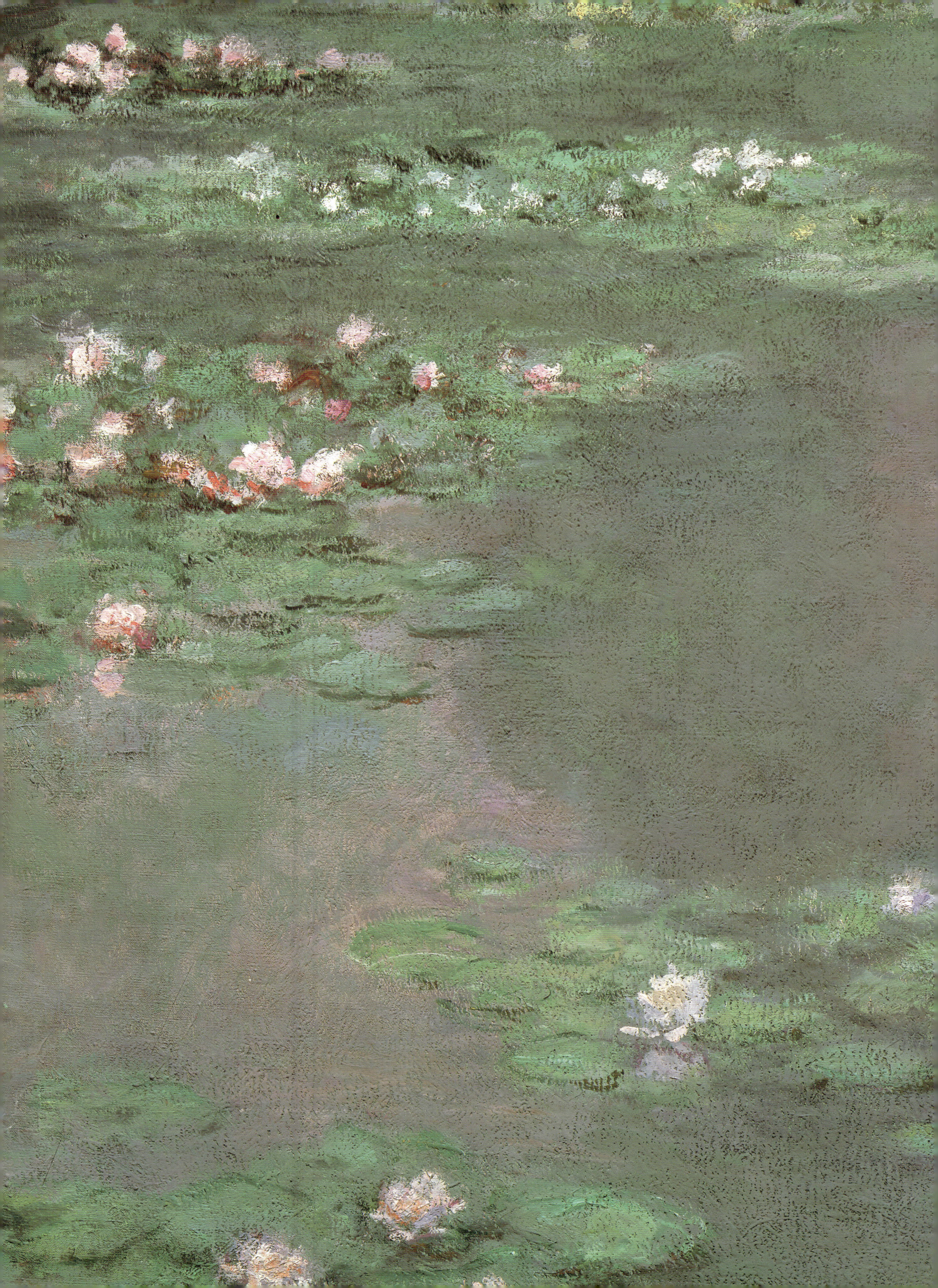

Monet

Frank Milner

This edition produced
by PRC Publishing Ltd,
64 Brewery Road, London N7 9NT

A member of **Chrysalis** Books plc

Published by Greenwich Editions 2002
64 Brewery Road, London N7 9NT

A member of **Chrysalis** Books plc

ISBN 0 86288 576 0

Printed and bound in China

Page 1: *Vase of Chrysanthemums*, 1880,
National Gallery of Art, Washington
Page 2/3: *Waterlilies*, 1905, Museum of
Fine Arts, Boston, Gift of Edward
Jackson Holmes.

Contents and List of Plates

Introduction

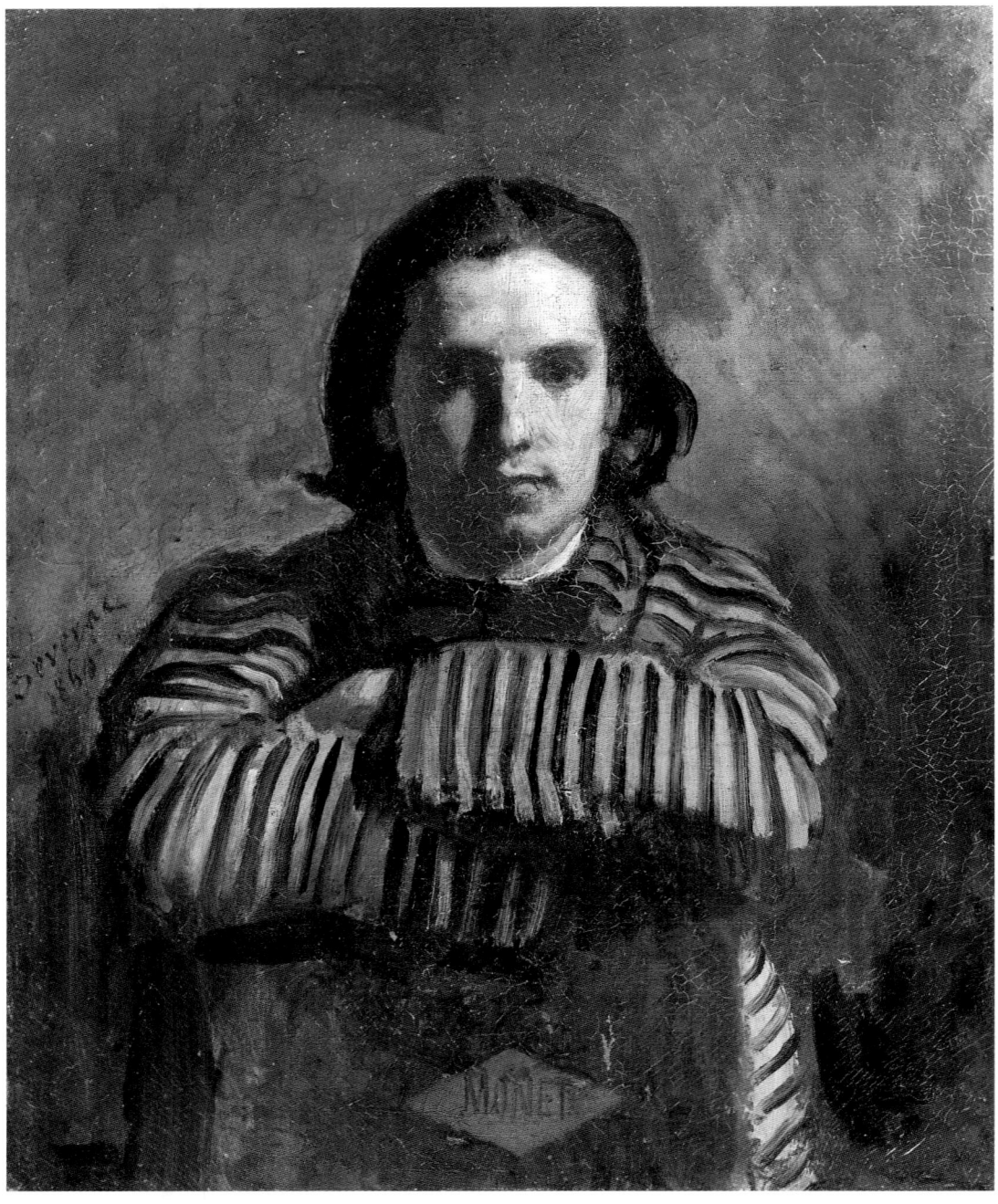

At Monet's funeral in 1926 his four pall-bearers were an ex-Prime Minister of France, Georges Clemenceau, and the artists Bonnard, Vuillard and Roussel. Monet at his death had an international reputation, the result of nearly seven decades of almost uninterrupted production, and his oeuvre is one of the largest of any artist. When he began painting, around 1858, Delacroix and Ingres were still dominant figures in French artistic life; when he ceased, Cubism was already going out of fashion.

Monet's principal claim to fame rests upon his role as a founder of Impressionism, and during the late 1870s his pictures were in the forefront of avant-garde art. But he also created further shockwaves of modernity in the 1890s with his paintings in series, which had a profound effect upon Kandinsky and others. In the last decade of his long life he once more produced a novel vision, this time with semi-abstract, dazzlingly free depictions of waterlilies. Few artists have had such a sustained innovative influence.

Claude Oscar Monet was born at rue Lafitte in Paris in November 1840, but his family moved to the channel port of Le Havre when he was about six years old. His father was in a family partnership that dealt in wholesale grocery, and Monet had a provincial middle-class upbringing that under normal circumstances would have led to his joining the family business. By the time he was eighteen, however, he had chosen to become an artist. In May 1859 he arrived in Paris to begin his artistic studies. His father had given qualified approval. His aunt who, since the death of Monet's mother the previous year, had taken on a general maternal responsibility for her nephew, was more encouraging; she knew a number of artists and collected paintings. Monet had already shown distinct artistic ability. By selling caricatures of local Le Havre worthies he had been able to accumulate savings of 2,000 francs, and he had also worked for two years under the supervision of Boudin (1825-98), a resident Le Havre landscape artist. He was not, however, considered talented enough to be awarded a scholarship to study in Paris, for which his father applied to the city of Le Havre, and he used his own savings and family money to support himself.

Left De Séverac's 1865 *Portrait of Monet* shows the artist in relaxed pose with Romantic hairstyle and dress.
Above *Theater People*, c. 1858, demonstrates Monet's youthful gift for caricature. He both copied from magazines and lampooned local individuals, leading to sales that helped fund his art education in Paris.
Below Eugène Boudin, who first encouraged Monet to make the recording of nature his subject.

Monet's father's traditional conception of a proper artistic training for his son was that he should be supervised by an established artist, which might lead in time to acceptance into the state Ecole des Beaux-Arts where, after further training, awards, and possible success exhibiting at the biennial Salon, he might obtain state or even Imperial patronage. The preferred master for Monet was Thomas Couture (1815-1879) a classical academic artist who had trained Manet and who was himself an ex-pupil of Gros and Delaroche. Monet, however, preferred to register at the *Académie Suisse*, a fluid grouping of artists who paid 10 francs a month to draw from the nude model. Used by some students to supplement more traditional tutors, and by practising artists to keep their hand in, the Suisse was an easy-going gathering place and suited Monet, who wished to work unsupervised at this time.

Early artistic influences. Le Havre and Paris 1859-61

Monet's prejudices were, not surprisingly, already partly formed by his contact with Boudin. Boudin painted oil sketches out-of-doors and chose subject matter that was deliberately mundane. This was broadly in tune with the values of those French landscape artists of his generation who were seeking a fresher, closer response to Nature, usually expressed in smallscale, unheroic, unidealized images of pure landscape and views of peasants and provincial life. The most clearly identified exponents of this view in the public mind were the artists of the Barbizon School, including

Millet, Rousseau, Corot, Daubigny, Diaz and Jongkind. Named after the village on the forest edge at Fontainebleau where they often painted, the group shared a taste for low-keyed earth colors and grays and a tendency to broad handling and distinct surface facture. They represented a more modest self-effacing side of the Romantic viewpoint, and their approach to nature was far removed from the largescale literary, historical or socially dramatic themes of more heroic Romantics like Delacroix. The artists of Barbizon were the first major influence upon Monet. Visiting the 1859 Salon he dutifully reported back to Boudin his enthusiasm for their works on show, especially the pictures by Daubigny, one of whose paintings his aunt owned.

In addition to Paris artists recommended by Boudin, Monet gravitated toward the more radical circle of painters and theorists surrounding Courbet. Based at the Brasserie des Martyrs, this group's distinctive quest for modernity was expressed in an approach to the transcription of nature which had close affinities with Barbizon but was often grander in scale, which

also included urban subjects and which in its depiction of the human figure tended toward heroic celebration.

Calling themselves 'Realists', Courbet's group were also more overtly critical of the political authority of the French state and of the Emperor Napoleon III who, since his *coup d'état* in 1852, had stifled open democratic activity in France. Realism, like Barbizon, was a late flowering of Romanticism, but it was also proto-Impressionist in its concern with the matter-of-fact and the ordinary. Some Realists, such as Courbet, were socialists. Other, particularly writers like the Goncourts, saw the analysis and depiction of the lower classes, both peasants and urban proletariat, as a quite distinct autonomous artistic activity, unconnected with propaganda for social improvement. Monet held rather general left-wing beliefs throughout his life but, aside from his later strong stand pro-Dreyfus, he was not politically active and did not paint any picture that suggests social criticism or a definite political point of view.

A third ingredient in Monet's development was the influence from 1863 onward of Manet's art. Eight years older

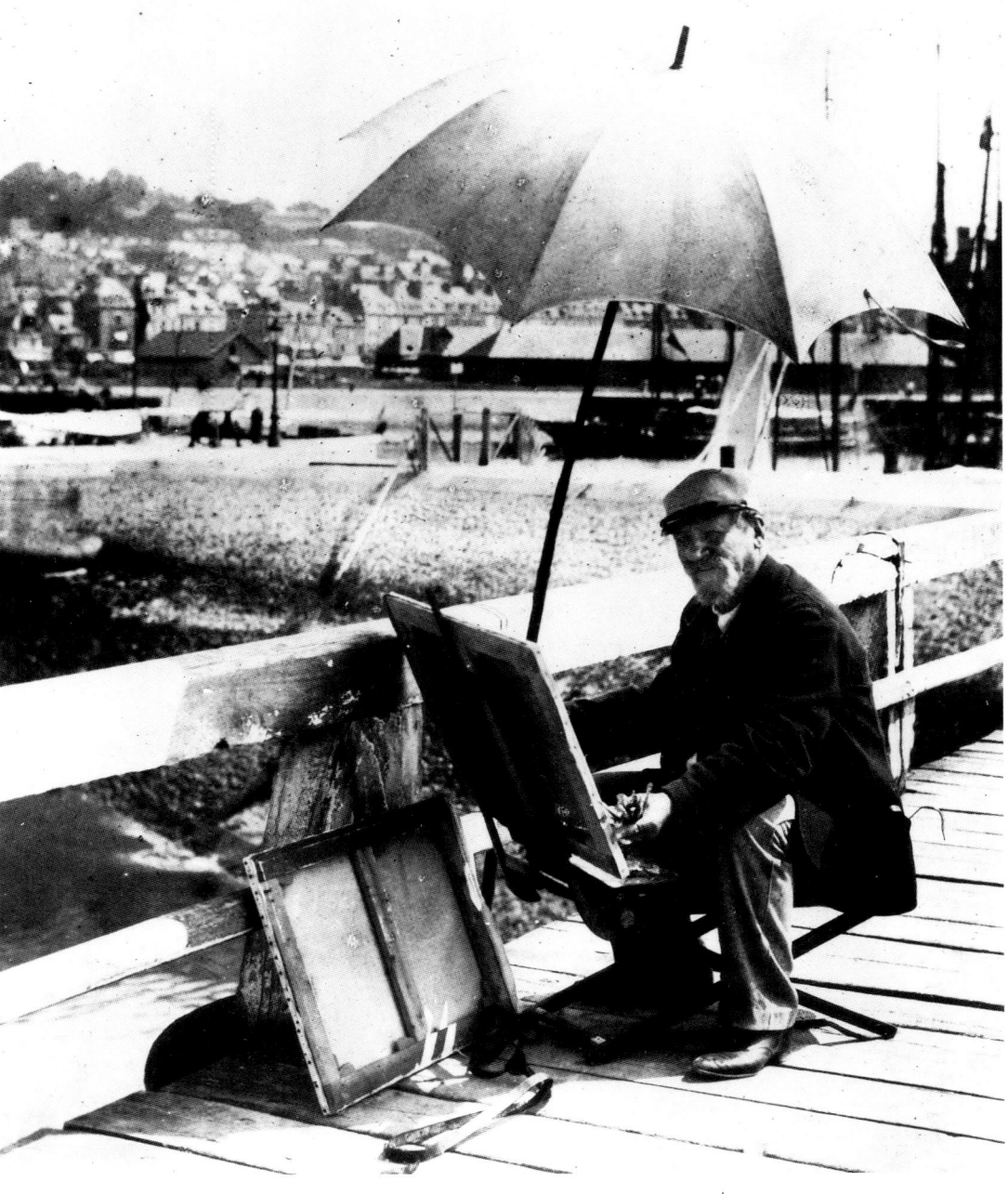

than Monet, Manet was the acknowledged leader of the artistic wing of a group that met at the Café Guerbois and included Duranty, Zola and other writers sympathetic to Realism but less dogmatic than Courbet and his followers. Usually designated 'Naturalists', to distinguish their approach from Courbet's Realism, they were interested in developing appropriate modes in art and literature to describe the modern city and particularly Parisian life; what Baudelaire described as 'the pageant of fashionable life and the thousands of floating existences – criminals and kept women – which drift around in the underworld of a great city'. Realists, Naturalists and Barbizon painters were all subject, like their parent Romanticism, to varying degrees of hostility from older academic and classical artists, who were over-represented on Salon juries, controled the curriculum of the Ecole des Beaux-Arts and were prominent in the centralized bureaucracy of French artistic life. Classical and academic values were still associated, in the minds of public and critics, with skill and proficiency and also with moral issues such as suitability of subject-matter. Despite decades of alternative Romantic painting and the proliferation and popularity of more modest genres, 'official' art in France was still dominated by Classicists.

During his first year in Paris, exploring Barbizon and Realism and rejecting academic and classical values, Monet did not achieve any coherent position. A tendency to play the part of the metropolitan bohemian meant that he did not

seriously settle to art. His very earliest work includes a group of still-lifes; *Corner of the Studio* (page 24) of 1861, a strikingly competent picture, is broadly an exercise in Realism in the manner of Chardin and Dutch seventeenth-century still-life painters. In this work the influence of Boudin is less evident than that of Armand Desiré Gautier (1825-94), a painter whose 1858 exhibition in Le Havre was probably seen by Monet. Gautier was a close friend of Courbet and an uncompromising left-wing radical. He knew Monet's aunt, who introduced her nephew to him, probably helping to gain Monet access to Parisian

Realist circles. The studio corner shown in this early work, with its heavy carpet and wallpaper, is fancifully luxurious. It is an aspirational picture suggesting a young artist's hopes for prosperity and in its blandness appears aimed for an easy sale.

It is usual to view Monet's development toward landscape painting as a more or less inevitable progression precipitated by Boudin but, had Monet died aged 24, his few surviving works would have suggested that he was primarily a burgeoning still-life painter. The direction that his art was to take was by no means resolved when, in 1861, he was

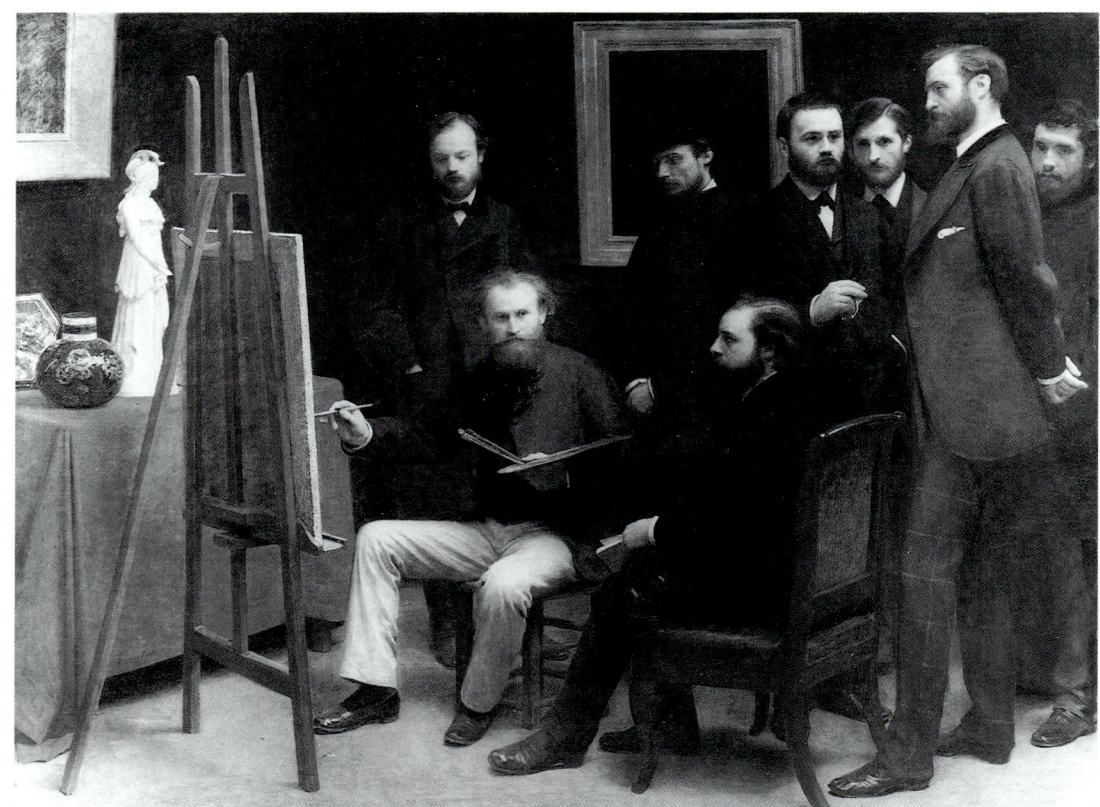

drafted into the army, chosen by lottery to serve seven years. He refused to allow his father to purchase his release from military service and joined a French North African regiment in Algiers, attracted, he later said, by the glamour of the uniform. He served for a year, until dysentry followed by lengthy home convalescence brought a more measured appraisal of his future prospects and he allowed his father to pay for his discharge. Much later Monet said that the light of North Africa had captivated him, but this may have been no more than an old man retrospectively giving biographical significance to what was at the time a disaster.

Studying alongside Renoir, Sisley and Bazille 1862-63

When Monet resumed his artistic training in Paris in November 1862, he was obliged to conform more closely to his father's expectations and registered to study at the studio of the classical Swiss artist Charles Gleyre (1808-74), an ex-pupil of David who ran an easy-going studio, charged the same monthly rate as the Académie Suisse and maintained an arm's-length supervision of his students. Although Gleyre prepared candidates for the examinations of the Ecole des Beaux-Arts, Monet did not choose to take up this option. His fellow students included Renoir, aged 21, who had come to oil painting and high art via an apprenticeship in porcelain decoration; Sisley, aged 23, who was born of

prosperous silk-dealing English parents but had rejected family tading options, and Bazille, aged 21, who was supposed to be combining medical studies with painting. Monet gained ascendancy over this group, partly through his greater worldly experience but primarily because of the conviction with which he was able to argue for a clear, distinct and appealingly modern approach to painting based upon his contact with Barbizon and Realism. During his convalescence at Le Havre he had again worked with Boudin and also come into contact with Jongkind, the Barbizon painter who came to have a significant influence on his own style.

Although not as yet committed to a future in landscape painting, all four young artists spent Easter 1863 together at Chailly, a village near Barbizon. There, as well as meeting the artists that they had come to admire under Monet's tutelage, they also painted out-of-doors oil studies in front of the motif, adopting Barbizon colors and facture. Typical of Monet's Barbizon-inspired work are *The Road From Chailly to Fontainebleau*, 1864-65 (page 26), showing foresters dragging logs through a clearing, and *Rue de la Bavolle, Honfleur*, 1864 (page 27). Both are compositionally almost identical and used a muted range of close-toned pale browns, greens and silvery grays painted on a pale background. These and the Jongkind-like beach scene of the same time, *La Point de la Hève at Low Tide*, (page 25) all began as oil sketches done on the

spot but also included substantial studio-based finishing.

In March 1863 the group probably all saw the small exhibition at Martinet's Paris gallery of works by Manet, as well as the exhibition of 4000 rejected pictures from the 1863 Salon – the so-called 'Salon des Refusés', which included pictures by Jongkind, Cézanne and Pissarro as well as Manet's famous *Déjeuner sur l'Herbe*. Manet became a hero to Monet and his circle, who were attracted by the persistent intensity of his choice of modern subjects and the alternative pictorial vocabulary that he used. The close-toned colors of Barbizon and other landscapists tended to reduce spatial depth in a picture. Manet took this further, by dramatic simplified contrasts of figure on ground, as a result of his elimination of halftones; by his suppression of detail in large areas of a particular color and by his adoption of outline. Manet's modified pictorial vocabulary was influenced by photography, by contemporary discussions about the need for optically-derived rather than mathematical perspective models, and by an awareness of alternative spatial

Left above Boudin's *Beach at Trouville*, c. 1864 is typical of his smallscale, low-key approach to landscape.
Left below Henri Fantin-Latour's *Studio in the Batignolles Quarter* is an act of homage to Manet, who is shown with his admirers including Monet.
Below *Honfleur*, 1865, by Jongkind, with whom Monet painted at Le Havre in summer 1867.

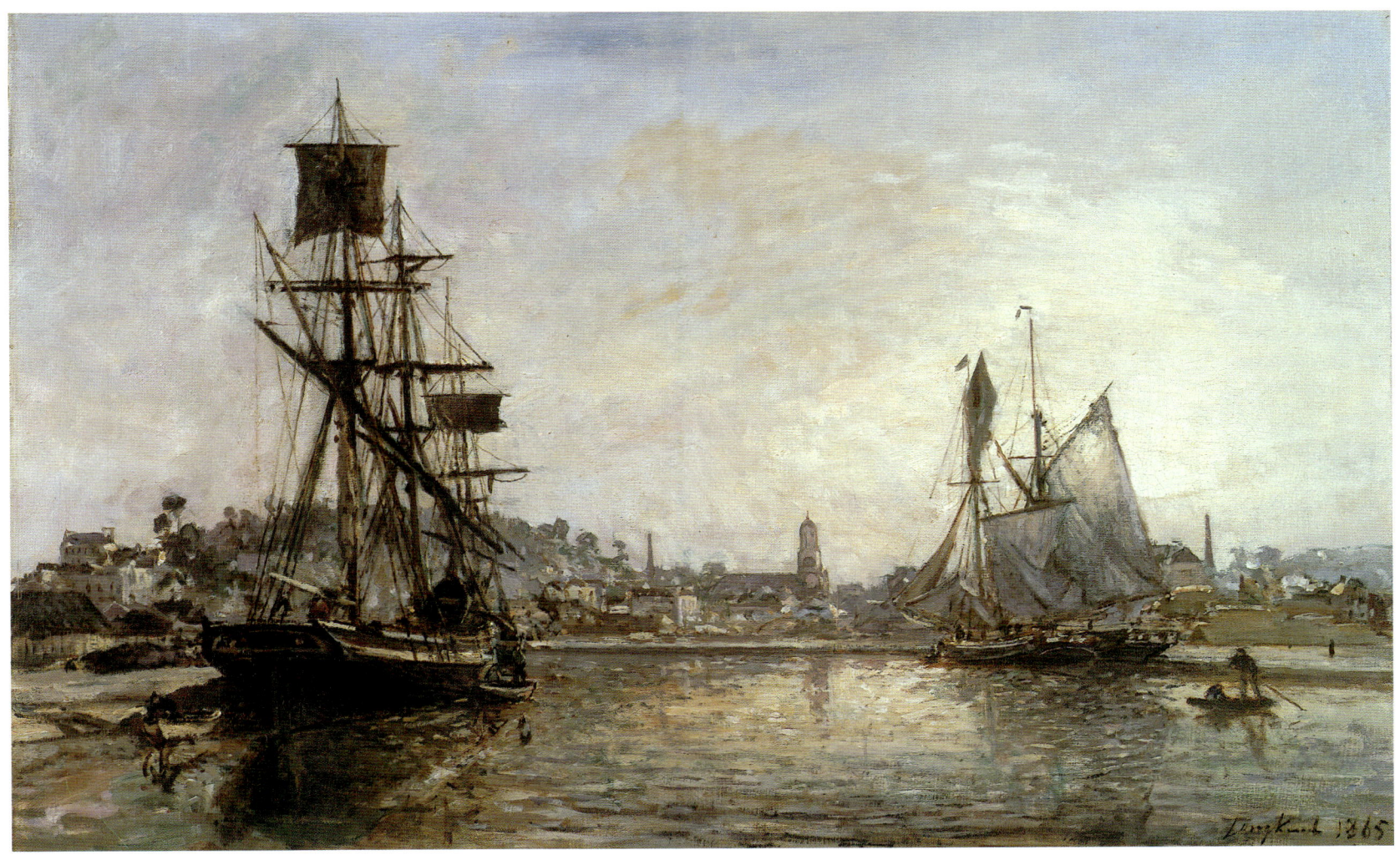

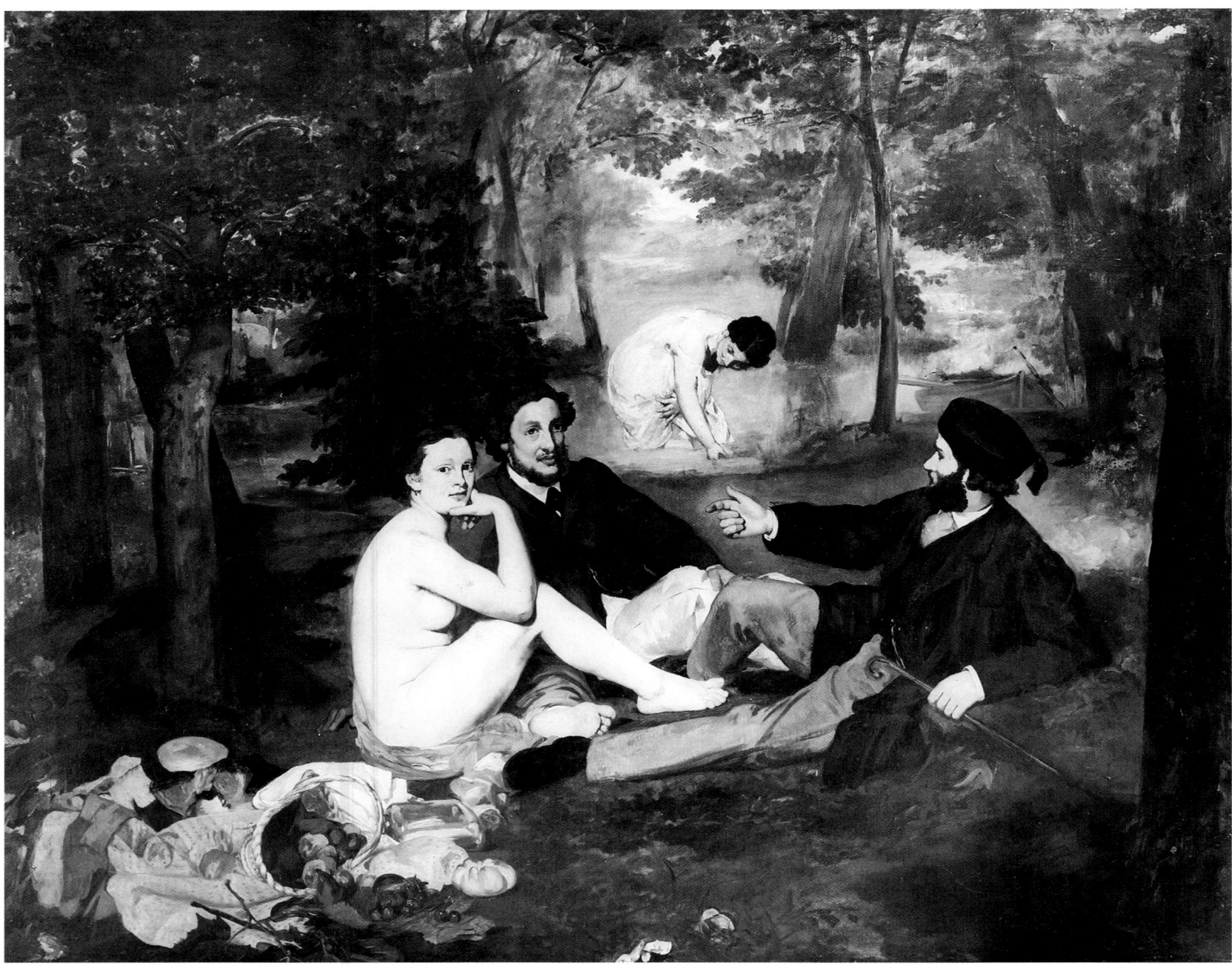

conventions provoked by Japanese woodblock prints. Although Courbet was often a Realist in his choice of subject-matter, technically he remained a Romantic; Manet was the first artist to try for a complete change of both subject and handling, and as such was viewed by his contemporaries as the first painter of Modern Life.

Exploring Naturalist outdoor and indoor themes 1864-68

During the period 1864-68 Monet moved freely between various genres and, with surprising versatility, painted in different styles. Family pressure kept him tied to Gleyre's instruction until late 1863, when as a result of failing eyesight Gleyre was forced to close his studio. Monet's abandoning of a definite programme of study caused friction with his father, who cut off his allowance. Fortunately for Monet his friendship with Bazille strengthened and the latter was able to help by buying occasional pictures and paying for studio rental.

Unexpected success came when two seascapes were accepted for the 1865 Salon and given favorable critical atten-tion. Because these two pictures were hung close to Manet's *Olympia*, some critics took advantage of their proximity to compare Manet's work unfavorably with Monet. Stimulated by Salon success, Monet's enormous undertaking for the summer of 1865 was the 20 feet × 15 feet canvas entitled *Déjeuner sur l'Herbe*, influenced by Manet's similarly titled picture of two years earlier. Instead of a group of contemporary men and a naked woman with poses based on a sixteenth-century engraving, however, Monet painted a thoroughly modern gathering of his own middle-class friends with the forest near Chailly as a backdrop; a matter-of-fact life-size picture of ordinary life but on the huge scale normally reserved for history painting. Studio-posed and largely studio-painted, it remained unfinished. An accident to his leg at Chailly slowed him down (Bazille recorded his bedbound convalescence) and he made alterations to part of the picture on the advice of Courbet. Eventually he abandoned it in despair, and it was later damaged as a result of being badly stored after seizure for non-payment of debts. As a result Monet cut the canvas down and the entire composition is known only from the large oil study (page 28).

Monet's hastily painted alternative entry for the 1866 Salon was the full-length portrait of his new lover, Camille Doncieux, *Camille (The Green Dress)* (page 30). Apparently executed in just four days, this was a further daringly modern piece of portrait painting emphasizing activity and the chance seizing of the sitter as she appears to hurry diagonally through the picture. In the pose of the single figure against a simple background, Monet was once again influenced by Manet but the darker overall color and paint facture is also reminiscent of Courbet. Although Zola and other critics were enthusiastic, sales of Monet's works were not forthcoming and his financial problems grew worse.

Between 1867 and 1869 Monet lived variously in central Paris, at Ville d'Avray, Le Havre, Fécamp and Etretat, lodging with family or friends, sometimes borrowing empty apartments and houses. He was unable all the time to live with Camille and their newborn son Jean; brief periods of precarious security

were interrupted by ejection for non-payment of rent and pursuit by predatory creditors. In late summer 1866 Monet fled Ville d'Avray after slashing over 200 canvases to prevent their seizure and forced sale. In July 1867, around the time of Jean's birth, he temporarily lost his sight, and in June 1868 he wrote to Bazille to say that he had attempted suicide. His picture *The Luncheon* (page 36) of 1868 records a rare period of stability. As a result of a portrait commission given by the Gaudiberts, a prosperous Le Havre family, Camille and Monet were able to set up home at Etretat. The internal evidence of the charming mealtime scene suggests why Monet had such problems. Financing a servant, laundry bills for table-linen and the maintenance of middle-class standards familiar to both himself and Camille made it difficult to eke out the money obtained from loans and occasional picture sales. The commissioned portrait that helped them survive is of *Madame Gaudibert* (page 32). Lighter than the earlier picture of Camille, it adopts a similarly convention-breaking view of the sitter in profile.

From 1867 onward discussions intensified among several Naturalist and Realist artists about the possibility of an alternative exhibition to the official Salon. Some artists had unsuccessfully petitioned the state for another Salon des Refusés. Courbet's Pavilion of Realism at the 1855 Exposition Universelle and Manet's similar one-man show at the 1867 World Fair showed that public interest could be aroused by a separate exhibition. Pissarro and Cézanne, both often rejected by the Salon and vilified in the press, were especially keen to have

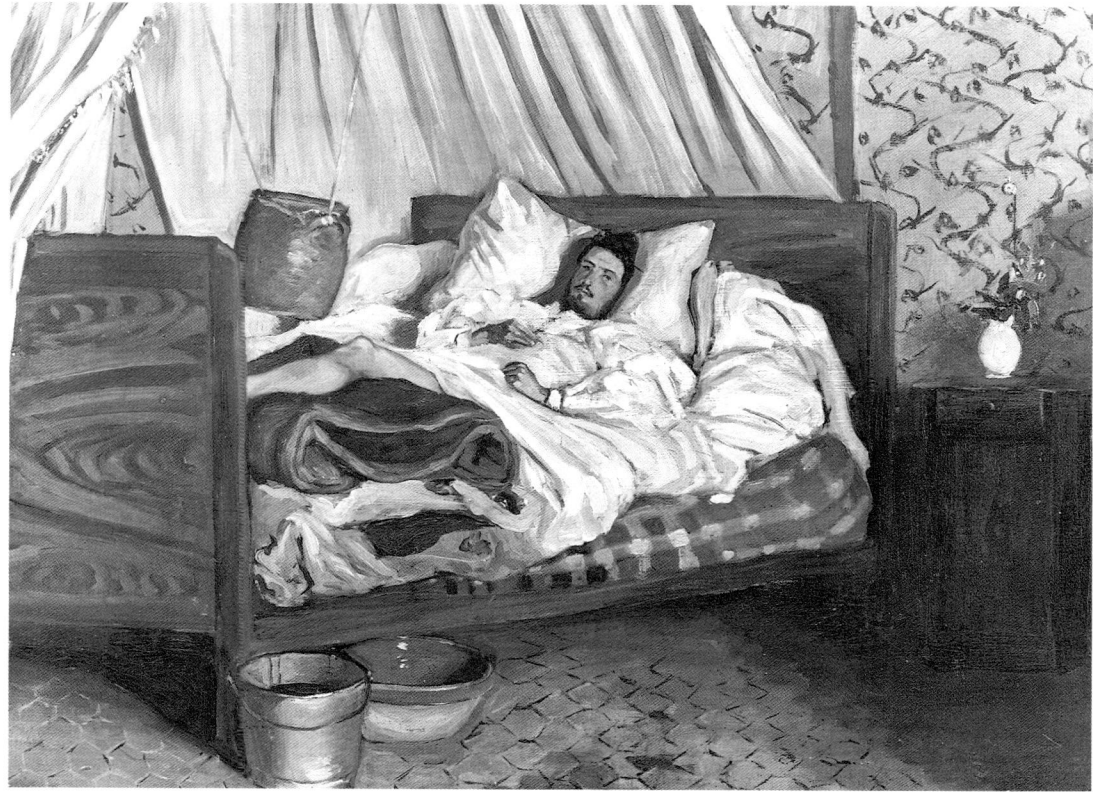

an alternative exhibition. Degas was slower to come round to the idea and was not convinced until 1871. Manet, while prepared to have his own show, would not abandon the Salon to exhibit in a separate group exhibition. He believed that the fight for Naturalism should be taken into the enemy camp. Monet's attitude was equivocal. Both he and Bazille strongly advocated holding an exhibition but for Monet it probably always remained a strategy for increasing public exposure of his pictures to obtain sales, and he was less inclined to view it as an attack upon official exhibitions as such. Nothing came at this stage of these discussions, some of which took place at the Café Guerbois. Monet was introduced by Manet to this café circle

in 1869. As a junior member of the group he probably came to draw inspiration by listening to the lively discussions rather than to take prominent part.

Throughout his life Monet's connections with Paris remained limited and he was never a *boulevardier* like Manet or Degas. Although he did not cut himself off from the capital until old age, he preferred the countryside and his subjects rarely included Parisian views. It took a special occasion like the 1867 World Fair to turn his attention away from rural landscape or seascape.

The World Fair of 1867 made Paris a focus of international attention. In the twelve years since the previous Paris Exposition Universelle in 1855, Napoleon III and his Prefect of the Seine, Baron Haussmann, had transformed the capital, demolishing narrow streets, creating wide apartment-lined boulevards, building new quarters for the rapidly expanding population, and conveniently combining military advantage (broad straight avenues for rapid troop deployment and direct cannon-fire) with modernity. Haussmann's Paris is the central Paris beloved by tourists today; Monet, Manet and Renoir all painted Paris in 1867. Although the World Fair may be seen as a publicity-seeking show for a threadbare dictatorship, combined with the new Paris it commanded the attention of artists for whom the depiction of modernity was a primary aim.

Monet's two most important 1867

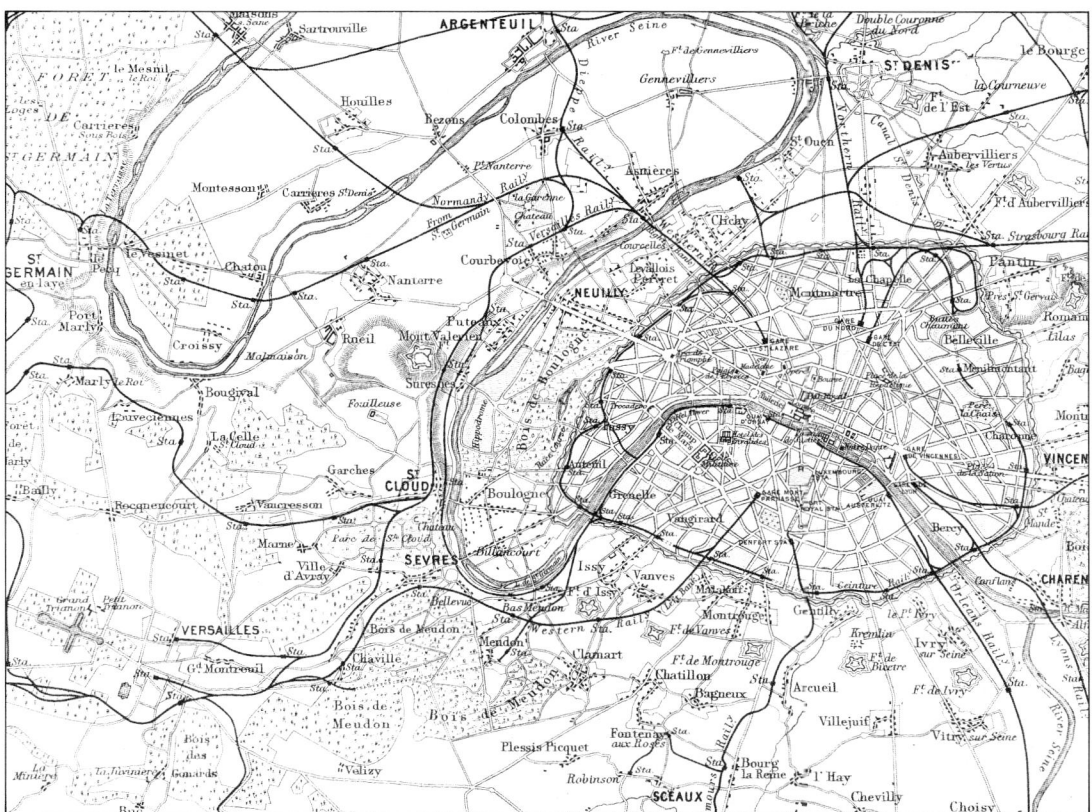

Left above Manet's *Déjeuner sur l'Herbe*.
Above Bazille's *Monet after his Accident at the Inn in Chailly*, a bizarrely Realist record, with cold water dripping on the injured leg.
Left Map showing central and western Paris c. 1900.

Above Lithograph of the Exposition
Universelle of 1867.
Below Courbet: *Cliff at Etretat after the Storm*,
Right above The beach and cliffs at Etretat.
Right below The popular resort of La
Grenouillère, often painted by Monet and Renoir.

Paris landscapes are the related views
that he made from the terrace of the
Louvre, looking toward the Seine with
the Pantheon in the distance, *The Garden
of the Princess* (page 37) and *The Quai du
Louvre* (page 38). Little of Haussmann's
new architecture figures in either work:
gas-lighting, advertising, organised cab
ranks, full omnibuses, good pavements
and well swept and maintained parks,
the communications network and sup-
port services for the rapid movement of
people, is what Monet documents in his
broad and detached topographical view.

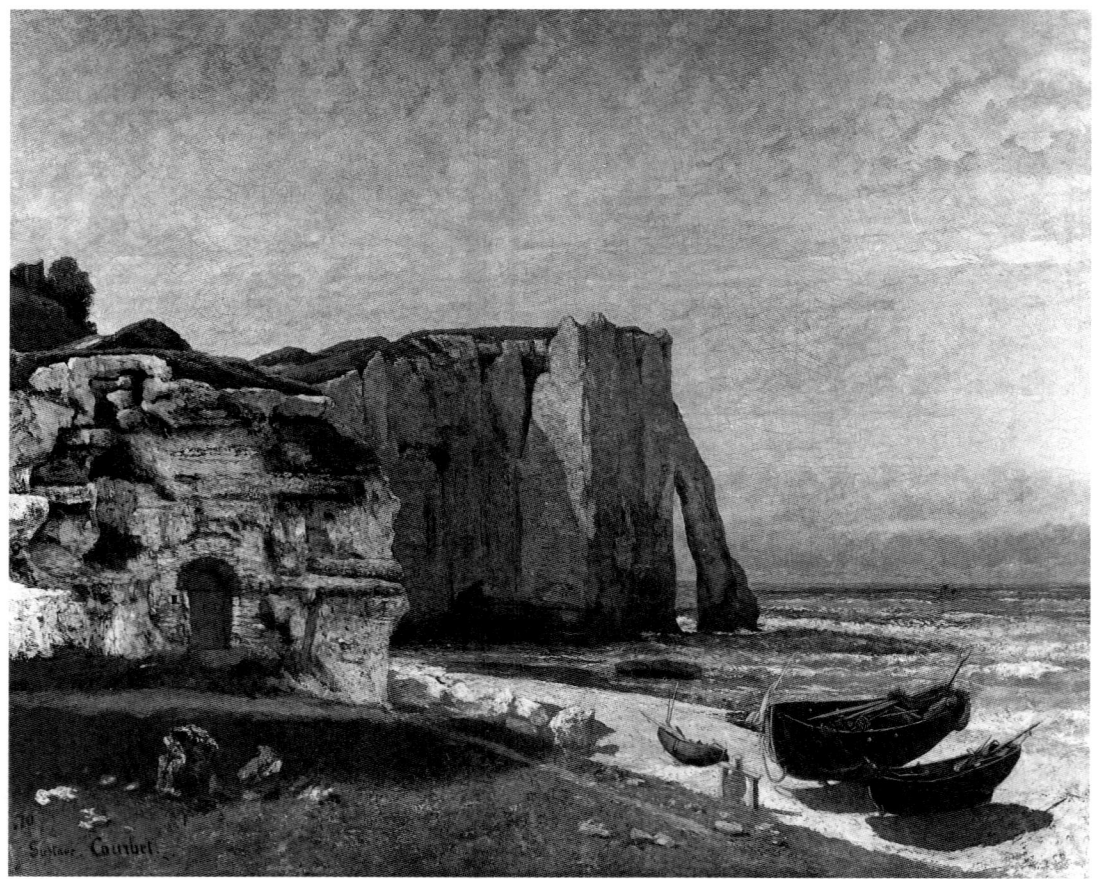

Figures, of which there are nearly 100,
are summarily described as a blurred
mass.

Impressionist practice refined 1867-70

Although the designation 'Impression-
ist' was not to be attached to Monet and
his fellows until the first Impressionist
Exhibition of 1874, the shaping of a dis-
tinctly Impressionist practice prompted
by Monet belongs to the period 1867-70.
Monet later suggested that *Women in the
Garden* (page 33) of 1867 was the first can-
vas to be painted according to his new
principles. As a movement, Impression-
ism does not lend itself to precise defini-
tion. Three major threads weave into the
confusion. First, Monet himself never
stated or wrote down clearly what the

fundamentals of his practice or theory
were. He preferred in interview to con-
fine himself to rather general state-
ments, leaving others sympathetic to his
art to elucidate a more extended mean-
ing and to give a greater coherence to his
views. What have been taken as the clas-
sic statements of Monet's beliefs have
invariably been written by others.
Secondly, Monet's own 'Impressionist'
practice gradually changed and the
paintings of the 1890s do not share the
same brushwork, palette, subject-matter
or, in so far as it is possible to deduce it,
theory, as works done in the 1870s. Final-
ly, Impressionism during the last three
decades of the nineteenth century was,
as it still is, a flexible term, used more
freely for categorization than any similar
umbrella term applied to any other
group of artists or artistic movement.
This was due in part to the diversity of
those who showed at the eight exhibi-
tions between 1874 and 1886, so that the
appellation 'Impressionist' became for
many synonymous with the avant-garde.
Certainly when Vincent Van Gogh came
to Paris in 1886 to study Impressionism
he took a very broad view of its scope.
Several critics found it convenient to use
the term to collectively dismiss all the
varied strands of modernity in painting.

Impressionism for Monet was, first, an
approach to Nature; secondly, a rela-
tively constant practice governing the
act of painting; and thirdly, a variable
practice as regards the handling of paint
and color. If it is borne in mind that Im-
pressionism was a branch of Naturalism,
a daughter of Realism, a descendant of
Barbizon; that during its period of maxi-
mum influence between 1874-90 its prac-
titioners adopted a position of flexible
self-definition in relation to all these
three as well as to other more traditional
orthodoxes; and that it was never given
to complex intellectual justification; it
then becomes easier to isolate such dis-
tinctive character as it had.

Monet's disposition toward Nature,
his subject-matter, was essentially
Romantic – Nature remained the great
teacher. Various young artists who at
different times during his life asked for
his advice or tuition were instructed to
go direct to Nature, to transcribe their
own observations, and if they were not
satisfied to give up being artists. The
critical relationship between the artist
and his subject was the *sensation*. Monet,
Pissarro and Cézanne all talked on
several occasions of building pictures
from their sensations. What Monet
meant was his intuitive spontaneous
seizing of the information before him,
translated into a particular picture-
making vocabulary. This subjective side
to Monet's quest needs some emphasis,
particularly since at times both his own

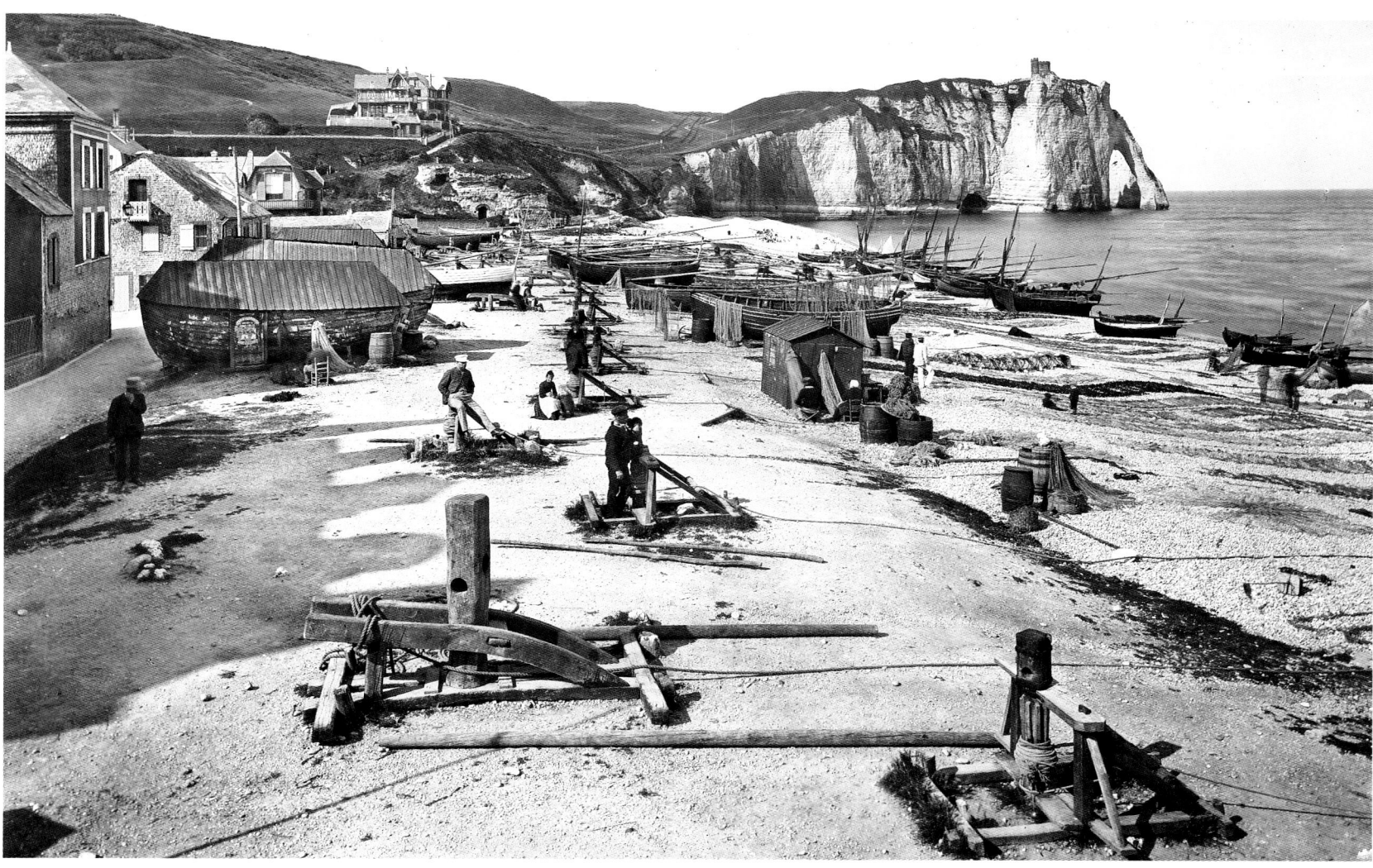

propaganda and the popular notions of his work held by critics and supporters alike tended to understate individual creative input and to see his Impressionism as simply an attempt at a particular form of objectivity. The '*sensation*' did not however in Monet's case have any extended spiritual or religious dimension; he was a lifelong atheist with perhaps just a shade of pantheism.

Monet's most dogmatic statements about his practice concern the absolute primacy that he gave to painting in front of the motif. From 1867 onward he insisted that all of the picture should be painted from start to finish with the subject before him. Most landscape artists, aware that light is fugitive, had traditionally settled for more or less general approximations to a particular time of day or fall of light in their pictures. Monet argued that the specificity of appearance should not be compromised and that the artist should stop painting a motif when light changed and only recommence when conditions were again broadly similar.

This emphasis on the dominant role of light in conditioning the truth of appearance led to Monet's modification of traditional landscape painting practice. Earlier Barbizon artists, interested to a lesser degree in the same problem, had evolved a blonder, paler tonality for their pictures, lightening colors to produce more specific approximations (albeit studio painted) of the complexity

of cast sunlight. The result of Monet's scrutiny of the motif with an eye tuned solely to the fall of light on objects was that for him all Nature tended toward equality, whether the massy bulk of a treetrunk, the semi-transparency of leaves, a sheet of water, or the vaporous river mist that rises at dawn.

Traditionally subtly graduated tone is used to model the mass of a form, giving bulk to an object in space by suggesting light's fall, from dark shadow through to white highlight. Monet rejected tone as a method of modelling and later, certainly by 1873, eliminated black altogether from his palette. Color alone was

sufficient, and relationships between colors could suggest solidity and space within a picture. Shadows were also to be painted in colors and not treated as a brown soup to be applied in various dilute strengths.

In his desire for fidelity to a specific fall of light, Monet painted quickly in bold separate strokes of paint. In itself this was not especially novel, since rapid oil sketches had long been a preliminary stage in the creation of pictures. The spontaneous freshness produced by such bravura painting had for over a century been enjoyed by artists and connoisseurs, who recognized, however,

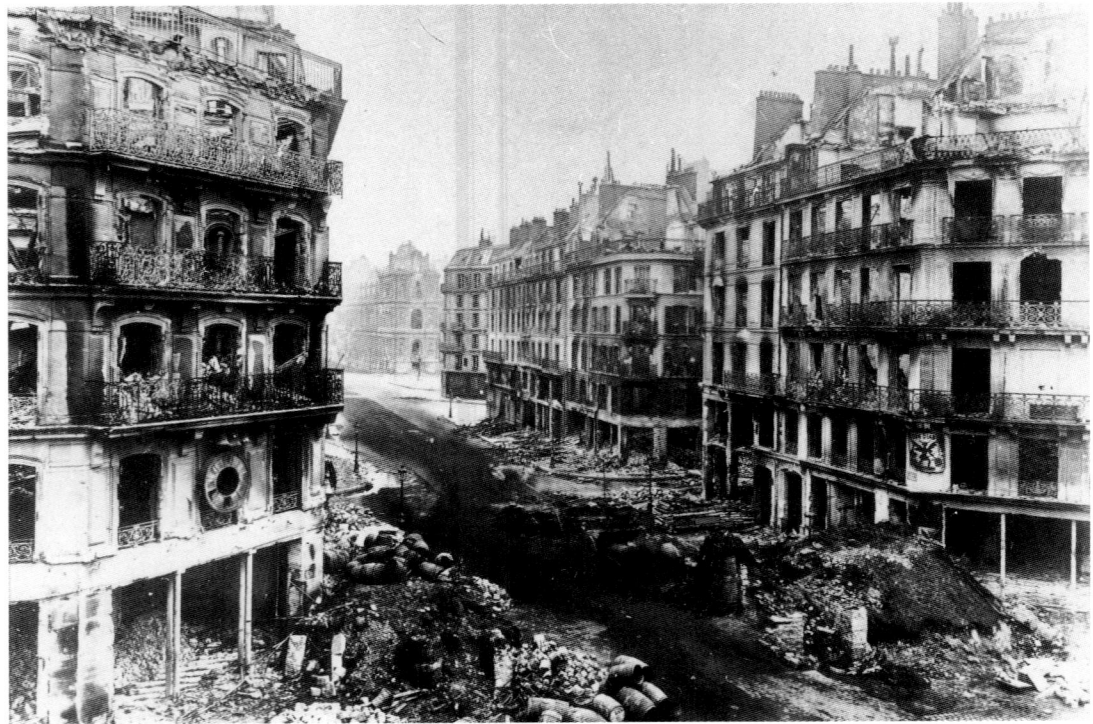

that such sketches were just a stage on the way to the reworked and properly finished canvas. Monet and his circle promoted this stage of picture-making to the status of a finished exhibitable work, and it was this that aroused some of the strongest criticism of their pictures.

Monet's early Impressionist work includes *Bathers at La Grenouillère* of 1869 (page 40) and *The Hôtel des Roches Noires at Trouville* of 1870 (page 41). The absence of tonal modelling is particularly noticeable on, for example, the facade of the hotel. Slabs of off-white reflected light on the most distant roof tower have equal tonal value with both the dress of the seated woman in the left foreground and the distant clouds. The hotel itself casts a solid green shadow, and green-gray tinged with blue is the predominant color of all shadow in this picture. Flags, with a surface sheen that catches the sunlight as they furiously billow, are painted with suggestive dashes of cream to indicate the busy play of light.

In the Grenouillère canvas of a year earlier, one of the earliest Seineside views undertaken by Monet, tone is still used in a few places to model form, as in parts of the rowing boat interiors, while black is still used for the shadow of boats in the water. Large strokes of confidently placed paint summarily describe the busy throng of people and the dappled sunlight upon the water. There is also evidence in this picture of what was to become a characteristic feature of Monet's painting of foliage – the deliberate complicating of his range of greens as he sought for variety within a color, to compensate for his dropping of tonal modelling.

When Monet painted at La Grenouillère he was accompanied by Renoir, who executed canvases from the same view-point. Although Renoir's brushwork usually retained a wispy bearded edge that distinguishes it from Monet's, he painted according to similar ground rules. Monet's and Renoir's choice of La Grenouillère (literally 'the froggery') set a fashion for Seineside pictures of bathing and yachting that later became almost the stereotypical Impressionist subject. Painting such slightly down-market bathing-spots celebrated out-of-town Sunday and holiday Parisian leisure. Unchaperoned mixed public river-bathing had that rather daring edge of modernity, a sort of characteristically French moral laxity that contemporary British and American guidebooks to Paris warned visitors against.

In choosing to paint by water, Monet and Renoir were giving themselves the maximum challenge in the depiction of fugitive light. Painting the dappled light shining through trees on to white dresses in *Women in the Garden* (page 33) is a relatively simple problem compared to the mixture of reflections, riverbank shadows, variable damp atmospheric haze and foliage-filtered sunshine.

London 1870-71

The outbreak of the Franco-Prussian War, in July 1870, found Monet honeymooning on the Channel coast at Trouville. Rather than rejoin his regiment, to which he was still attached as a reservist, he fled to London, probably in mid-September, and was later joined by his family. Other refugees included Pissarro and Daubigny. The latter was probably instrumental in persuading the art dealer Paul Durand-Ruel, who had arrived from Paris with a substantial stock of Barbizon pictures, to buy a Trouville view by Monet and exhibit it in the January 1871 exhibition in his new Bond Street Gallery, thus beginning a dealer-artist connection that was to last over half a century.

During his nine months or more in London, Monet painted few landscapes, possibly only five. The most important was *The Thames and Westminster* (page 42), showing the Houses of Parliament in the foggy London haze that he found so especially attractive. Long after Monet gave up painting central Paris subjects he repeatedly returned to London and eventually painted well over a hundred views of Parliament and the nearby bridges. Although Monet was not close to Whistler at this stage there are strong affinities between Whistler's own Thames 'harmonies' and this atmospheric canvas with its range of grays and closer-toned light effects. Apart from two other Thames views, Monet also painted in Hyde Park and Green Park, again exploiting the distinctive muted haze of winter London, rather than exploring brighter sunlit views.

During early 1871 Pissarro and Monet together visited London's public galleries and exhibitions and admired land-

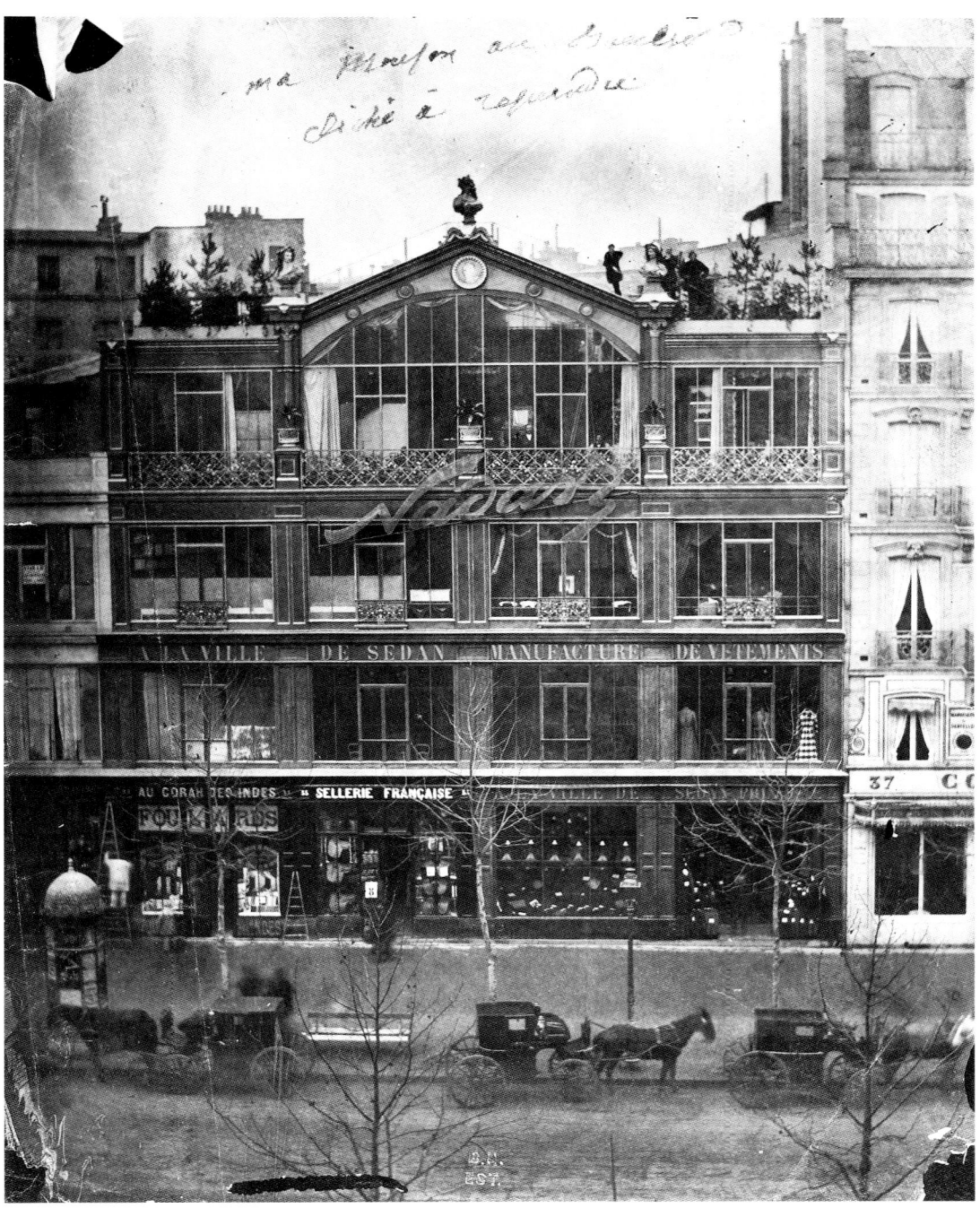

exhibition held at Nadar's, a Paris photographer's studio on the Boulevard des Capucines. Monet actively involved himself in the exhibition's organisation. His five exhibited oils included a view of the port of Le Havre, similar in treatment to his earlier 1871 view of the Houses of Parliament; an atmospheric rather sketchy work, less finished than his other exhibited pictures. Emphasizing this distinction, Monet titled it *Impression, Sunrise* (page 46). The first part of his title was taken up by critics and used as a convenient name derogatively to describe the work of the whole group.

Monet's contribution also included his first substantial central Paris subject since 1867, *Boulevard des Capucines* (page 55), with a distanced upper-storey viewpoint close to that actually seen by visitors to the exhibition through Nadar's large plate-glass frontage. No Seine pictures were exhibited and *Wild Poppies* (page 52) was his only Argenteuil subject. Although there was considerable adverse criticism in the press, of which selective quoting by art historians over a century has tended to suggest the exhibition's failure, there was sufficient praise and enough visitors for it to be broadly considered a success, even though a deficit had to be paid. Monet's work was reasonably well received. Reflecting his Durand-Ruel sales, he put a price of 1000 francs on *Impression – Sunrise*, and later sold it for 800 francs. From the early 1870s Monet, through his own enterprise, began to gather and cultivate a small group of enthusiastic private collectors. At the second Impressionist Exhibition in 1876, 9 of the 17 landscapes that he showed already belonged to the opera singer Jean-Baptiste Faure. A year later, at the third exhibition, the catalogue indicated that 11 of his 30 works were the property of Ernst Hoschedé. At the 1879 fourth exhibition only 5 of 29 pictures were actually for sale. Monet's marketing strategy for himself in the 1870s involved a deliberate projection of his sales success – he could after all have included other saleable works on hand. During this period Monet sold widely and later regretted letting some pictures go before they were fully resolved, but his high standard of living demanded ready money. The many surviving letters from Monet seeking to borrow money are not so straightforwardly indicative of poverty as has often been assumed. It has been calculated that

scapes by Crome, Constable and Turner. Monet's later Thames pictures owe a significant debt to Turner's approach but at this time he was not directly influenced by his work which he thought 'exuberantly Romantic'. Pissarro also was particularly critical of what he perceived as Turner's ignorance of the analysis of shadow and his use of it 'simply as an effect, as a huge absence of light'. In many ways it was Pre-Raphaelite artists like Holman Hunt and Ford Madox Brown, who also emphasized *plein air* painting directly from the motif, who were closest among British artists to Monet's concerns, despite their very different precise brushwork and their greater concern with narrative.

Argenteuil 1871-78

Returning to France via Holland, Monet settled with his family at the small town of Argenteuil on the Seine, about six miles and a fifteen-minute train ride to Paris from the railway station opposite his home. His fortunes began to improve. Durand-Ruel bought nearly 29,000 francs worth of his paintings in

1872 and 1873; Camille inherited money; and in grander style Monet continued his habits of the 1860s – living beyond his means and borrowing from his friends.

Argenteuil, prosperous and rapidly developing, still retained in 1871 a semi-rural charm that was gradually being eroded by overspill housing for the capital and new industries. It was a popular boating and Sunday excursion spot for Parisians of all classes. Monet was able there thoroughly to explore diverse motifs using water. On the river, painting from a specially constructed studio boat, he could choose quiet backwater or busy social gathering. The fields on the northern bank were still open countryside and at Argenteuil he first practised the twin arts of garden-making and garden-painting that he kept up for the next half century.

In December 1873, together with fifteen others including Renoir and Pissarro, Monet signed the charter setting up a limited company of independent artists, a move that culminated four months later in the first 'Impressionist'

throughout the 1870s he earned on average 10,000 francs a year. When desperate for ready cash Monet would offer to sell a picture for as little as 50 francs.

Monet's family life 1870-80

After their marriage (which brought respectability as well as a dowry) Monet continued to use Camille as his principal model. In 1870-71 he painted her looking rather doleful seated on a chintz-covered sofa in an English interior. Entitled *Meditation, Madame Monet* (page 44), this is the only picture in his career to which he appended a title that implied some extended narrative. Although he failed to have it accepted for the Royal Academy, it was accepted at the 1871 London International Exhibition and it represented a partial accommodation to the English taste for genre subjects, as well as recalling the type of interior single figure portrait that Degas and Whistler had developed during the 1860s. Much more typical of his work from this period are the substantial group of outdoor pictures made between 1873-76, in which Camille is accompanied by their son Jean and one or more servants; for example *The Luncheon* (page 50) and *Wild Poppies* (page 52). These pictures show how from about 1873 Monet ceased to let people in his canvases command spectator attention; occupying less space, figures are now treated on the same footing as other objects in the landscape. There is a resultant wraith-like quality to some of these images of his wife floating through garden or field, dressed in white, face hidden by veil of bonnet; almost as though Camille had become a giant camellia. *Gladioli* (page

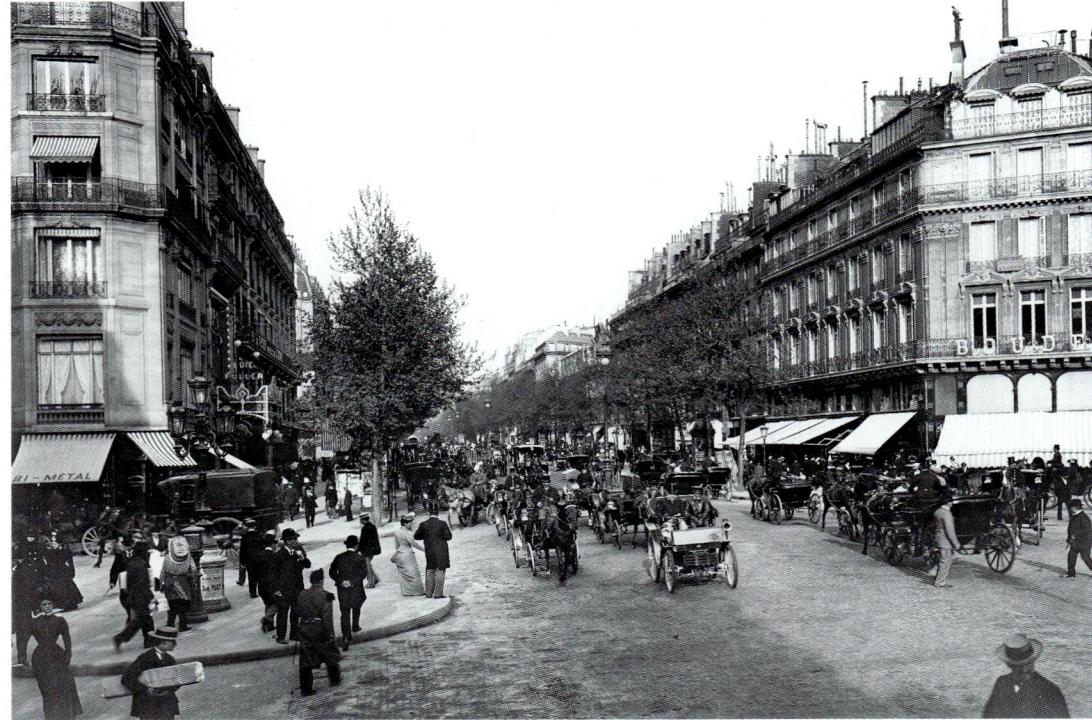

Above The Boulevard des Capucines as seen from Nadar's studio.
Below Renoir's *Monet Painting in his Garden at Argenteuil*, 1873, gives a less idealized view of Monet's garden, showing neighbors' houses which are only glimpsed in Monet's depictions.

62), painted in 1876, the year that she was first seriously ill, shows her lurking at the rear of the picture in blue shadow, out of the direct sunlight that bathes the foreground flowers. It has been suggested that these depersonalized figures may reflect a degree of estrangement between Monet and Camille, a symbolic reading of the pictures far from Monet's Impressionist intentions.

Monet's affair with Alice Hoschedé, wife of the rich but incompetent financier who was one of the Impressionists' best patrons and who originally owned *Impression – Sunrise*, is thought to have begun during 1876. Monet's decorative commission of four canvases for the Hoschedé chateau showing the house and surrounding landscape at Montgeron included *The Hunt* (page 65). Hoschedé's squandering of Alice's inheritance led to insolvency in 1875 and bankruptcy in 1877. In 1878 Monet, Camille and Jean joined financial forces with the Hoschedés and their children, and they all lived together at Vétheuil about 40 miles from Paris, where Camille gave birth to her second son Michel. Camille's health rapidly deteriorated and on her death in September 1879 Monet painted an extraordinary portrait of her on her deathbed (page 70). He later told a friend that he had been gripped by 'the series of colored gradations that death produced in her motionless face'. Viewed by some as evidence of his unrelenting objectivity, it has been seen by others as a guilt-ridden act of penance.

In 1881 Alice and her husband separated and she and Monet lived together with their tribe of children until in 1892 they married, a year after Ernst Hoschedé's death. Alice's sixth child, Jean-Pierre, born in 1878, is usually presumed to have been fathered by Monet and it is either Jean-Pierre or Michel Monet who occupies the foreground in *The Artists' Garden at Vétheuil* (page 72) with Alice now the spectral white clad woman at the top of the background steps.

Monet's garden pictures of the 1870s have received considerable recent critical attention, focussing on the idyllic partiality of their view of suburban life. During the six years that Monet was at Argenteuil, the local council and those of nearby districts were in recurrent con-

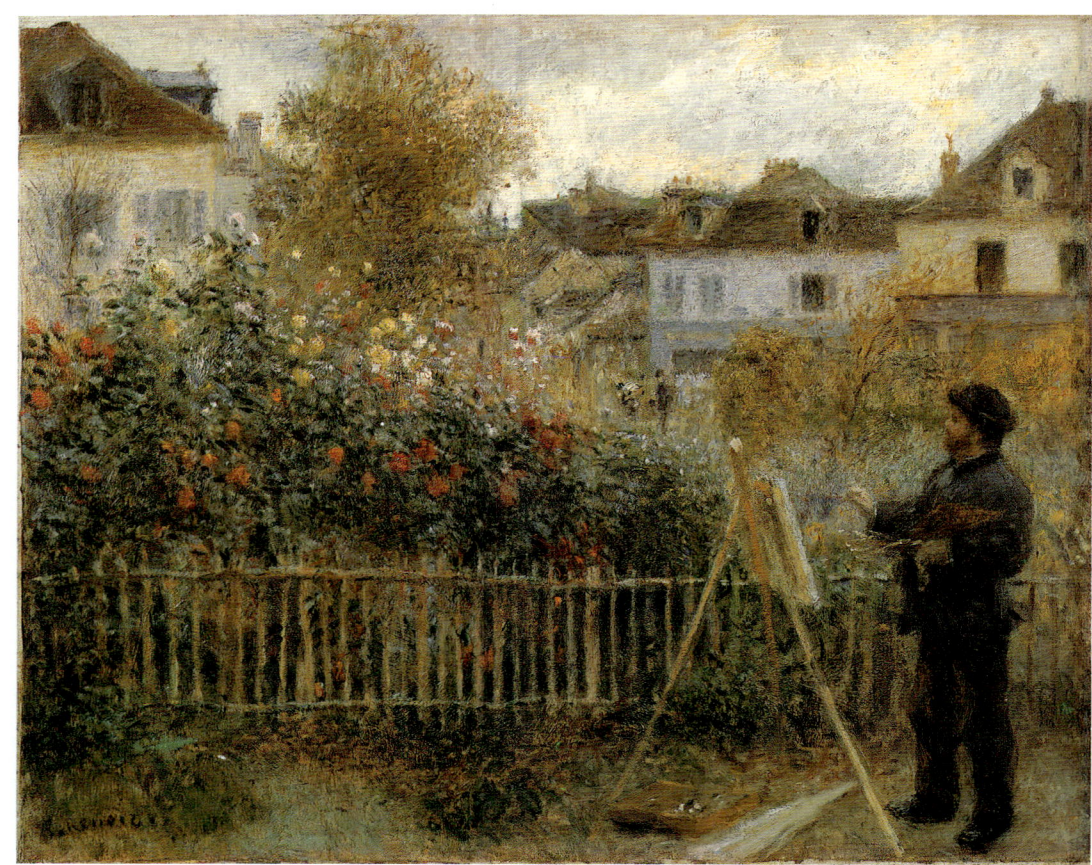

flict with the Parisian authorities over the huge deposits of fetid sewage accumulating along the Seine banks. Acrid smoke from the Argenteuil ironworks, the dust and dirt of house and road building, the proximity of neighbors' houses and gardens, are all carefully excised from Monet's pictures. Only in a few pictures is industrialization indicated. One such exception is *Train in the Snow* (page 60), with its temporary wooden fencing, recently planted trees and distant factory chimneys. Possibly painted at the station opposite Monet's house, it shows the train that he caught when he wished to visit Paris. This train passed through a large cutting before terminating at the Gare St Lazare and it was this unlikely setting that Monet chose for the series of pictures that are the consummate achievement of his mid-1870s work.

The *Gare St Lazare* (page 66) and the huge railway cutting bridged by the nearby *Pont de l'Europe* (page 68) represent Monet's last involvement with scenes of modern French urban life and his only protracted essay on mechanized progress. He explored in this series of canvases the mix of engine smoke and filtered sunlight in a cavernous glass shed that was as big as any cathedral. Effects altogether more complex than any combination of light, water and shadow on the Seine led in the best of these works to a much more heavily worked surface with rich scumbling and a dense accumulation of subtle additions and alterations. Exhibited as a group at the 1877 Impressionist Exhibition with Caillebotte's huge canvas of *The Pont de l'Europe*, they caused much critical comment, mostly approving. One anonymous critic singled out for particular attention 'the clamor' of the station that Monet showed. The reduction of individuals to crowds in these, and indeed all his Parisian views, is a characteristic distancing approach that Monet adopted toward metropolitan humanity and it separates his work from most other Impressionists, who painted close-up treatments of more intimate dance hall, café and sidewalk life as well as similar dispassionately distanced spectator views of the city.

Although Monet kept a small pied-à-terre in Paris until 1882 for showing canvases to prospective customers, he did not (perhaps because of the complexities of his personal life) take much part, as he had done before 1870, in the Parisian intellectual life of the Impressionist/Naturalist group, who now met at The Café de la Nouvelles Athenès in Montmartre. During the 1870s his friendship with Manet deepened and the latter stayed near Monet and painted at Argenteuil in 1873, for a while imitating Monet's paint handling. The links

forged with Pissarro remained close, as did his friendship with Renoir, but his greatest friend, Bazille, had been killed in action in the Franco-Prussian war. Monet's relationship with other exhibiting Impressionists has often been difficult to disentangle. Degas was wary of him and disliked his art, and later viewed him as unprincipled because of his decision to return to exhibiting at the Salon in 1880.

Monet was pragmatic about most matters connected with picture sales, and his reasons for exhibiting as an Impressionist were principally motivated by the scope this gave him to attract public attention. He had a similarly flexible approach with dealers. Although Paul Durand-Ruel was his main dealer, Monet, without a secure contract to guarantee income, also sold to other dealers and directly to individuals. By the time Durand-Ruel was financially stable enough to put him under contract, Monet had come to prefer his freedom to negotiate, at times setting one dealer off against another. He was also, to an extent, flexible about what he painted. Although never prepared to compromise his Impressionist/Naturalist practice he would when re-

quired bend to market forces, as can be seen, for example, with his magnificent series of still-life pictures, some of which Durand-Ruel included in the seventh Impressionist Exhibition of 1882. Because Durand-Ruel found these works easier to sell Monet obliged. In the process, however, he transformed his still-life practice beyond the traditional Chardinesque structures of his own earlier pictures and those of prevailing conventions. In canvases like the Hamburg *Pears and Grapes* (page 73), Monet tilted his tabletop and scattered fruit in an apparently haphazard way. The principles of still-life painting, even when applied by Realists like Courbet or Naturalists like Manet, had invariably explored objects within clear architectonic relationships. Monet's variations in still life at this period paralleled Cézanne's preoccupations at the same time. However these interesting pictorial possibilities were not further explored and it remained an innovative

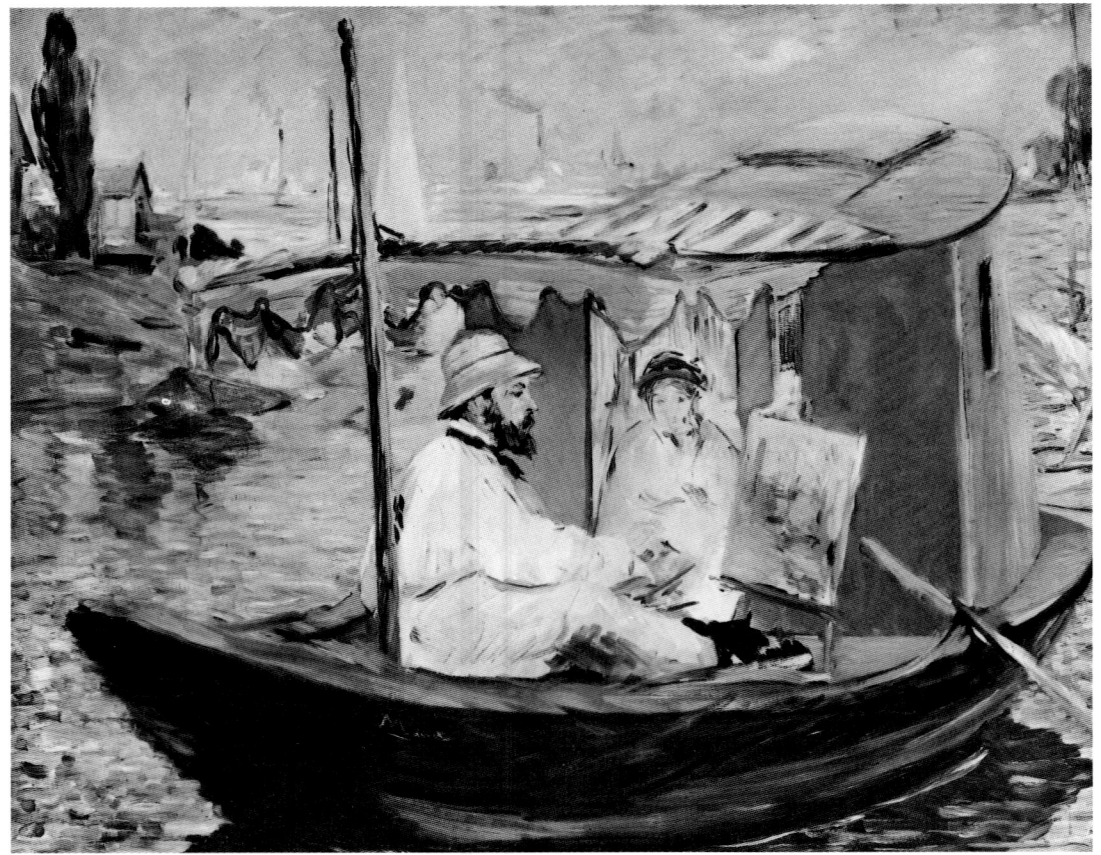

pressionism's instantaneousness, sought to combine something of the heroic monumentality and order of the traditional depiction of the female nude with the thoroughly modern subject of Parisian women bathing. Renoir experimented from about 1884 with a hard linear paint handling for largescale studio-posed pictures of nude bathers which harked back to classical painting and sculpture. Cézanne, although basing his landscapes upon natural motifs, began to use his distinctive vocabulary of faceted and overlapping planes in his pursuit of pure structure within Nature. Among younger artists broadly sympathetic to Naturalism but also aspiring to order and *gravitas*, the most serious critique of Monet's practice was Georges Seurat's development of Pointillism. Using tiny dots of unmixed color to construct large studio-painted pictures, Seurat tried to establish a complete set of 'scientific' rules for picture making that took account of the various laws of color and optics as well

Above Manet's *Claude Monet in his Studio Boat*, 1874.
Below Caricature of the seventh Impressionist Exhibition, 1882, including two Monet still lifes.
Right Seurat's *Seascape at Port-en-Bessin, Normandy*, 1888.

cul-de-sac in his work which did not reinform his art again until the more arbitrary smaller waterlily pictures that he painted from about 1915 onward.

The search for alternatives in the 1880s

The early 1880s have often been characterized as bringing crisis for Monet and Impressionism. Painting the fleeting appearance of nature brought criticism from those demanding greater system in a picture. Cézanne's comment on Monet that 'he is only an eye but my God, what an eye' was a back-handed compliment. It hinted that Impressionism risked becoming an 'idiot eye', displacing the more cerebral organization of forms, or denser emotional resonances, in a picture.

We now know of course that Monet took enormous care selecting motifs, was not above editing out interfering details, and tuned up his works away from the subject, but he played down any such intellectual input into his art. As late as 1880, when a magazine interviewer asked him about his studio, he angrily denied ever having or needing one; he liked to keep up the myth of his own apparently complete sponteneity.

The growing quest to make Naturalism more intellectually rigorous affected several of the exhibiting Impressionist group, which in turn affected Monet. Degas, who had always disdained Im-

18

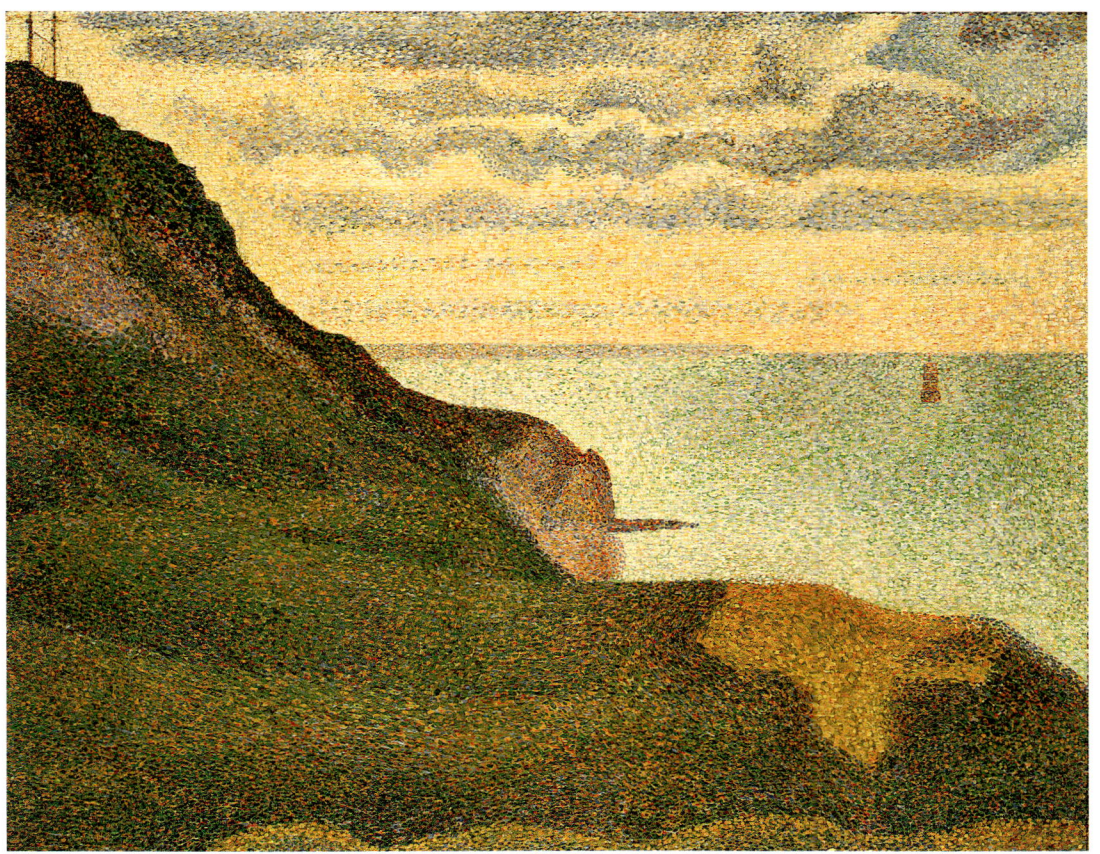

as the conditions that governed human vision. His aim was partly political, in that he wished to establish a grammar of certainty for making, teaching and looking at art that could be available to all classes of society. This essentially Positivistic and optimistic ambition won him a disciple in Pissarro, who gave up the touch of Impressionism for the self-effacing democratic dot of Pointillism. Monet's refusal to exhibit at the eighth and last Impressionist Exhibition in 1886 was partly prompted by his opposition to showing alongside Seurat. He did, however, under these various pressures seriously rethink his own art and the 1880s were for him a period of experimentation, in which he was forced to reconsider the place that order might have in his work.

During the 1880s Monet traveled widely seeking out more complex and extreme natural effects, from Norwegian snowscapes to the bright harsh light of the southern French coast. Characteristic of much of his work from 1882 onward is a calculated selection of simple motifs and a pictorial organization that gives less emphasis to traditional recessional space. The first compositions by Monet that seem to depend closely on Japanese prints for inspiration date from this period. Although earlier examples can be found of cropped foreground figures, occasional looming frontal motifs and dramatic shifts of viewpoint, his earlier landscapes tend on the whole to lead the spectator's eye comfortably into the view as though down a pathway. Unlike, for example, Degas and Manet, Monet did not experiment with flat Japanese-inspired black-oulined figures against flatter backgrounds. His one unsystematic exercise in this figurative vein was the 1875-76 *La Japonaise* (page 59), which sets a blond-haired kimono-clad Camille within a thoroughly western piece of spatial setting. Later dismissed as second-rate work by Monet himself, it was a somewhat cynical attempt to exploit the fashion for Japanese paraphernalia and does little to explore rigorously alternative spatial possibilities.

Japanese landscape prints were altogether more important reference points for Monet than actor or courtesan prints. In, for example, *The Church at Varengeville* of 1882 (page 76) the shift required of spectator vision from the dark foreground bluff and two trees to the pale and tonally unified sky, sea, church and cliff uses a pictorial device reminiscent of several Hokusai and Hiroshige views. Similarly *the Cliff Walk*, *Pourville* (page 78), painted while on the same trip, also invites the spectator to 'leap' the foreground cliff toward sea and sky beyond. These Channel pictures also share a tilting up of the land mass toward the picture surface which produces a viewpoint similar to that of his 1879-80 still-life pictures. In both there is also a contrast of texture between looped and coiling foreground paint-strokes and the horizontal overlapping background strokes – a contrast that works against pictorial integration.

A further change of facture is evident in the 1886 *Pyramides at Port-Coton* (page 84). Although again setting up a textural contrast between the modulating vertical brushwork of upright rocks and the curved and paralleled strokes of the sea, there is now a greater all-over integration of picture surface. A complex web of green and pale blue strokes knits all together. There is nothing especially novel about such integration; setting up tautness throughout a picture surface, whether through tone or repetition of a particular color, was part of a painter's traditional arsenal. It is, however, an organizational device that becomes particularly evident in these works because of the simplicity of subject matter.

Figure painting had not interested Monet since about 1873, but from the mid-1880s he returned for a few years to the subject with a series of works painted in the landscape of the Seine valley, around his new home at Giverny, to which he had moved in 1883. Showing his own and Alice's children, the balance of importance between figure and landscape in these pictures is usually about equal. Just as in earlier views at Argenteuil Camille had tended to look rather ethereal, these images, which include *Boat at Giverny* (page 82), show faintly lugubrious figures drifting within the landscape. They incline towards the same Whistlerian atmospherics as his 1870 view of Parliament. He may have been exploring a further kind of integration through a re-examination of an earlier experiment in harmonies.

Monet's Mediterranean pictures, which include *Bordhighera* of 1884 and *Stone Pine at Antibes* of 1888 (page 86) differ from his northern French seascapes of this decade. There is an intense contrast between foreground and background color, with the antithesis between blues and pinks particularly marked. These exaggerated color contrasts inform subsequent northern pictures painted after 1889. Greater use of lilac, purple and pink, and a veering towards china and wedgwood blue as well as a heightened use of lime greens, suggest that Monet was setting up possible balances and color contrasts on his palette to respond to the motif in an organized, even a premeditated, fashion.

The series pictures 1891-1912

These various experimentations with space, color, texture and motif helped

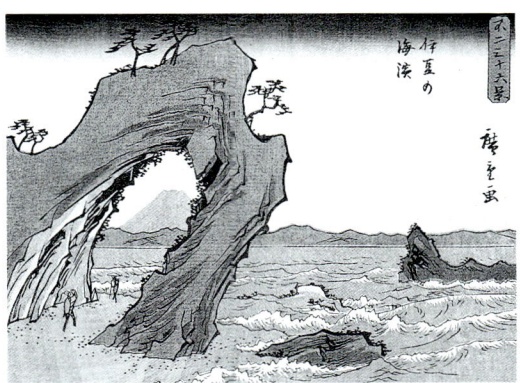

Above Hiroshige's woodcut of *The Seashore at Izu* bears a strong resemblance to Monet's simple dominant cliff motifs.

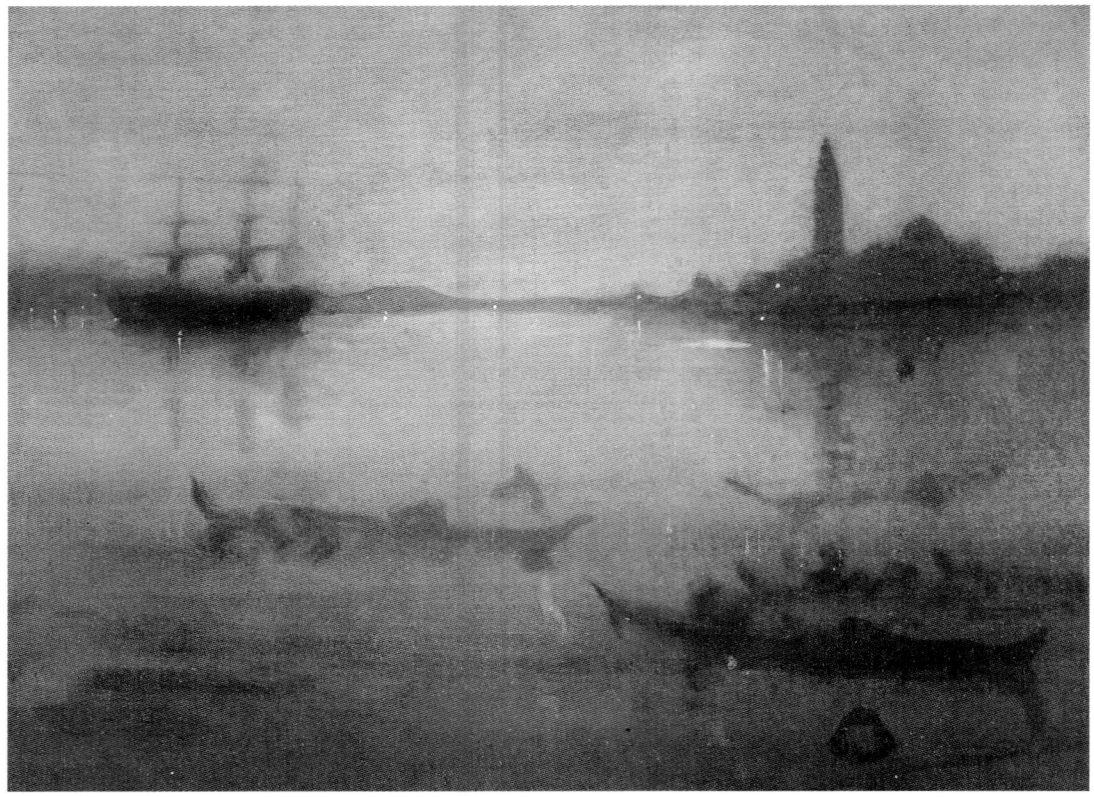

generally with the nostalgic peasant subjects, but any more extended political and social meaning seems unlikely.

The Waterlilies 1899-1926

From the late 1880s Monet spent more time at his home at Giverny. He bought the freehold to his property for 80,000 francs in 1890 and could afford to purchase extra land and expensive plants, to employ gardeners and to enlarge a pond to accommodate a Japanese-inspired waterlily garden. For the last three decades of his life, apart from a group of paintings of London exhibited in 1904 (page 96, 98) and the Venetian subjects shown in 1912 (page 100, 102), the pond and its glorious flowers became the principal focus of his art.

Monet's first exhibited waterlily paintings were the group of twelve shown at Durand-Ruel's in 1900, which included the National Gallery's *The Japanese Bridge* (page 97) of 1899. Collectively this group shows a far greater concern with depth and tonal contrast than the *Grainstack*, *Rouen*, and earlier 1890s pictures and has a rather friable paint surface. The foreground-dominating bridge, without visible bankside means of support, has the same insistent frontality as the earlier *Four Poplars* (page 89) but there is in this and related pictures an almost conventional use of left- and right-framing aquatic plants and centred spectator viewpoint, akin to earlier pictures of the 1870s.

Substantial modifications characterized the second waterlily series of 48 works, collectively shown in 1909 as 'A Series of Water Landscapes' and including pictures painted between 1903-1908. *Waterlilies*, 1905 (page 104), rather than taking a bankside view, now suggests looking downward from the bridge toward the surface of the water. These edgeless compositions still retain sufficient recessive diminution of scale and tonal contrast to be read as space treated in depth. Instead of the multi-directional paintstroke and encrusted surface facture of the earlier series, there is now an altogether more liquid use of dilute glazes, and a surface build-up achieved with long horizontal gestural stroking of paint — at times the medium approximates to the properties of water itself.

In later canvases, which include the *Waterlilies* of 1916 (page 106), Monet further modified his approach to include an eyelevel view of water, with minimal tonal differentiation and a deliciously

Monet work out for himself a new painting practice, culminating in his most important development in the late 1880s, a gradual evolution toward working in series. In a sense this had always been implicit in his art, from early days at Chailly when he painted paired views of the same subject at different times of day or season, but now he began to make several repetitions of exactly the same motif under differing light. Never keen on theory and not prepared to say much more than that he was trying to do something with more serious qualities, Monet certainly would never have described his new approach to painting in series as being scientific or in any sense a riposte to Seurat — but for all that, it was.

What Monet revealed in his exhibition of fifteen *Grainstacks*, shown at Durand-Ruel's gallery in 1891, was that by taking a microcosmic approach to Nature and affirming the transience of its appearance with a very simple motif under widely varying light, he was bringing to the spectator confronted by the whole series an extended temporal experience of the mutability of Nature. This was as 'scientific' a pictorial response to Seurat as Impressionism could make, re-affirming its central tenet through the vehicle of subtly modified repetitions. However, it was of course no longer Impressionism.

In order to achieve the complex *envelope* of object, atmosphere and light that was characteristic of each specific effect in the series, Monet was obliged to work at length in his studio, adjusting the relationships between canvases so that they read as a coherent ensemble. Monet of course never saw, even for a fleeting moment, the *Grainstacks* as depicted in each individual canvas, and

the same is true of the magnificent *Rouen Cathedral* series of 1892-94 (pages 90, 93). Human vision simply does not function like this, unless seeing through thick glass of differing hues. Each canvas is an exquisite, exaggerated, individually organized harmony of elaborate colors in which the object is subordinate to the effect. How, with these canvases, the fiction of Monet's continued verisimilitude was maintained in the face of such obvious subjective colorific lyricism is one of the most extraordinary contracts that an artist was able to keep with his devoted public. It is true that Monet continued to paint in front of the motif, that his pictures were broadly grounded in the form and colors that he saw in front of him, and that our own visual experience finds a kind of correspondence between the works and changing light, but they are, in the same way as Hokusai's famous views of *Mount Fuji* to which they have so often been compared, not so much nature seen as nature transformed into pure artifice.

The debate about any wider intention that Monet had in the *Grainstack* and *Rouen* pictures has recently focused on a possible patriotic symbolic connection linking Rouen, as a symbol of French cultural continuity, with the grainstacks, as a metaphor for the country's life expressed in its agriculture. Paul Hayes Tucker suggests that the cathedrals and grainstacks would have carried cultural resonances for a sophisticated Frenchman connected with the defeat of the French by the Prussians in 1870 and the subsequent lack of political and social unity. Monet must have known that the *Grainstacks* would be linked in particular with Millet's pictures of similar stacks and his famous *Gleaners*, and more

Above Whistler's atmospheric London and Venetian subjects influenced Monet's later Rouen Cathedral and Thames series.
Right above Monet in his specially built studio, c. 1920.
Right below Monet in the famous garden at Giverny.

were gifted to the French nation and are now installed in two circular rooms at the Orangerie of the Tuilleries in Paris. They have been described by André Masson as the 'Sistine Chapel of Impressionism' and are the crowning achievement of Monet's career as an artist. They wonderfully confirm the praise that Manet had used for his work half a century before, when he described Monet as the 'Raphael of Water'.

In his old age Monet was one of the most photographed of artists. Many friends, admiring artists and international collectors made the pilgrimage to Giverny to see the grand old man of French painting. Several photographs and one film show him at work, tweed-suited and cigarette-smoking, in his garden or studio. Others show him relaxing with the prolific progeny of Alice's children, or on trips to the races with his chauffeur in his motor car. Unlike Degas, whose natural pessimism combined with social isolation and blindness to make his last years miserable, Monet's old age was domestically secure, and despite sporadic depression he remained fundamentally sociable.

Alice died in 1911, and his own son Jean followed in 1914. In 1912 Monet was diagnosed as having cataracts in both eyes, which progressively worsened until he underwent a partially successful operation in 1923. He rose above these personal tragedies to produce in his late

Left Monet owned a print of Hiroshige's 1857 woodblock *Wisteria*, which influenced his own Japanese garden.
Below *Rain, Steam and Speed*, 1844; Monet's paint handling from about 1895 betrays Turner's influence.
Right above Monet's *Waterlilies* in the Tuileries.

free calligraphic use of paint. With these pellucid images it is difficult at times to decide whether one is looking downward at lilypads afloat on a pond or upward with a carp's eye view of the surface, so immersed does vision become in aquatic limpidity.

Monet's friends included Georges Clemenceau, the politician and journalist, who advocated in 1894 that the French nation purchase the *Rouen Cathedral* series and keep it together. Clemenceau suggested that it was in conversation with him around 1912 that Monet first voiced his desire to enlarge his waterlily series to include an ensemble for display in a circular room. Between 1914-16 Monet rebuilt his studio to accommodate enormously long canvases. At what point he decided that this ensemble might act as a potential celebration of post-war peace is unclear, but these works had his almost undivided attention for several years. In 1921 they

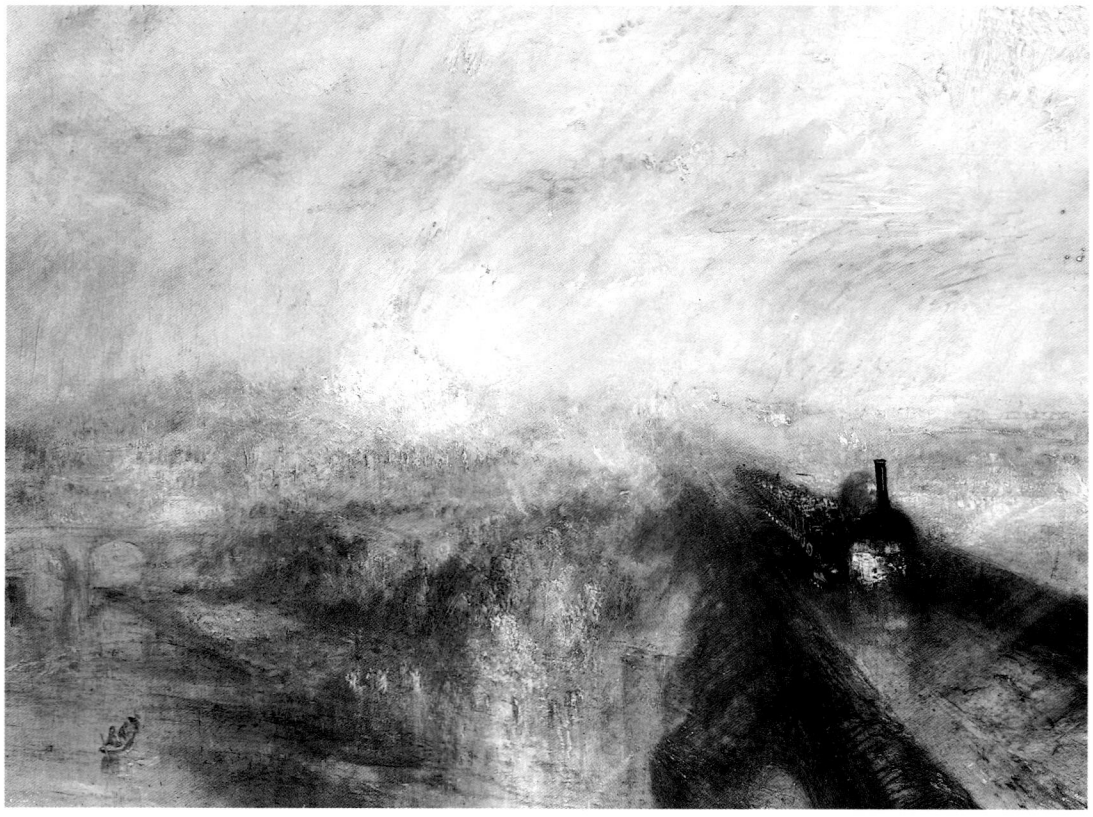

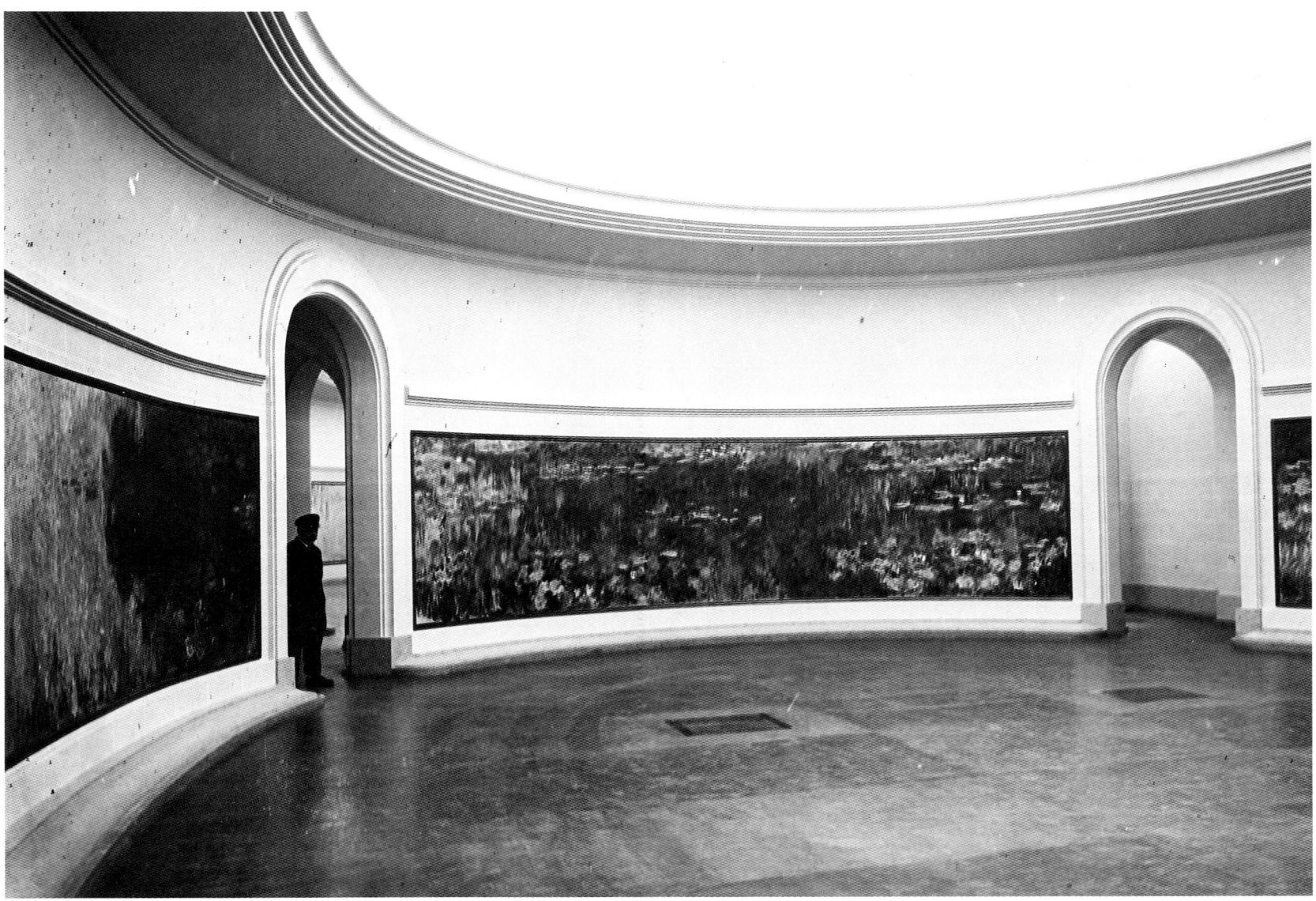

seventies and early eighties a group of pictures that represent for many one of the most optimistic pictorial celebrations of mankind's love for nature. Late and great pictures by Michelangelo, Titian, Rembrandt, Goya, Turner and others so often unhappily suggest human frailty and man's mortality. Monet, despite all his setbacks, had the extraordinary confidence to transmute the beauty of water and waterlilies into Hope itself.

Postscript

Estimation of Monet's overall significance as an artist subsequent to his death in 1926 tended initially to be reserved. While his works were popular and well collected they did not sell for really high prices. Average prices for Monet at auction in the mid-1920s were approximately £1000, while for Manet and Degas the figure was on average approximately £3000, and for Renoir an average of £6000. The sheer quantity and variable quality of his output partly contributed, as did collector's preferences for busier Impressionist pictures which included more people. Renoir's charm was more obvious, Manet and Degas were more traditional. Monet's standing seems also to have been affected by the view that his early Impressionist pictures were intellectually

lightweight and that his later pictures were too unstructured and 'decorative'.

The prevailing climate among artists of the various strands of the inter-war avant-garde was also inimical to Monet's art. Cubism, Constructivist abstraction, Social Realism and Surrealism each promoted an aesthetic that was more measured, linear, formal, committed or psycho-dramatic. It was not until the 1950s that Monet's art, and in particular his later paintings, began to be treated more seriously, prompted partly by the development of American Abstract Expressionism. An avant-garde movement that celebrated artistic gesture allied to feeling, in large color-field pictures, found a pedigree for its own pictures in the 'all-over' canvases of late Monet.

Our own Post-Modernist critical climate, hostile at times to the very notion of avant-gardism, has been benignly tolerant of Monet's art. Partly because he was a lifelong socialist, Monet shares with the anarchist Pissarro and the syndicalist Seurat an affectionate place in the feelings of those critics and teachers whose radical judgments are usually less mercifully bestowed upon nineteenth-century artists who worked within a bourgeois environment. Also, possibly because of the general absence of figures, clear narrative or evidence of

nude modelling, Monet has not to date, like Degas or Manet, been the subject of close and critical feminist art-historical scrutiny. The intellectual stature of his art has in general advanced. Contrary to earlier views there is now an increasing tendency to try and see his work, particularly the post-1880 pictures, as metaphors for particular emotional states or as controled orchestrations of viewer emotion. Although John House, the most important contemporary writer on Monet, disagrees with any such claim, others including Richard Wollheim argue otherwise. Wollheim believes that the most distinctive quality in Monet's later works is their capacity to evoke in the spectator a sense of human vulnerability and tenderness.

To celebrate the one hundred and fiftieth anniversary of Monet's birth, major exhibitions were held in Europe and the United States. Aside from general enthusiasm and critical acclaim, an interesting feature of public response was the considerable number of artists who were vocal in praise of Monet and saw his art as directly relevant to their own pictures. This was all the more surprising given their diversity of styles, and is perhaps the best evidence that Monet's influence will continue to be fertile and to provide varied sustenance for future artistic modernity.

24

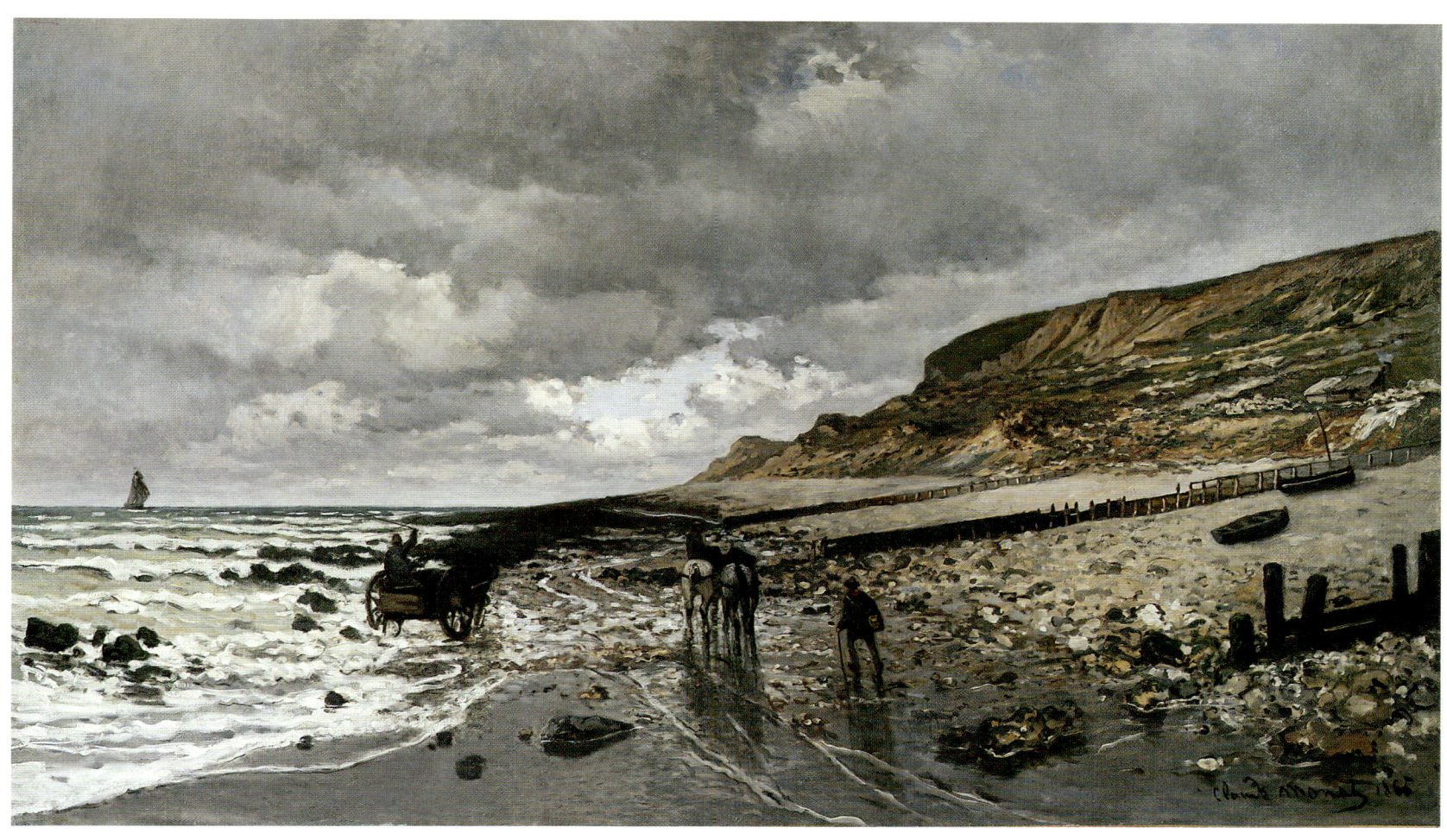

La Point de la Hève at Low Tide 1864-65
Oil on canvas
35½×59¼ inches (90.2×150.5 cm)
Kimbell Art Museum, Fort Worth, Texas

Corner of the Studio 1861
Oil on canvas
72×49½ inches (182×127 cm)
Musée du Louvre, Paris

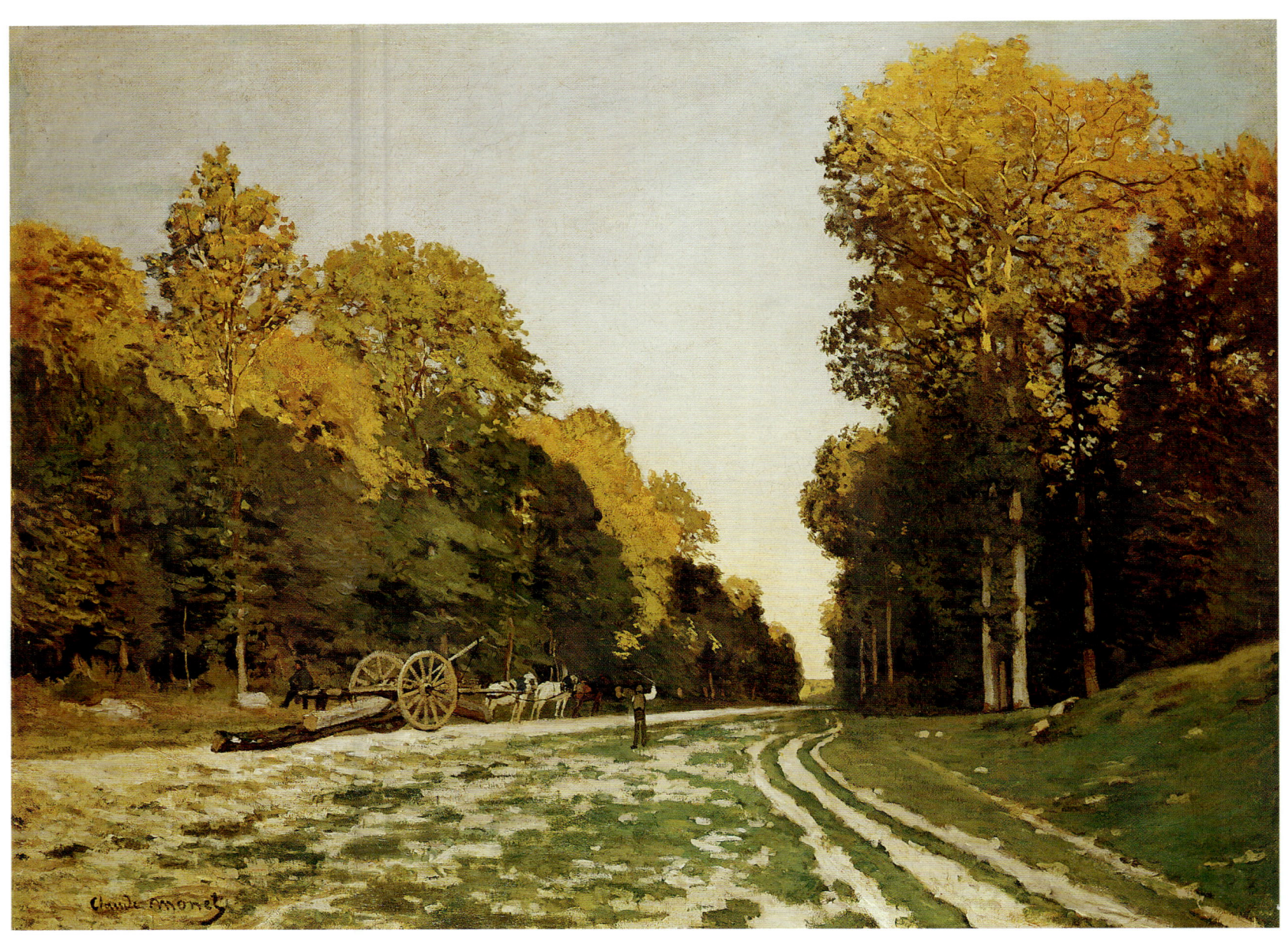

The Road from Chailly to Fontainebleau 1864-65
Oil on canvas
38½×40½ inches (98×103 cm)
Private Collection

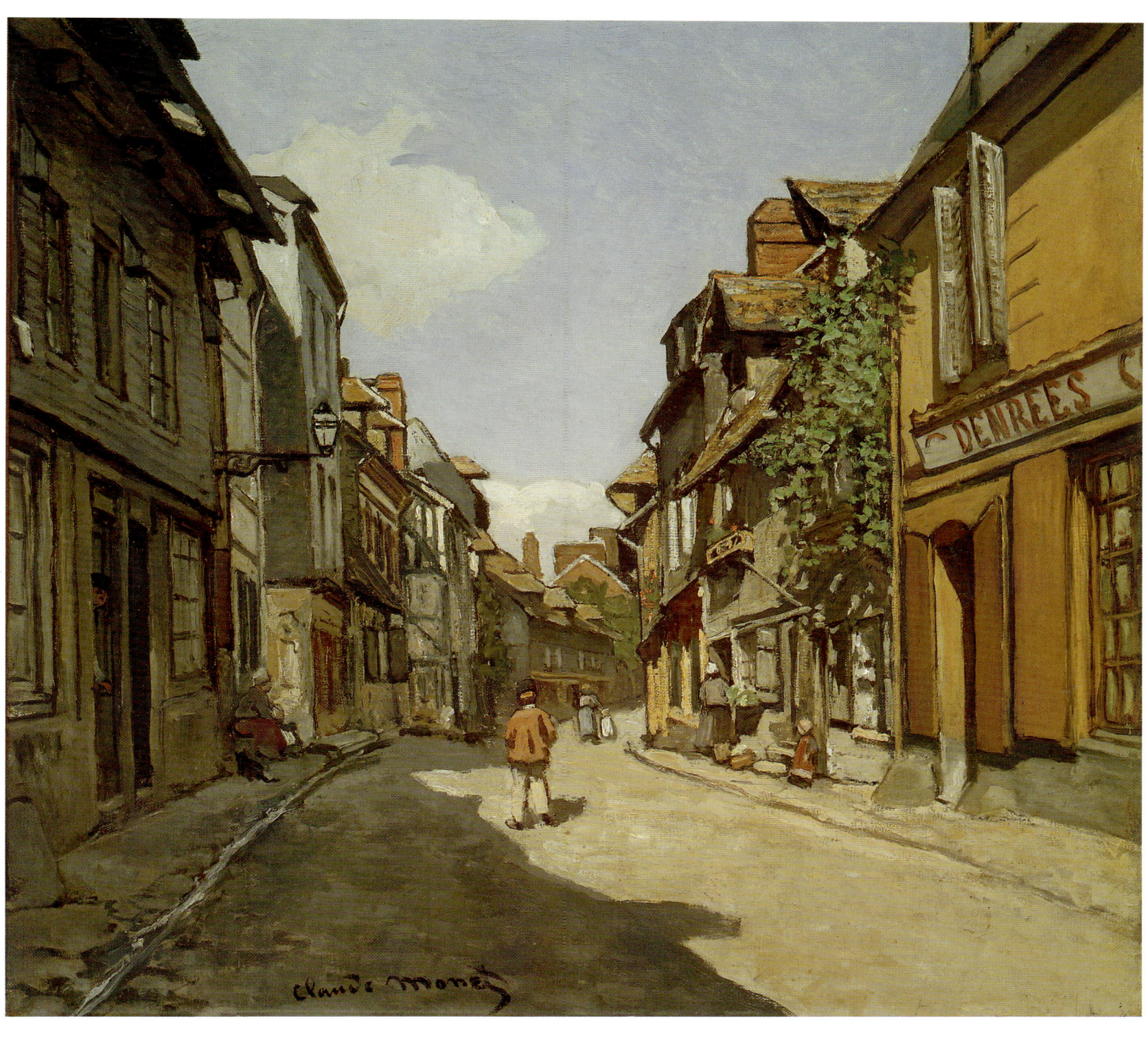

Rue de la Bavolle, Honfleur 1864
Oil on canvas
22×24 inches (55.9×61 cm)
Museum of Fine Arts, Boston, Bequest of John T Spaulding

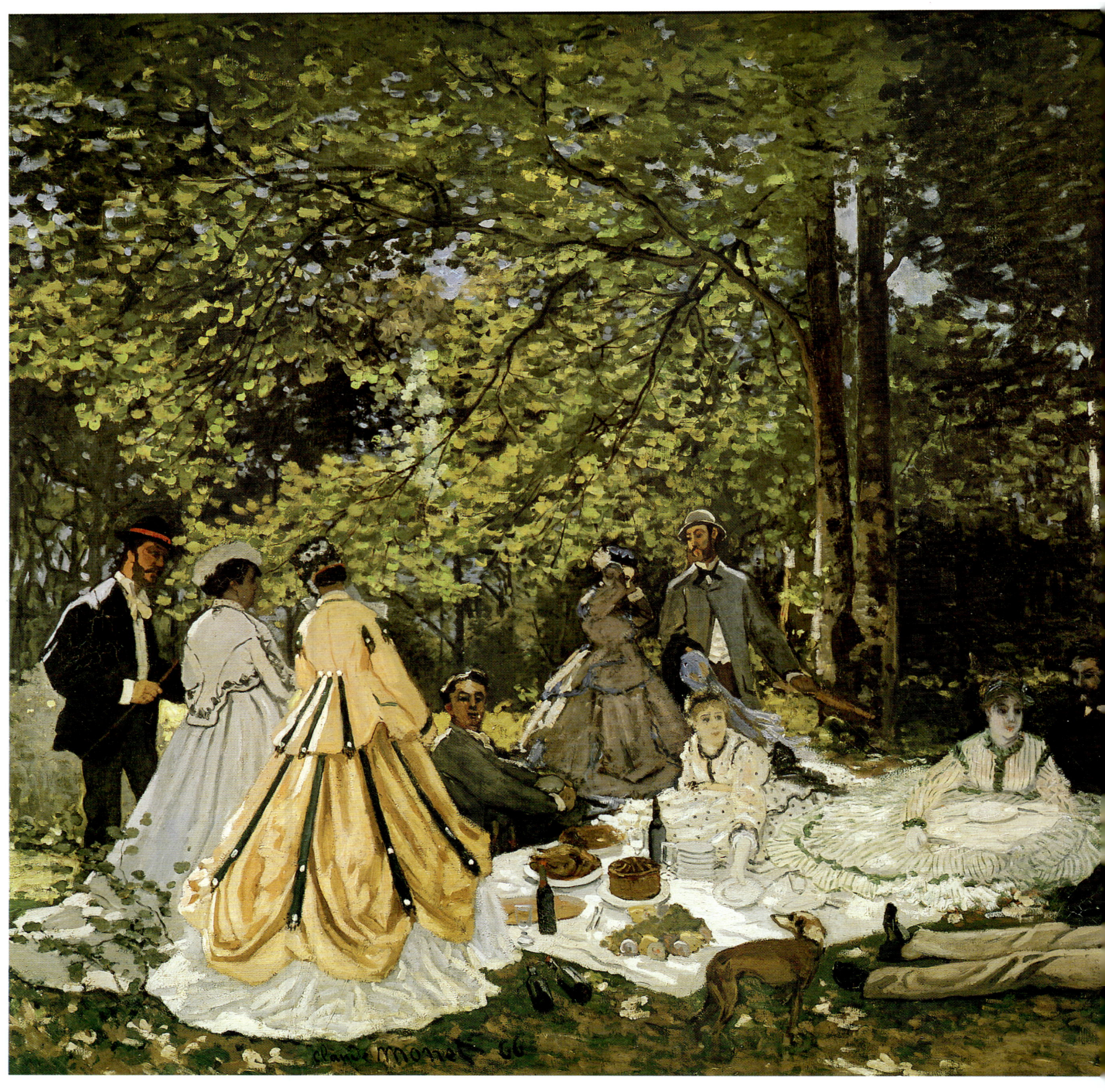

Le Déjeuner sur l'Herbe (final study) 1865 (dated 1866)
Oil on canvas
51¾×71¼ inches (130×181 cm)
Pushkin Museum, Moscow

Camille (The Green Dress)
1866
Oil on canvas
91×59½ inches (231×151 cm)
Kunsthalle, Bremen

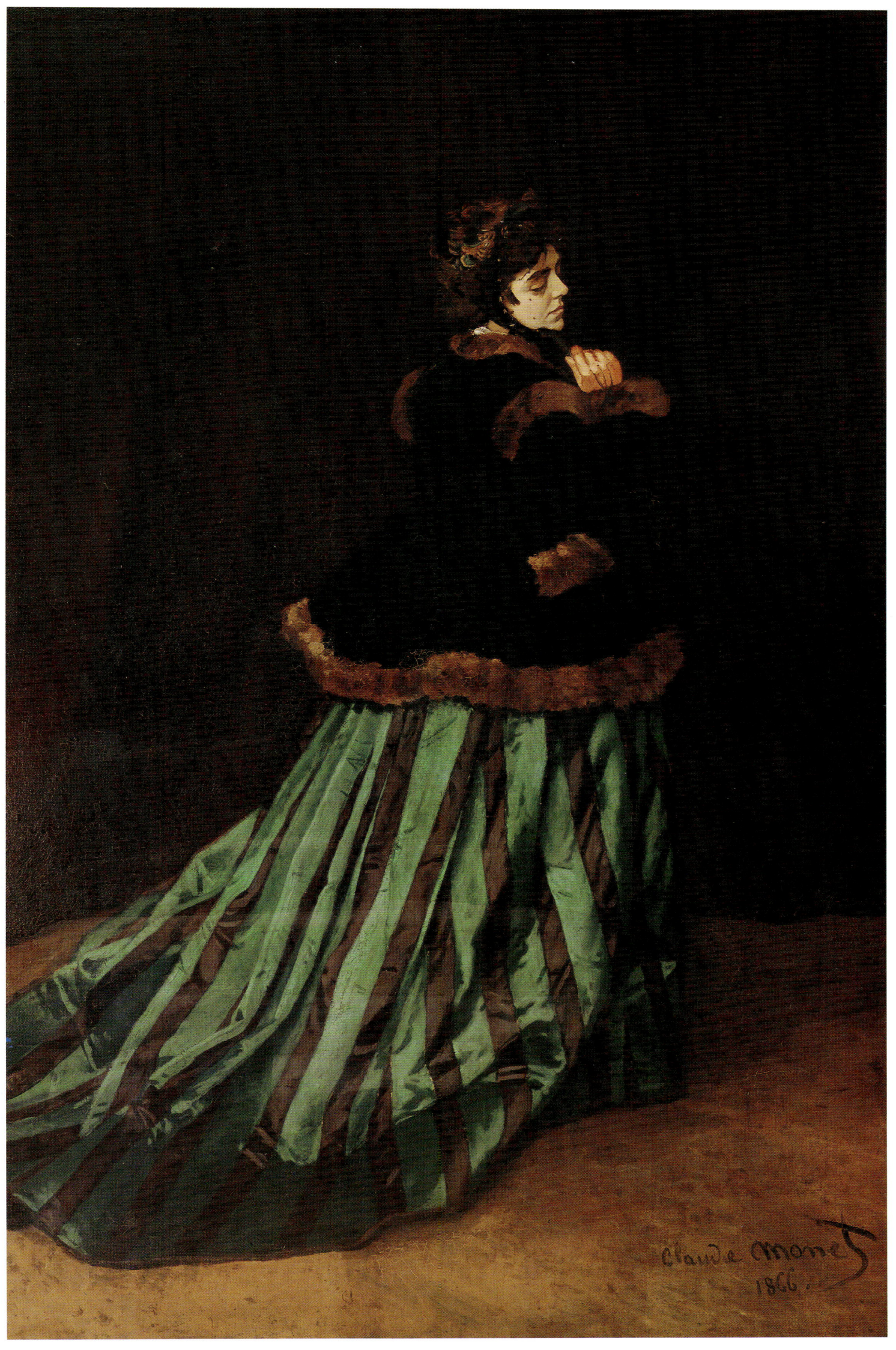

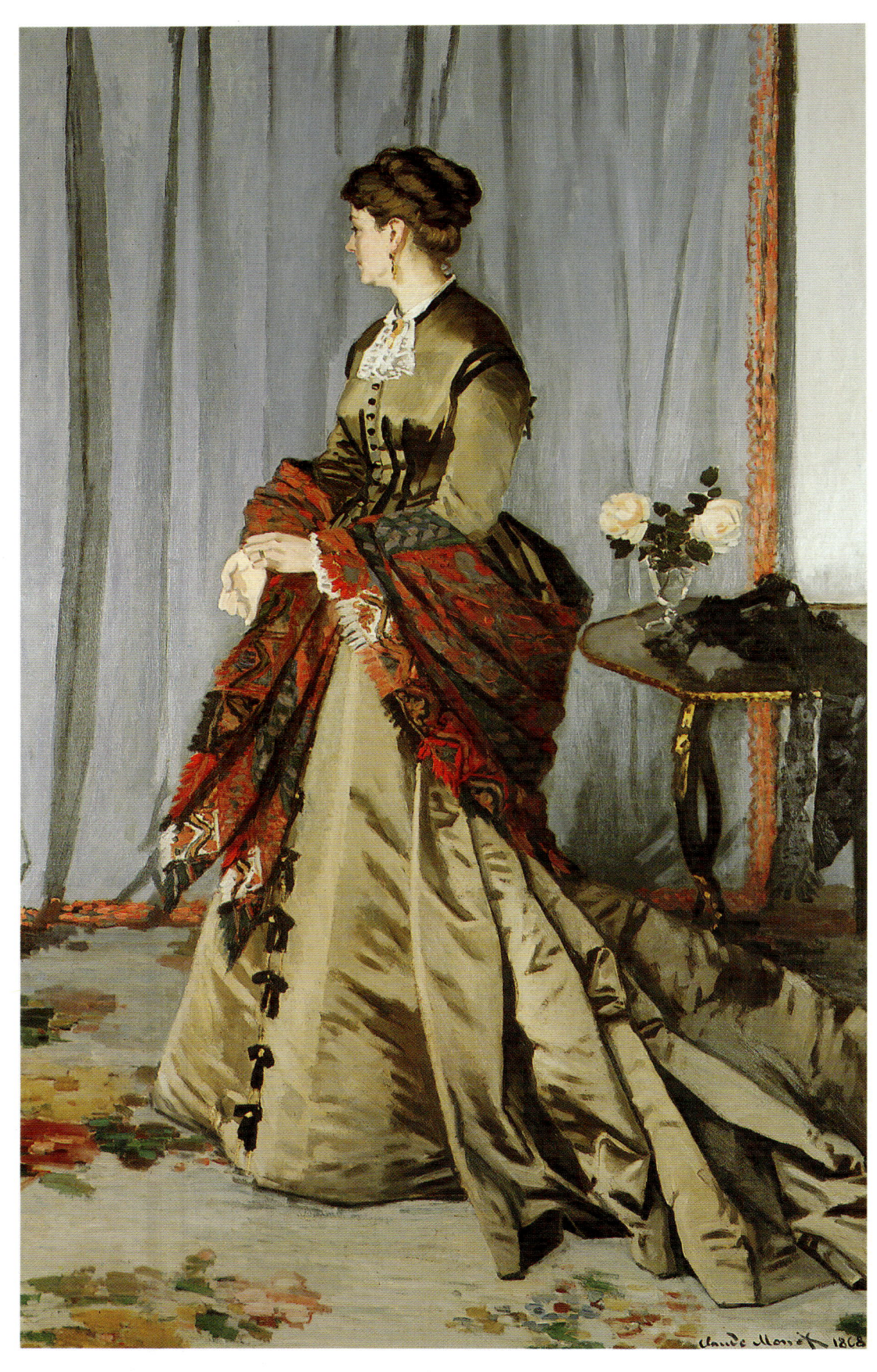

Madame Gaudibert 1868
Oil on canvas
85× 54½ inches (215.9×138.4 cm)
Musée d'Orsay, Paris

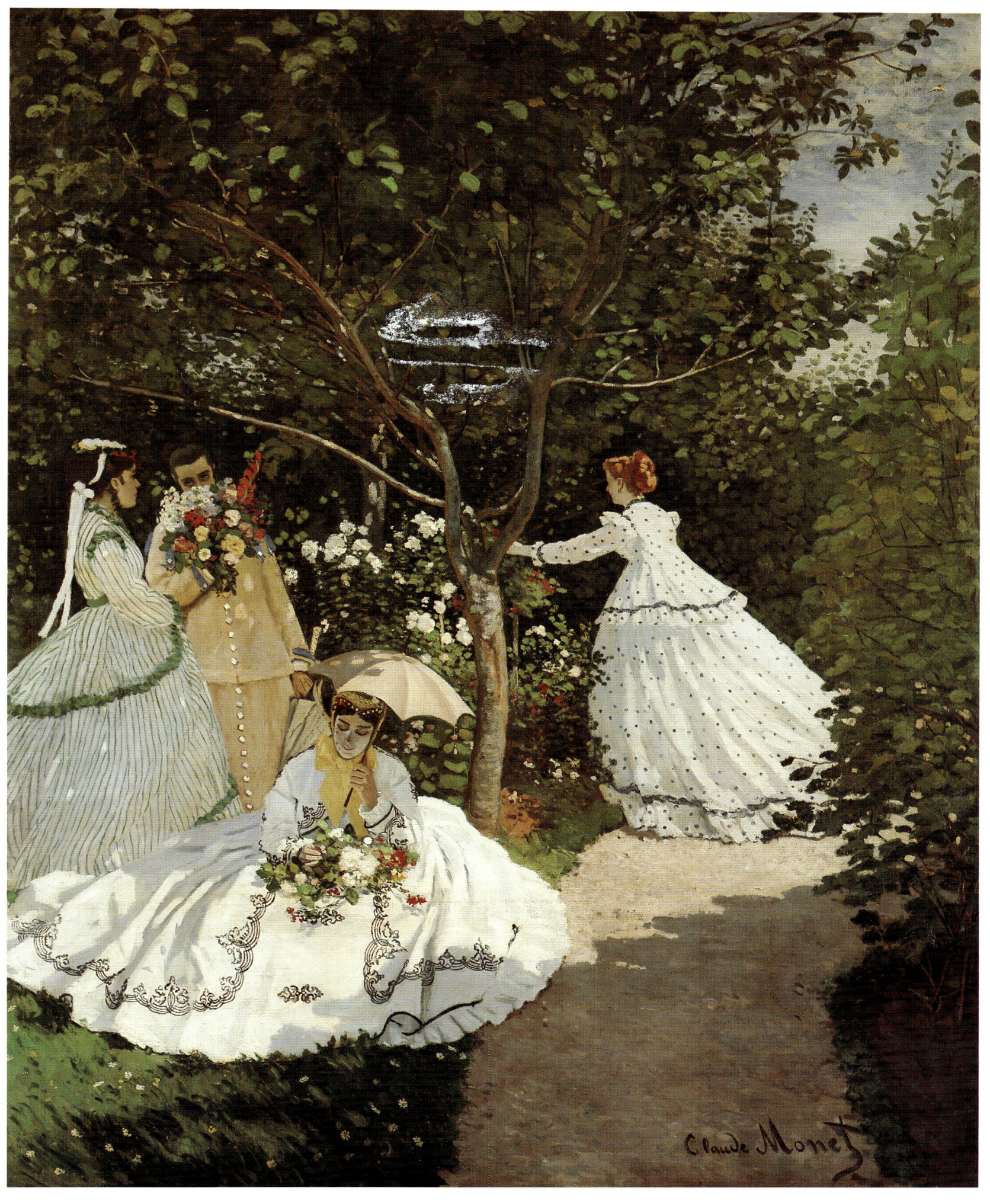

Women in the Garden 1866-67
Oil on canvas
100½×80¾ inches (255×205 cm)
Musée d'Orsay, Paris

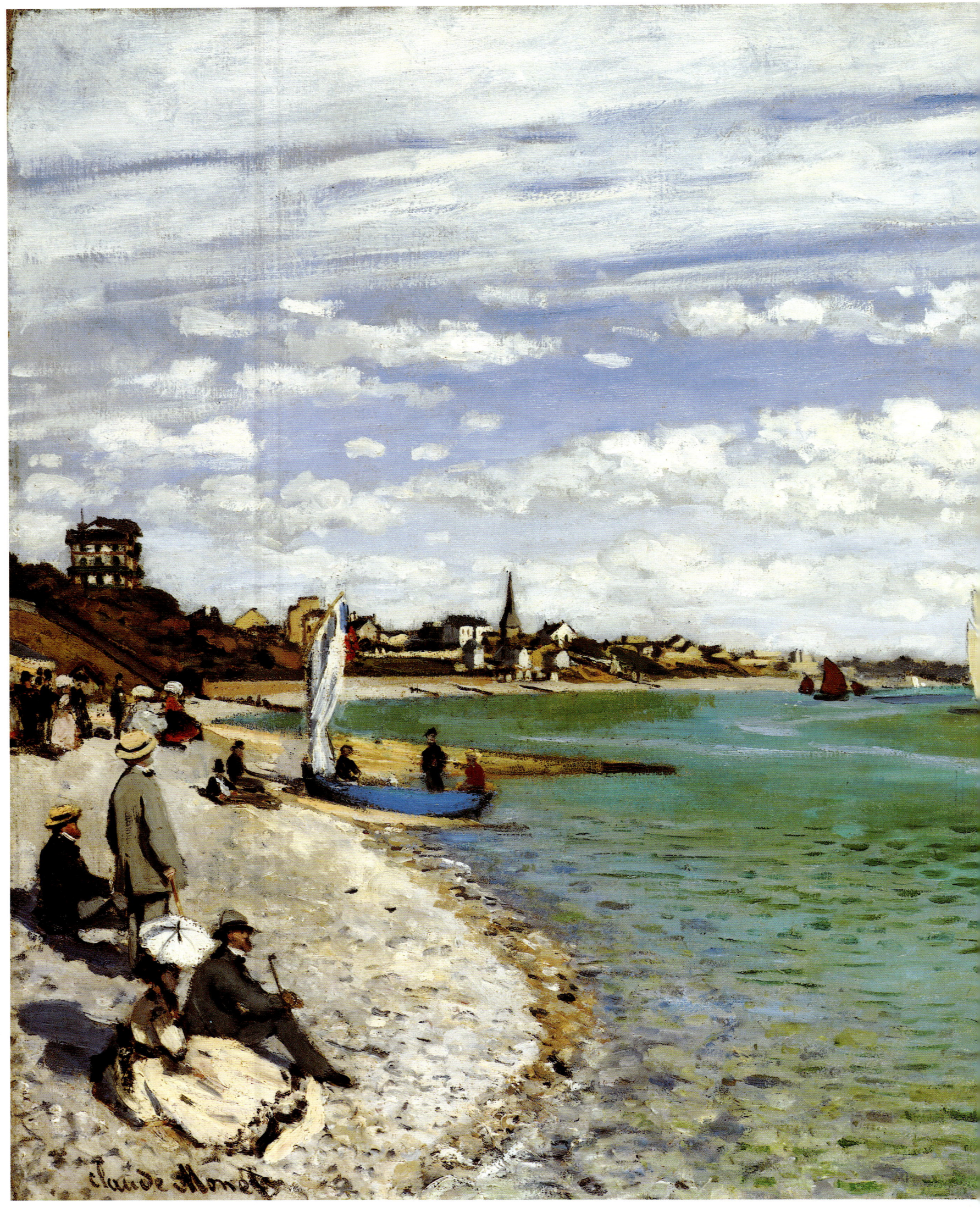

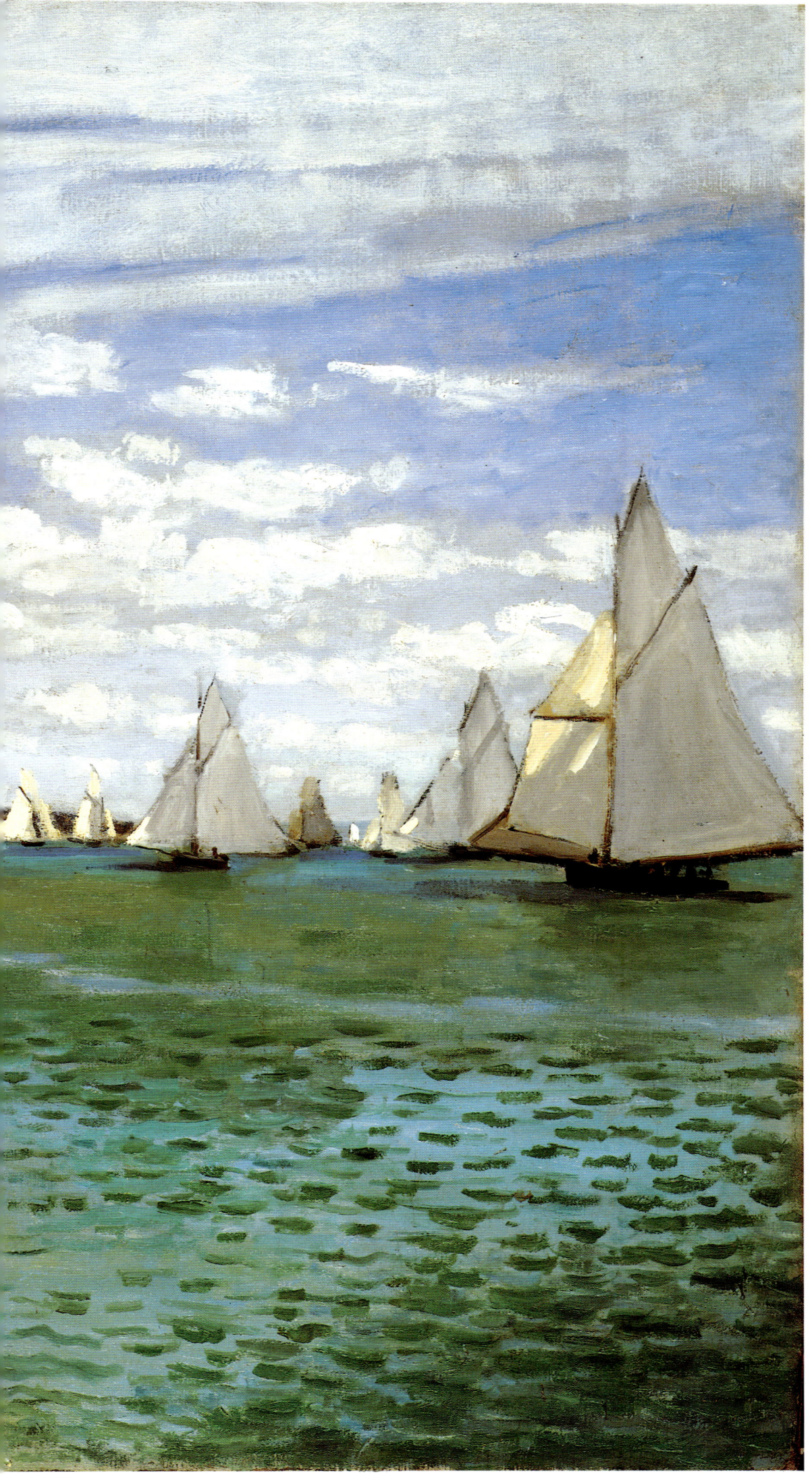

The Beach at Sainte-Adresse
1867
Oil on canvas
29¾×40 inches (75.3×101 cm)
Metropolitan Museum of Art, New York

Overleaf, left

The Luncheon 1868
Oil on canvas
90½×59½ inches (230×150 cm)
Städelsches Kunstinstitut, Frankfurt

Overleaf, right

The Garden of the Princess
1867
Oil on canvas
35¾×24 ½ inches (91×62 cm)
Allen Memorial Art Museum, Oberlin, Ohio

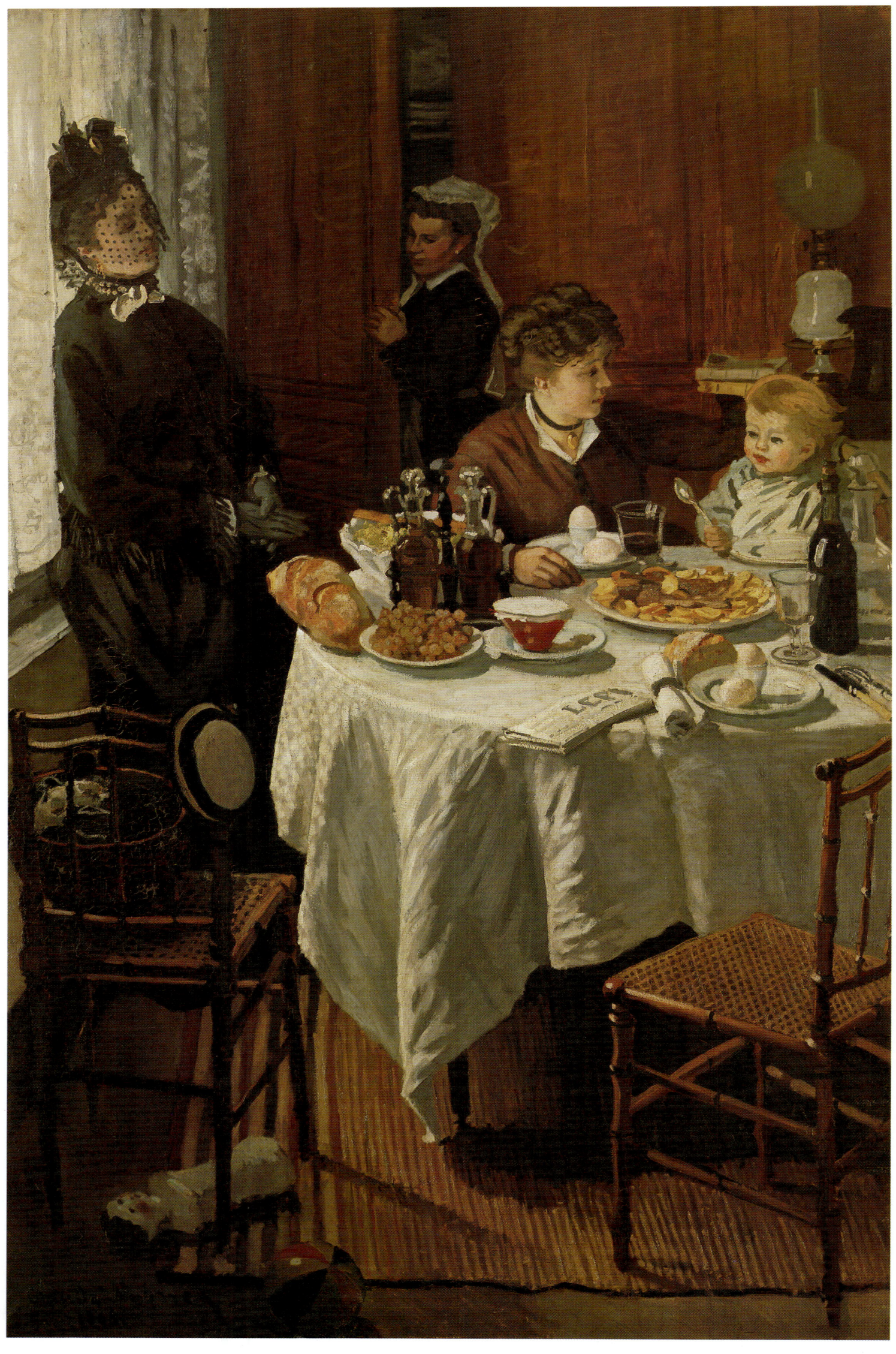

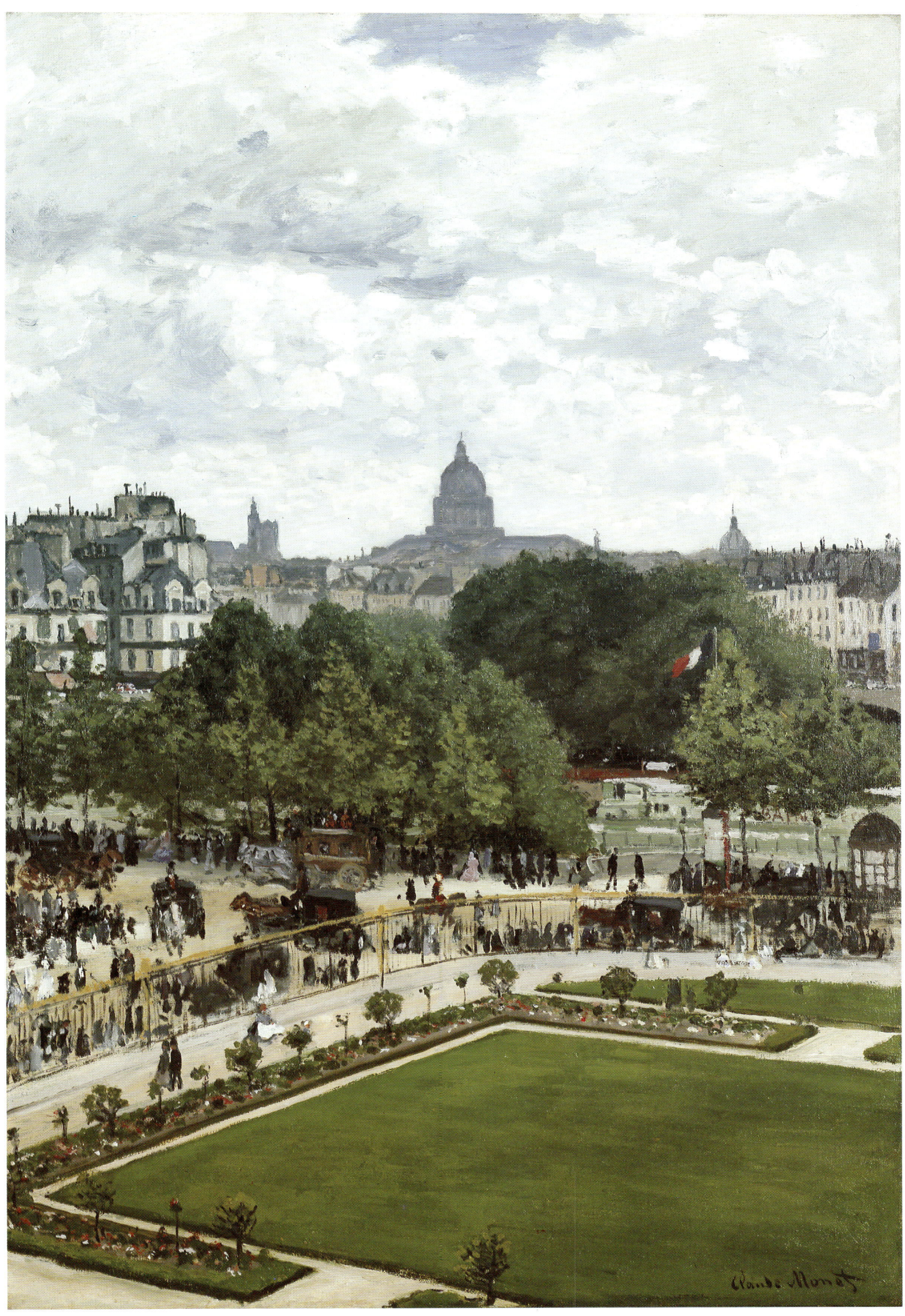

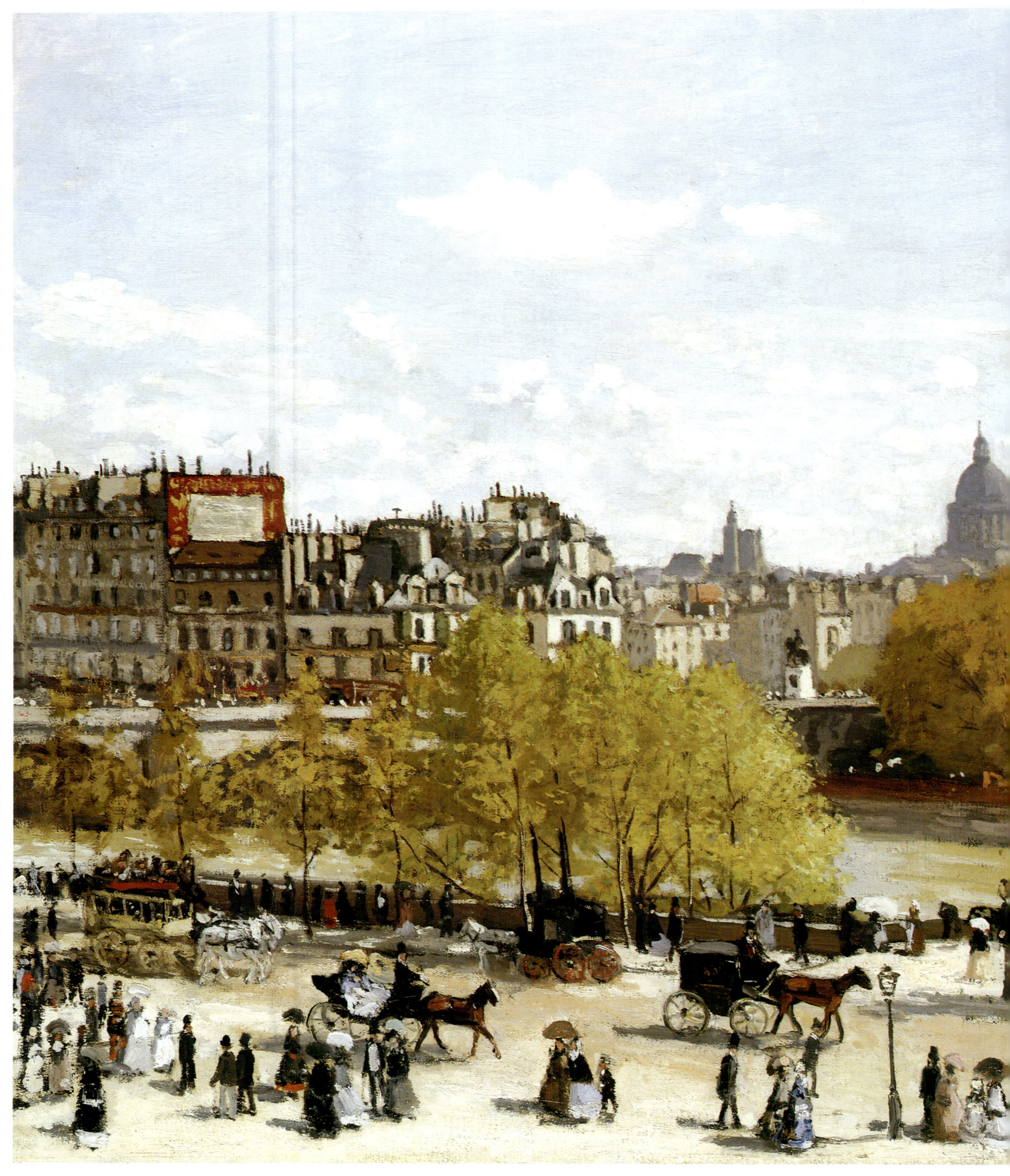

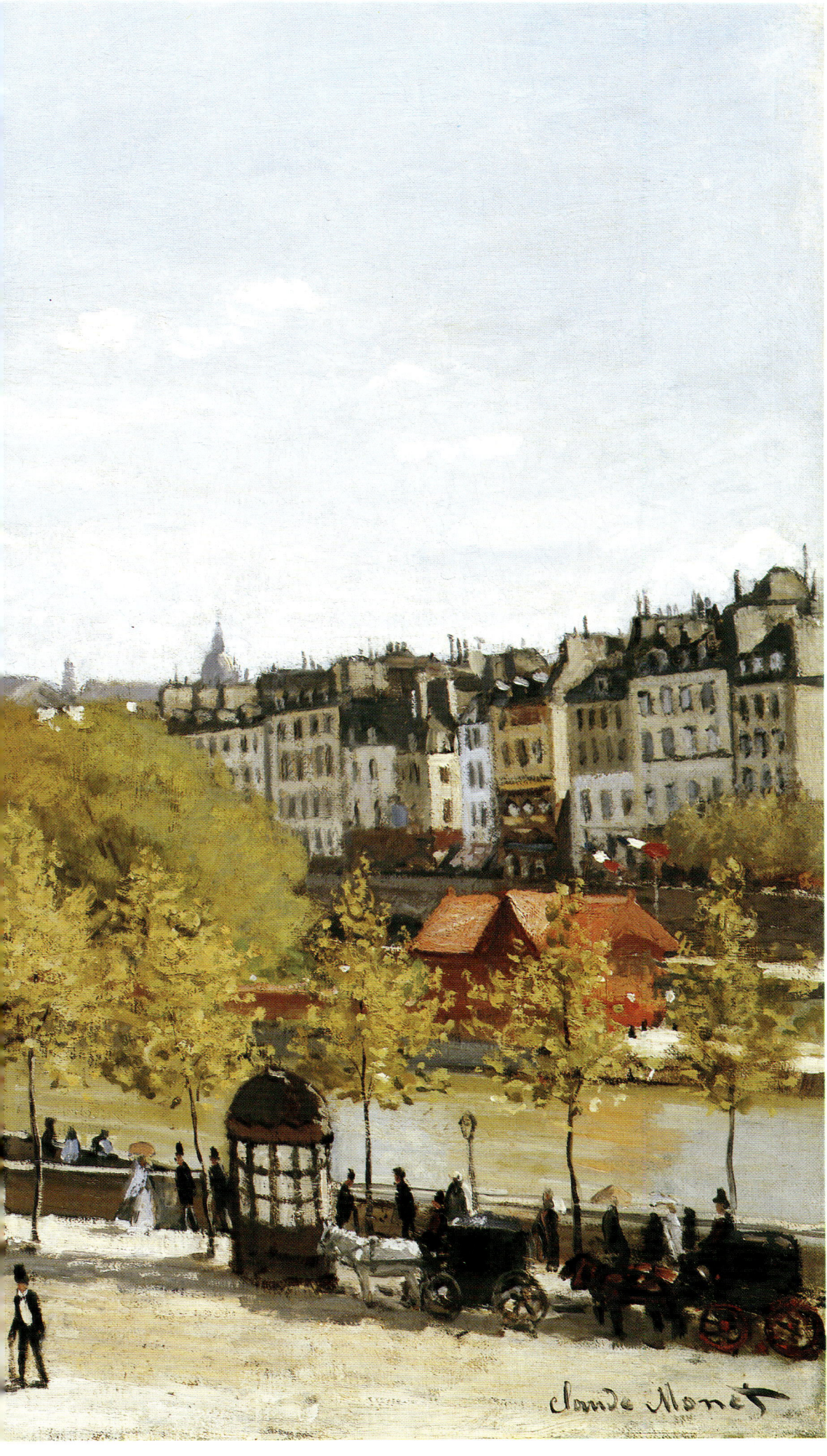

The Quai du Louvre 1867
Oil on canvas
36½×25½ inches (65×92 cm)
Gemeentemuseum, The Hague

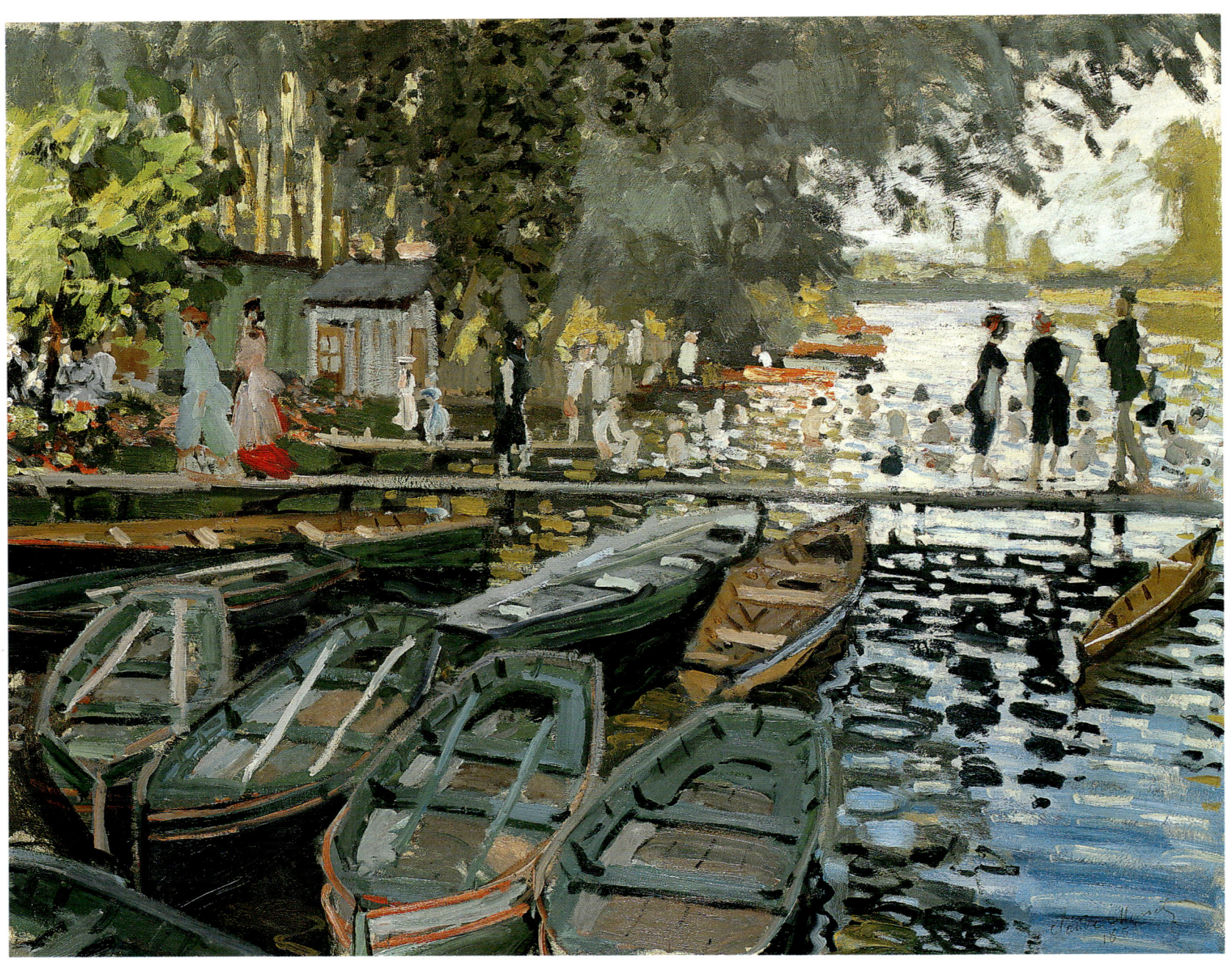

Bathers at La Grenouillère 1869
Oil on canvas
30¼×36¼ inches (77×92 cm)
The National Gallery, London

**The Hôtel des Roches
Noires at Trouville** 1870
Oil on canvas
31½×21¾ inches (80×55 cm)
Musée d'Orsay, Paris

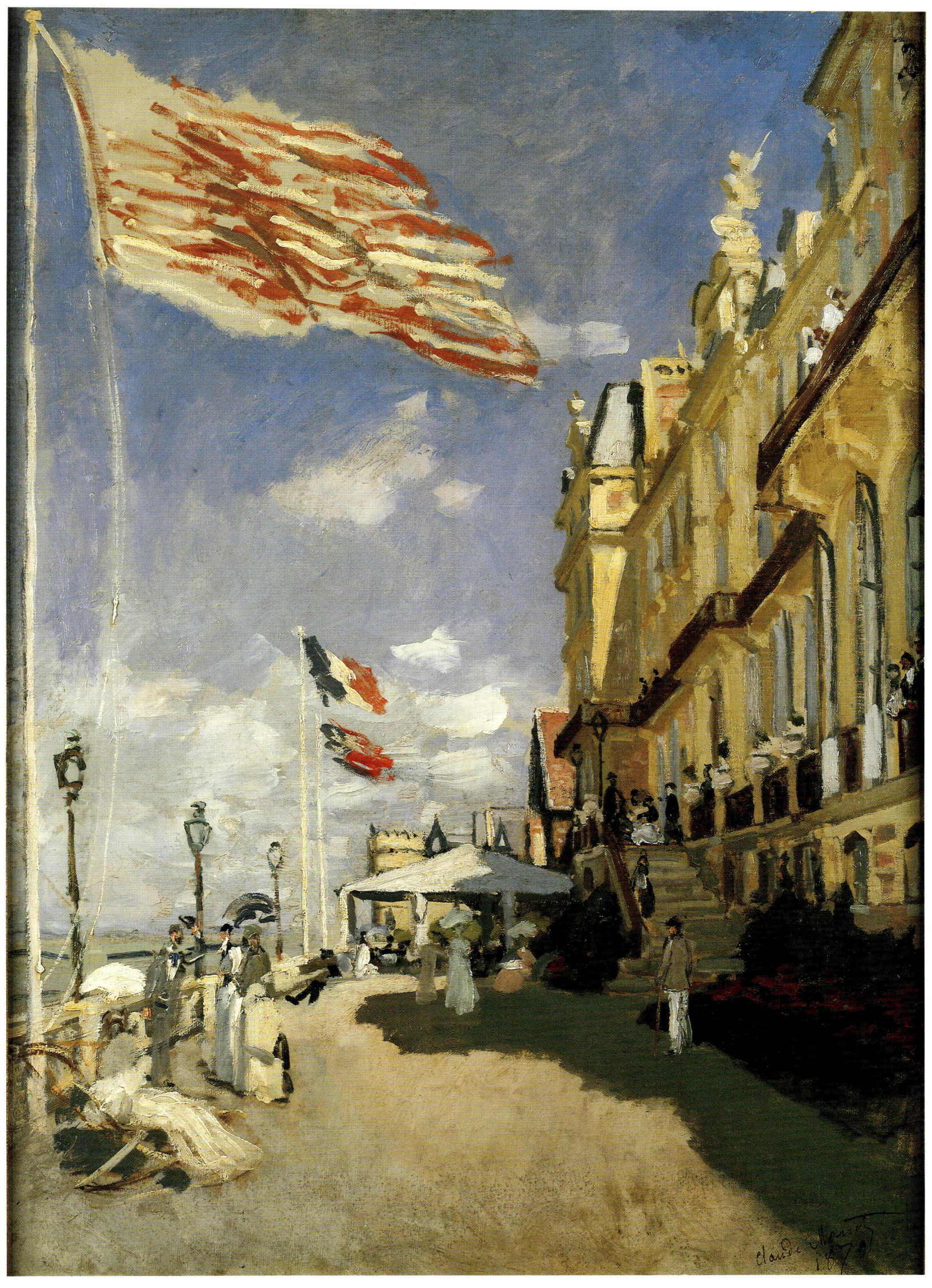

The Thames and Westminster
1871
Oil on canvas
18½×17 inches (47×43 cm)
The National Gallery, London

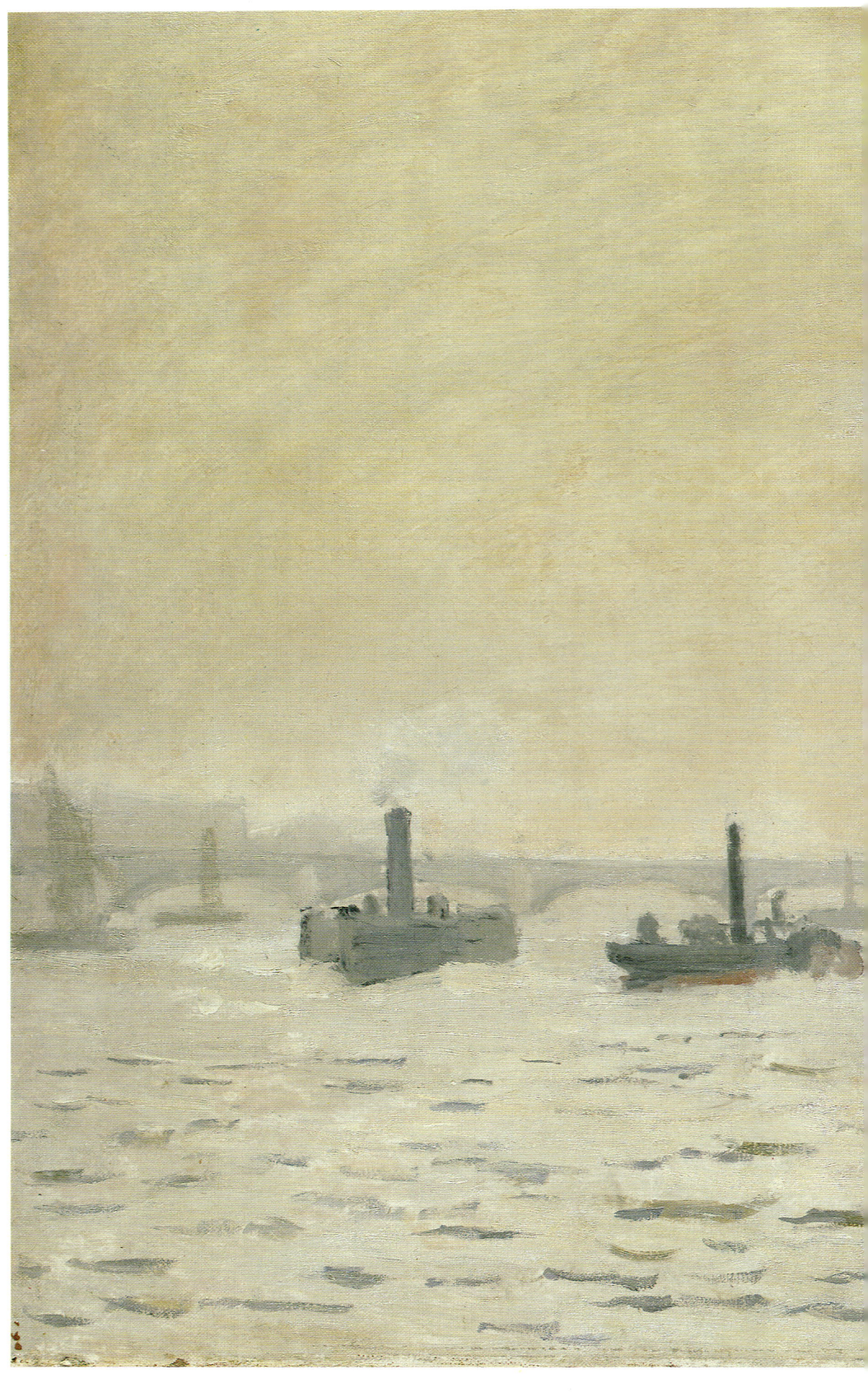

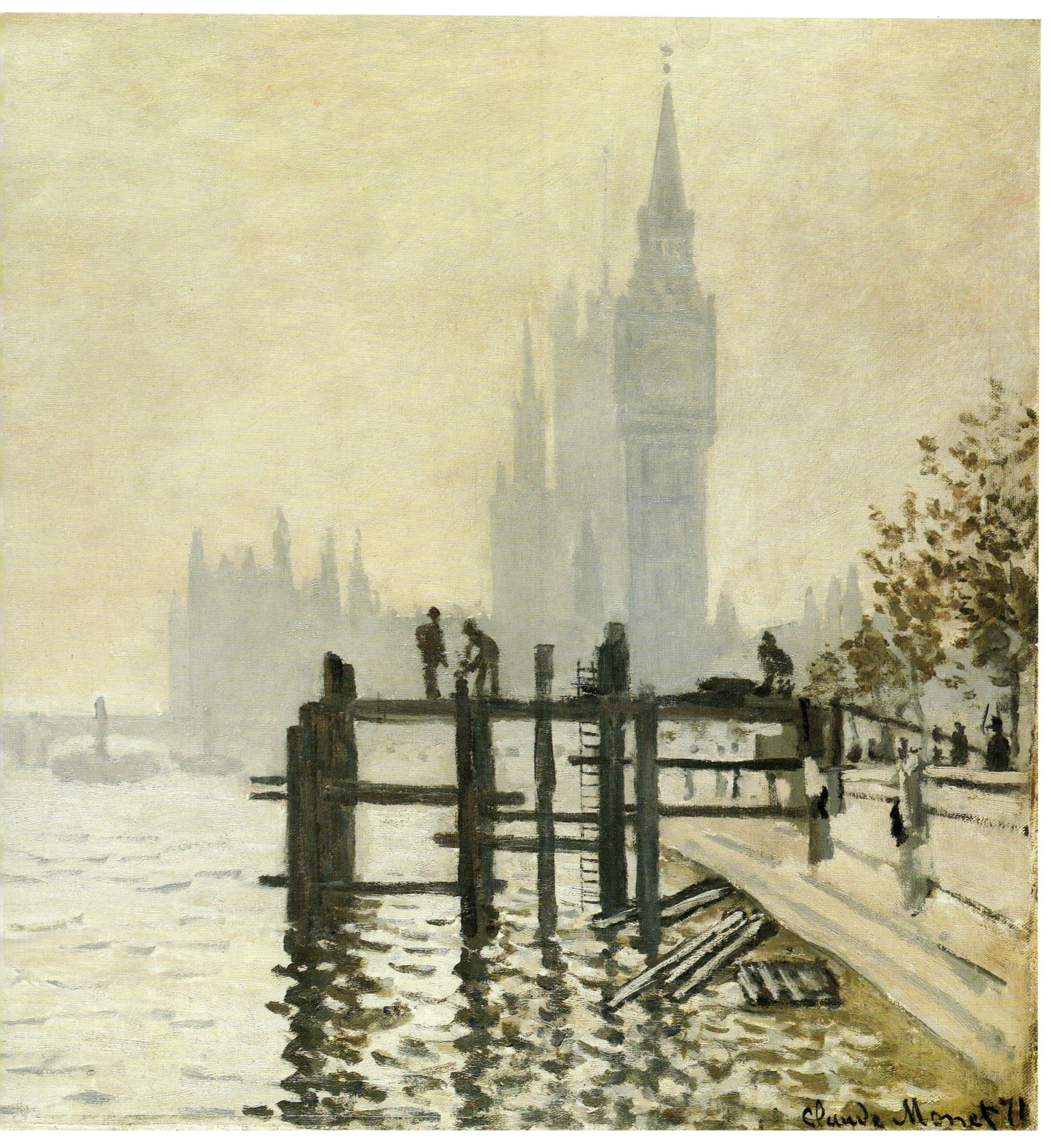

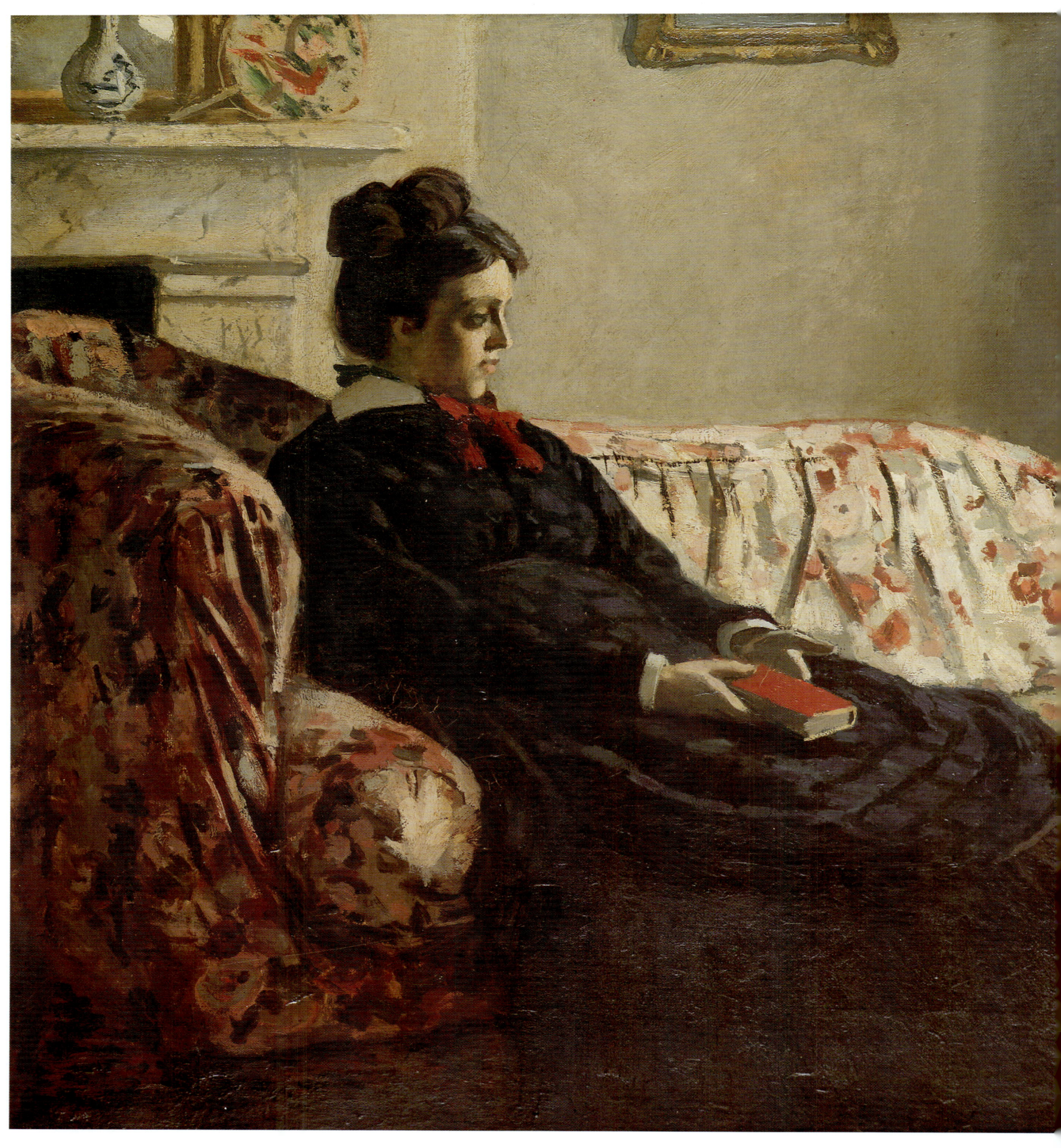

Meditation, Madame Monet
c.1870-71
Oil on canvas
19×29½ inches (48×75 cm)
Musée d'Orsay, Paris

Impression, Sunrise 1872
Oil on canvas
19×24¾ inches (48×63 cm)
Musée Marmottan, Paris

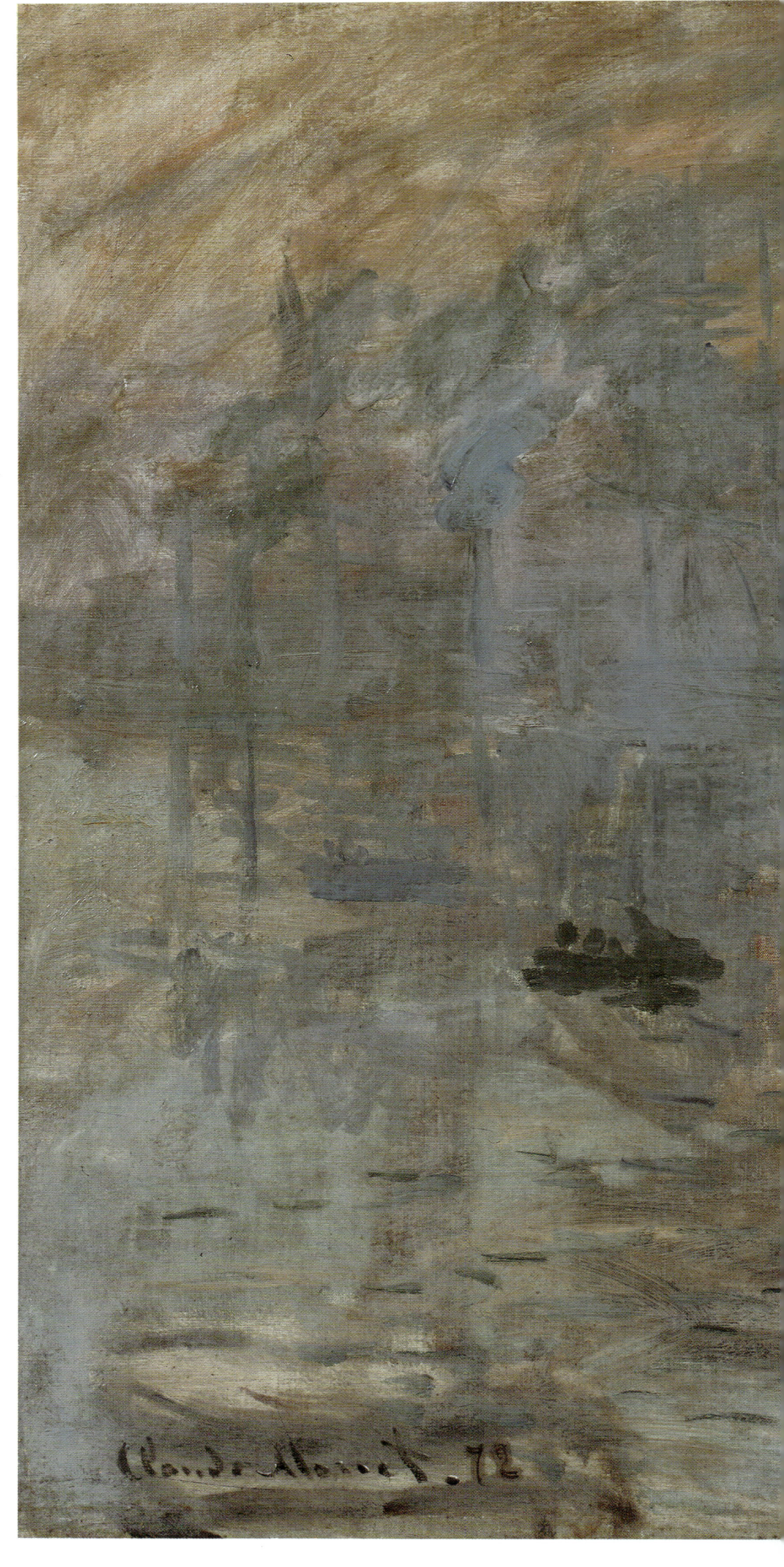

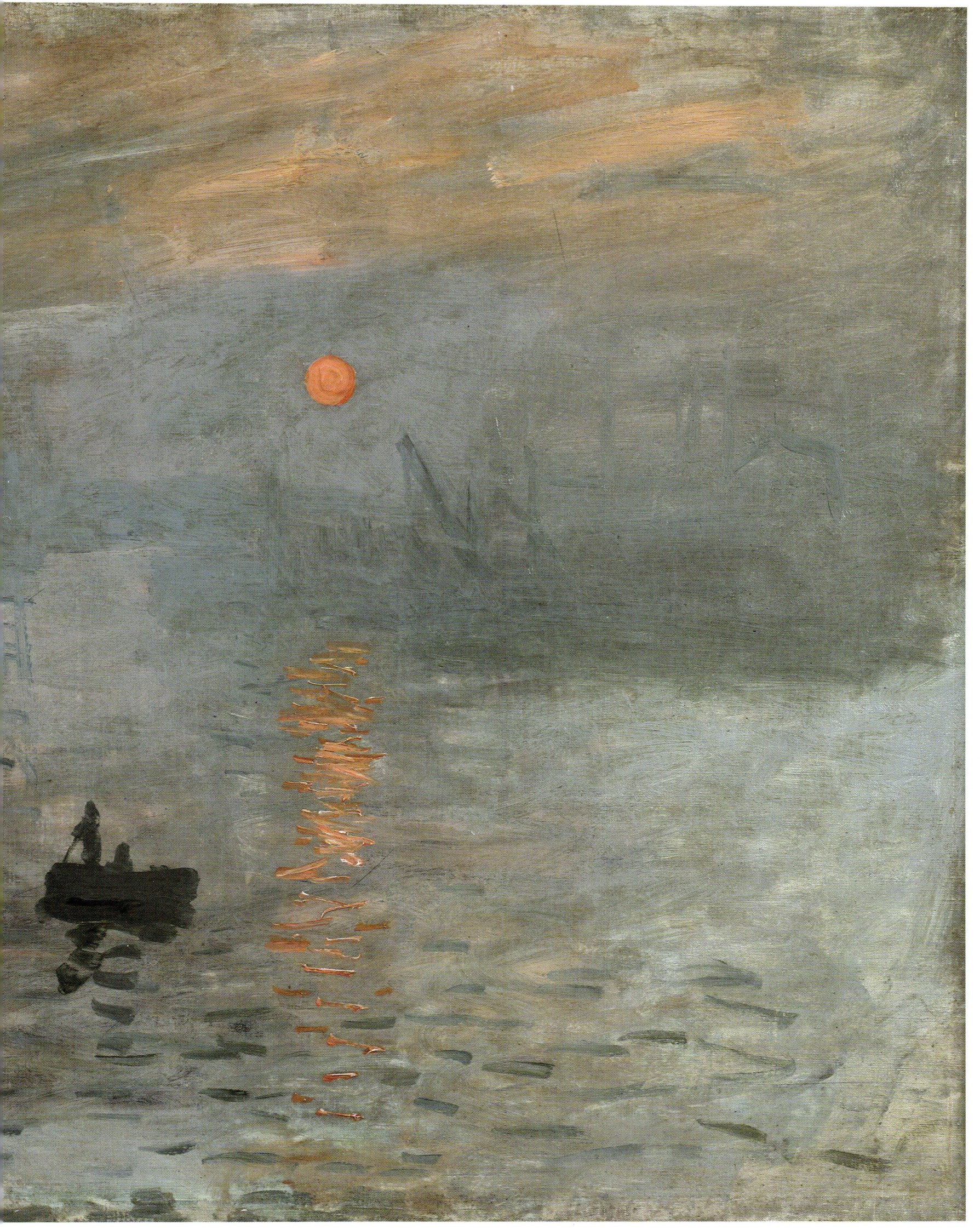

Still Life with Melon c.1872
Oil on canvas
21×28¾ inches (53×73 cm)
Calouste Gulbenkian Foundation Museum,
Lisbon

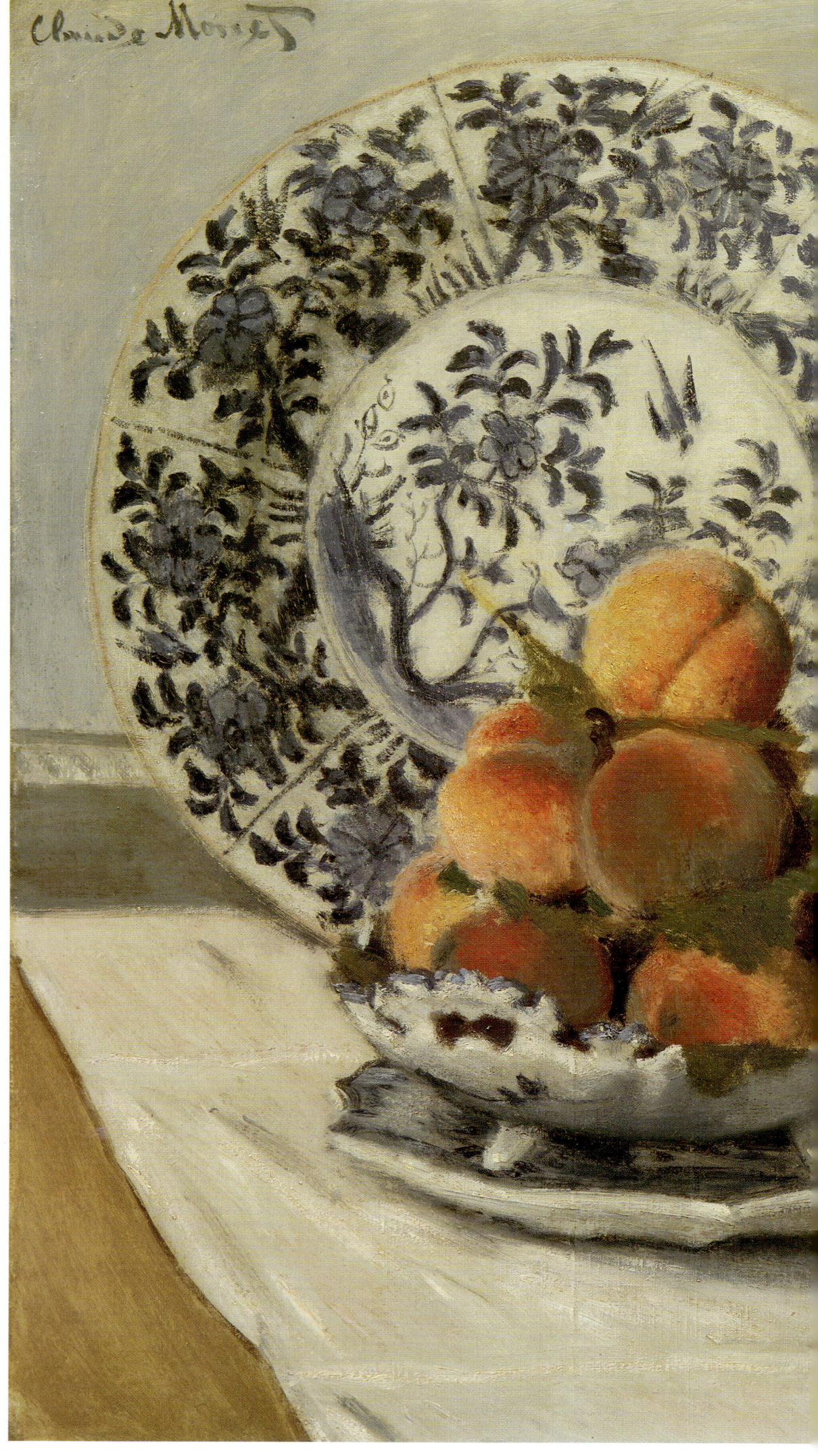

48

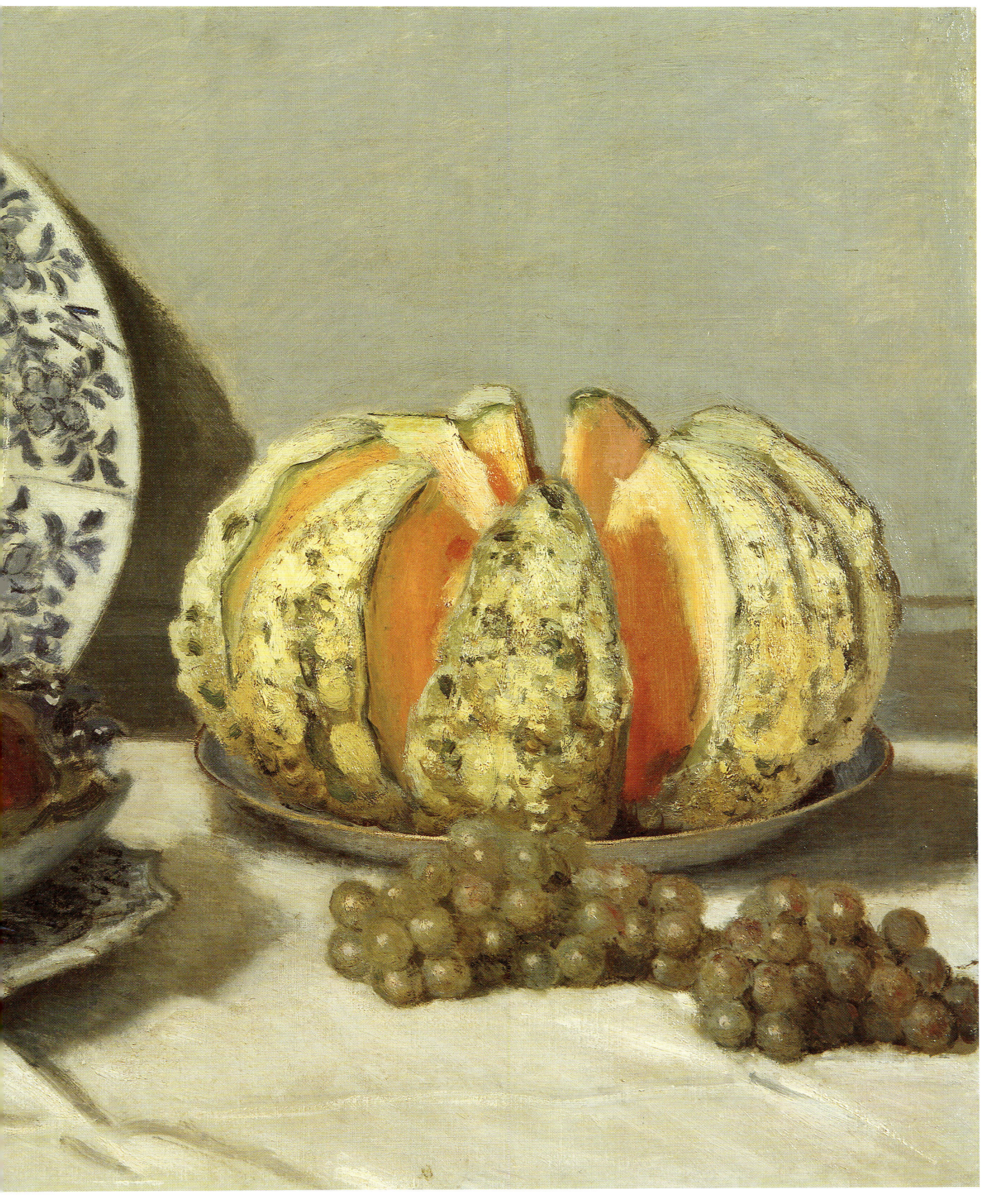

The Luncheon c.1873-74
Oil on canvas
63×79¼ inches (160×201 cm)
Musée d'Orsay, Paris

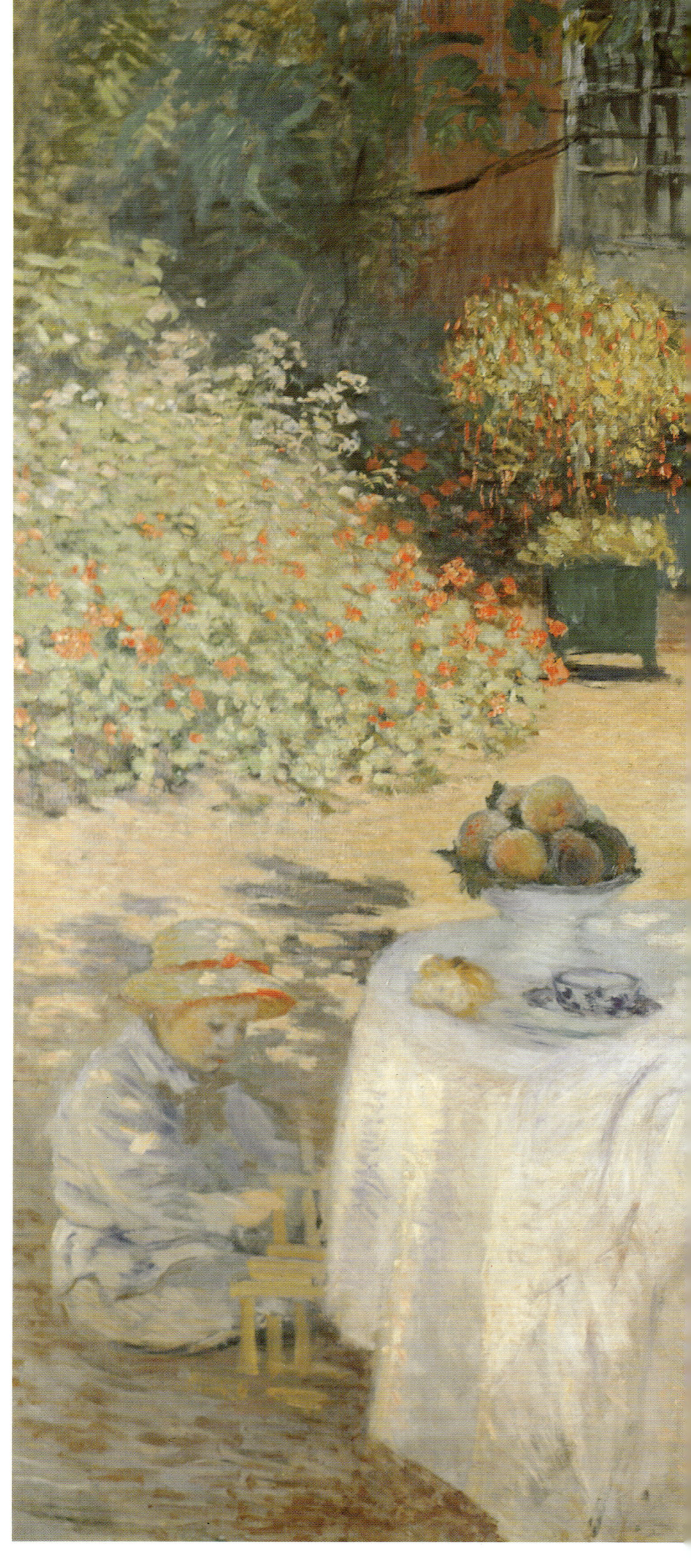

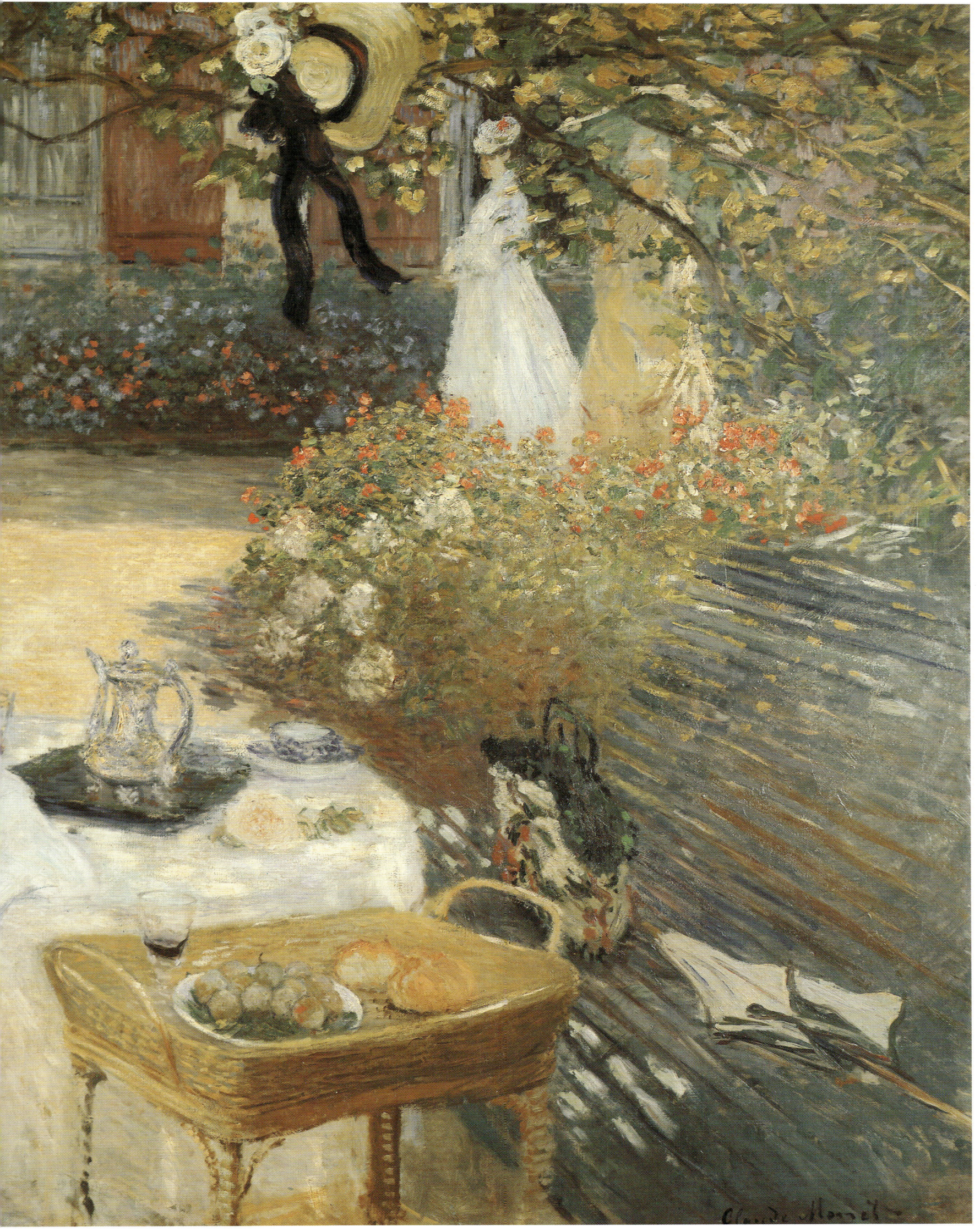

Wild Poppies 1873
Oil on canvas
19¾×25½ inches (50×65 cm)
Musée d'Orsay, Paris

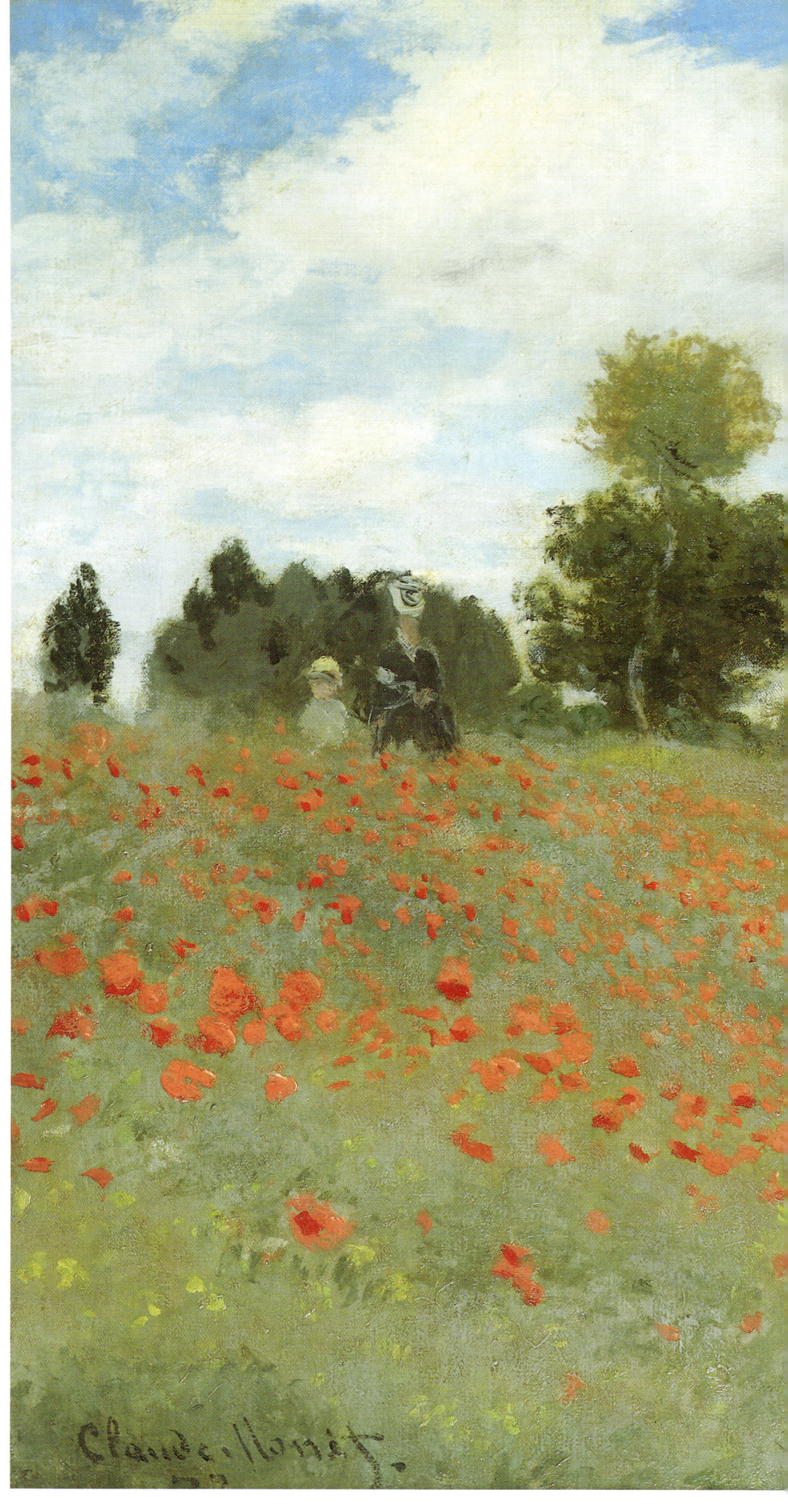

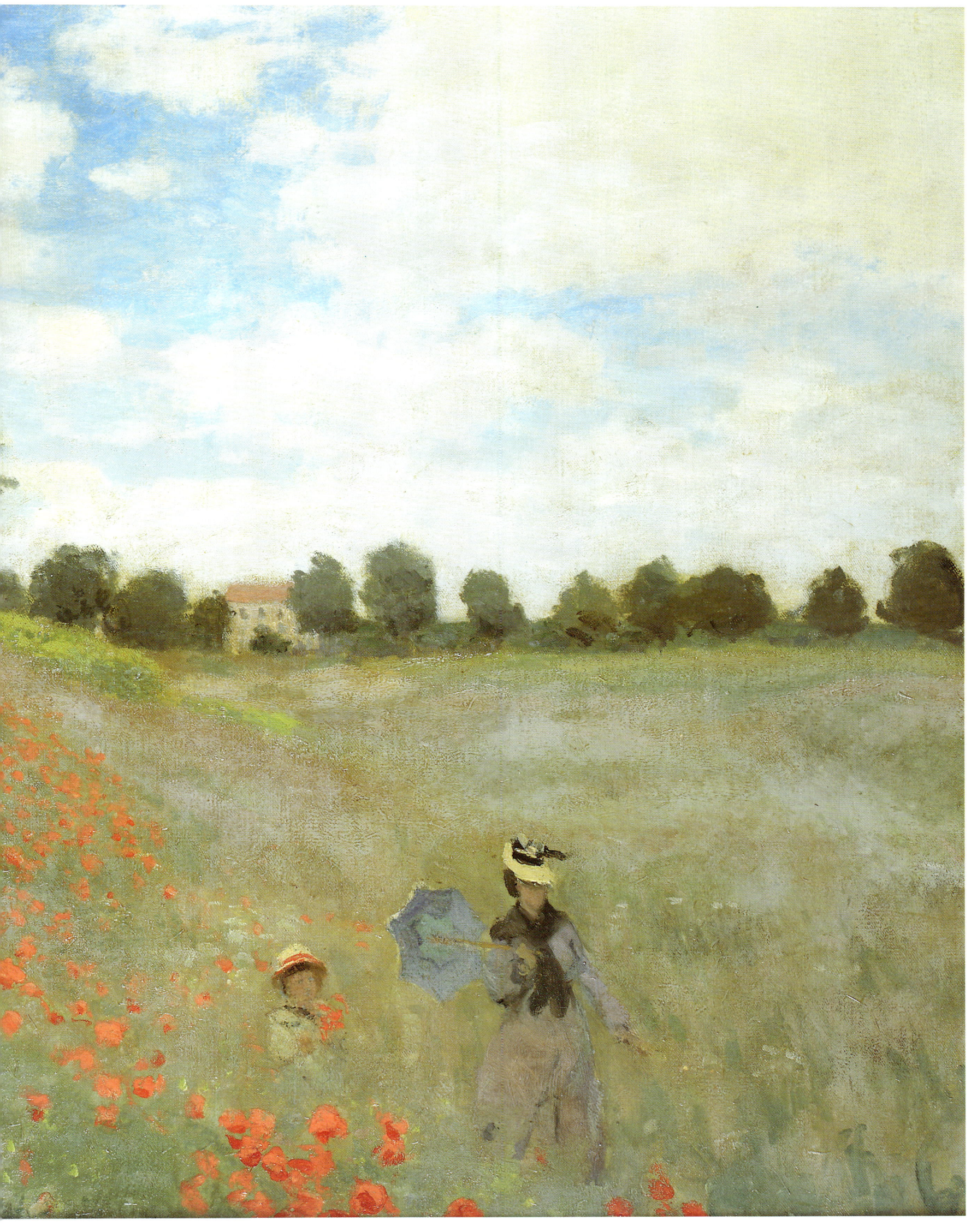

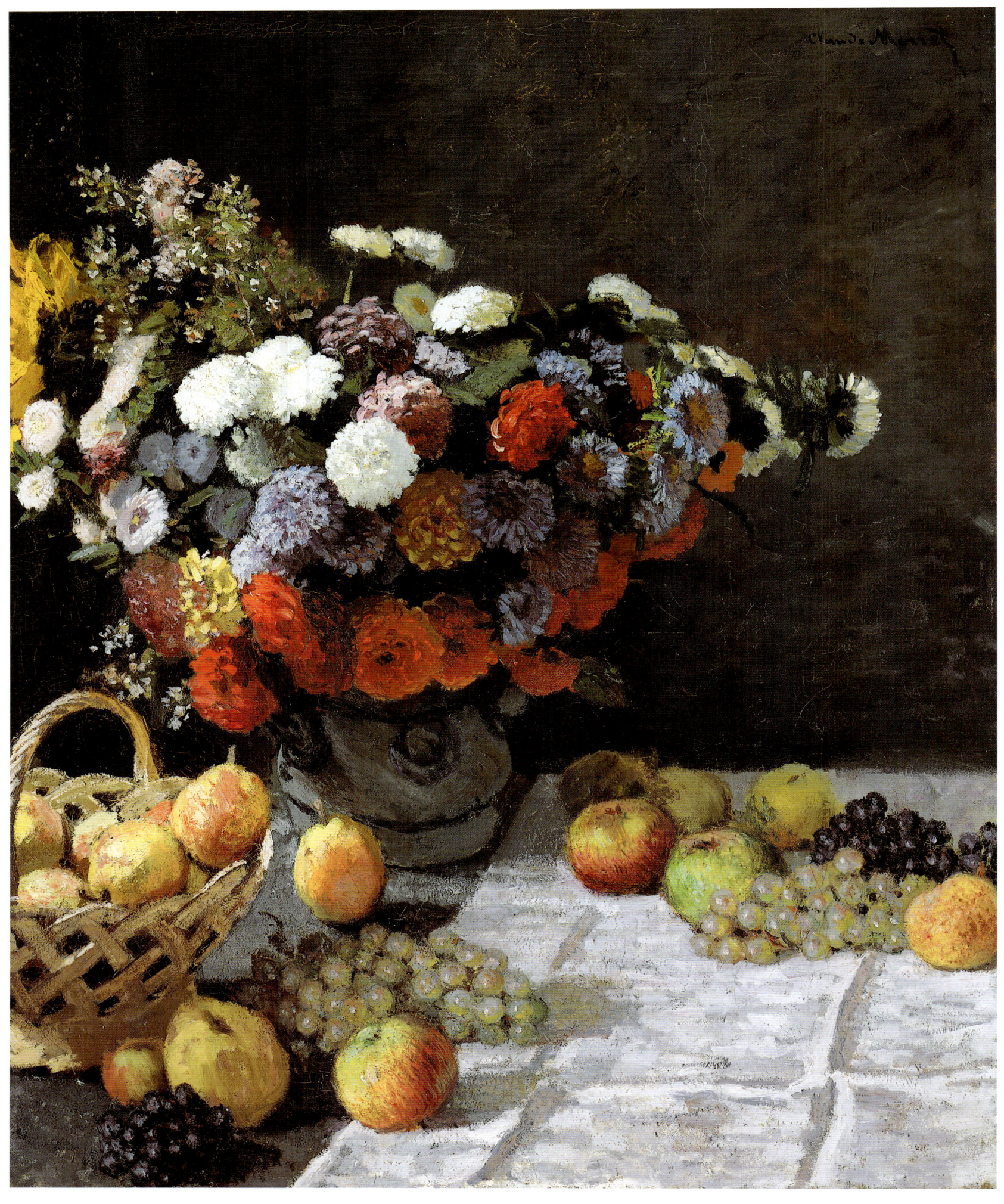

Still Life with Flowers and Fruit c.1869
Oil on canvas
41½×31½ inches (106×81 cm)
J Paul Getty Museum, Malibu, Florida

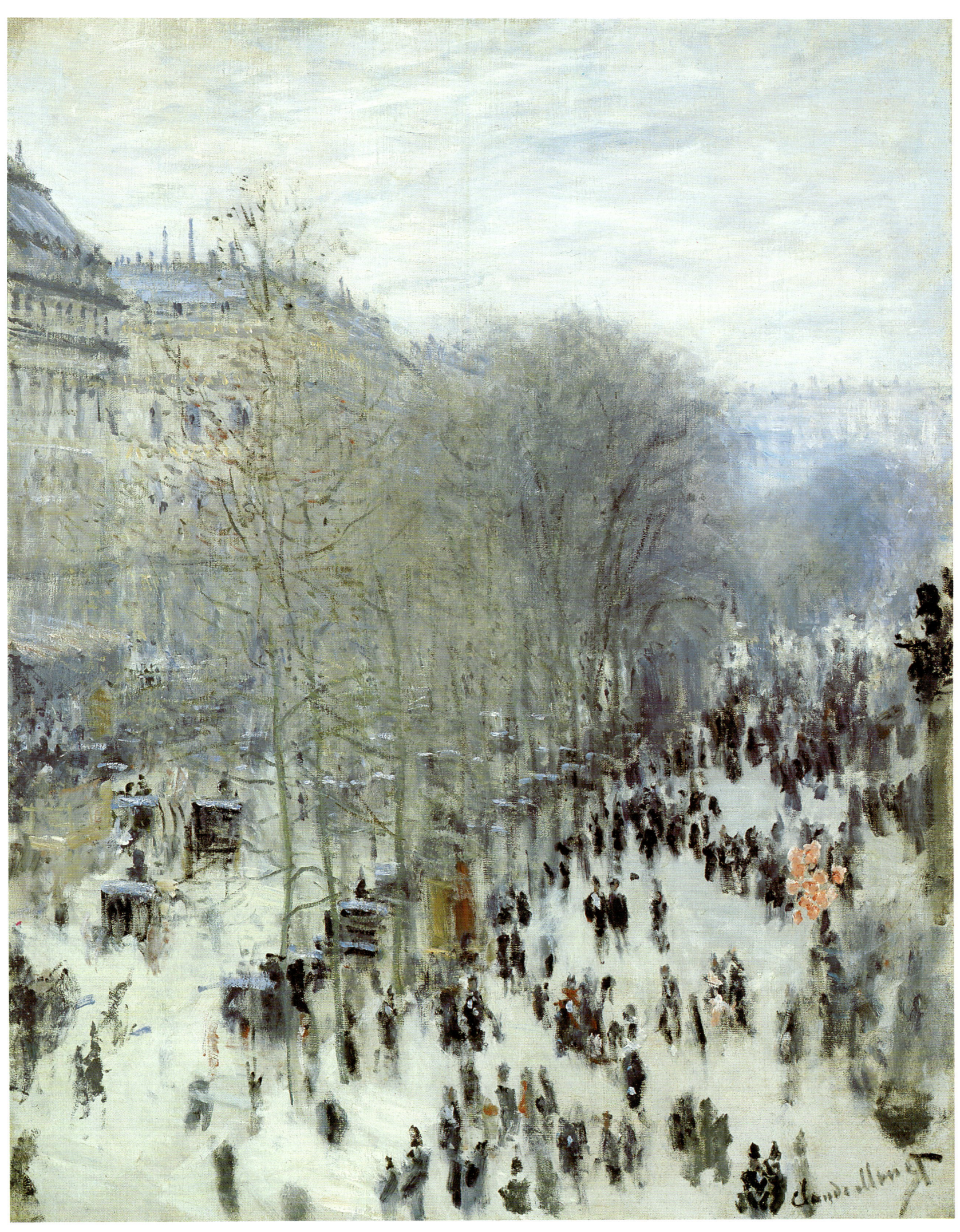

Boulevard des Capucines 1873
Oil on canvas
31½×23¼ inches (80×59 cm)
The Nelson Atkins Museum of Art, Kansas

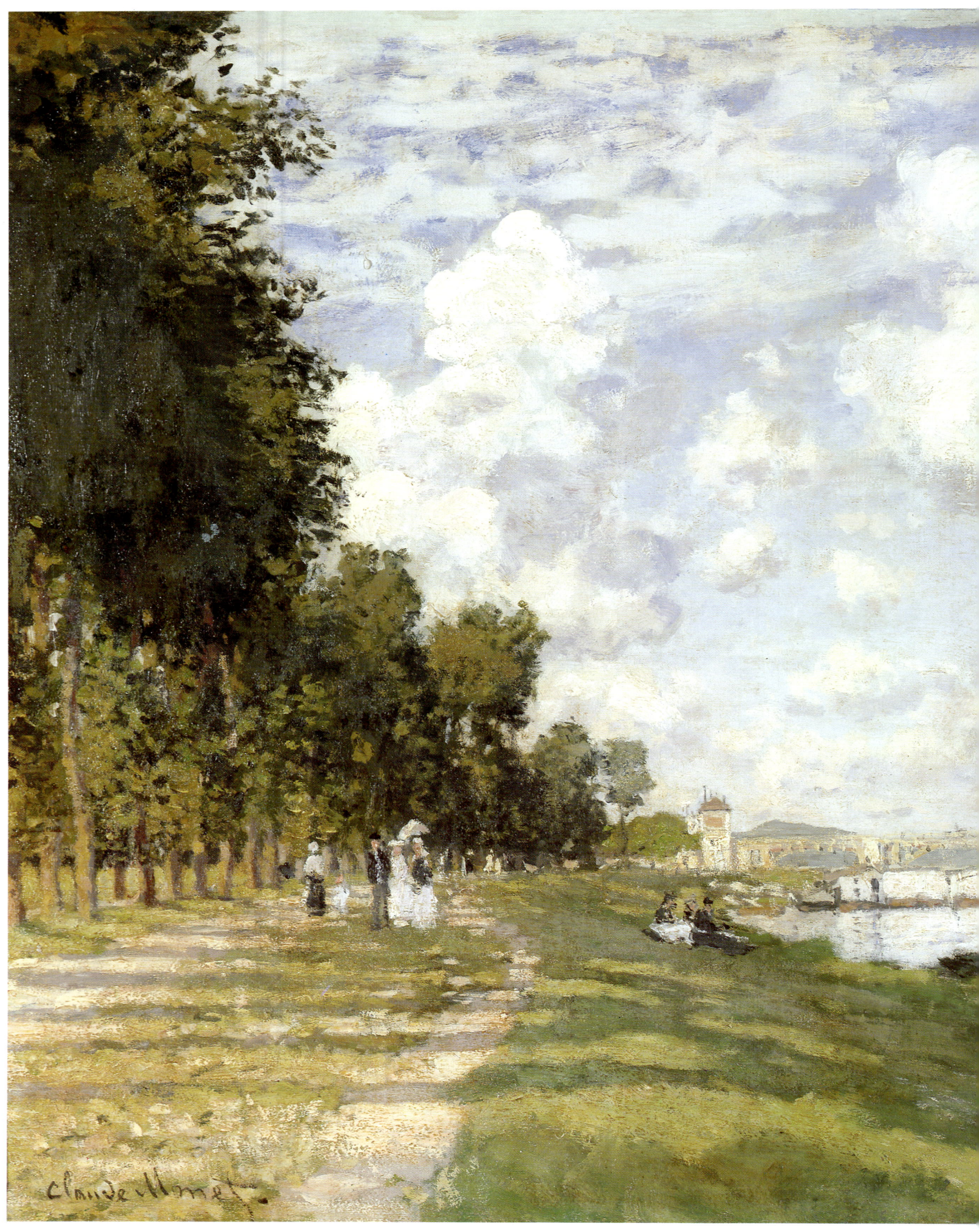

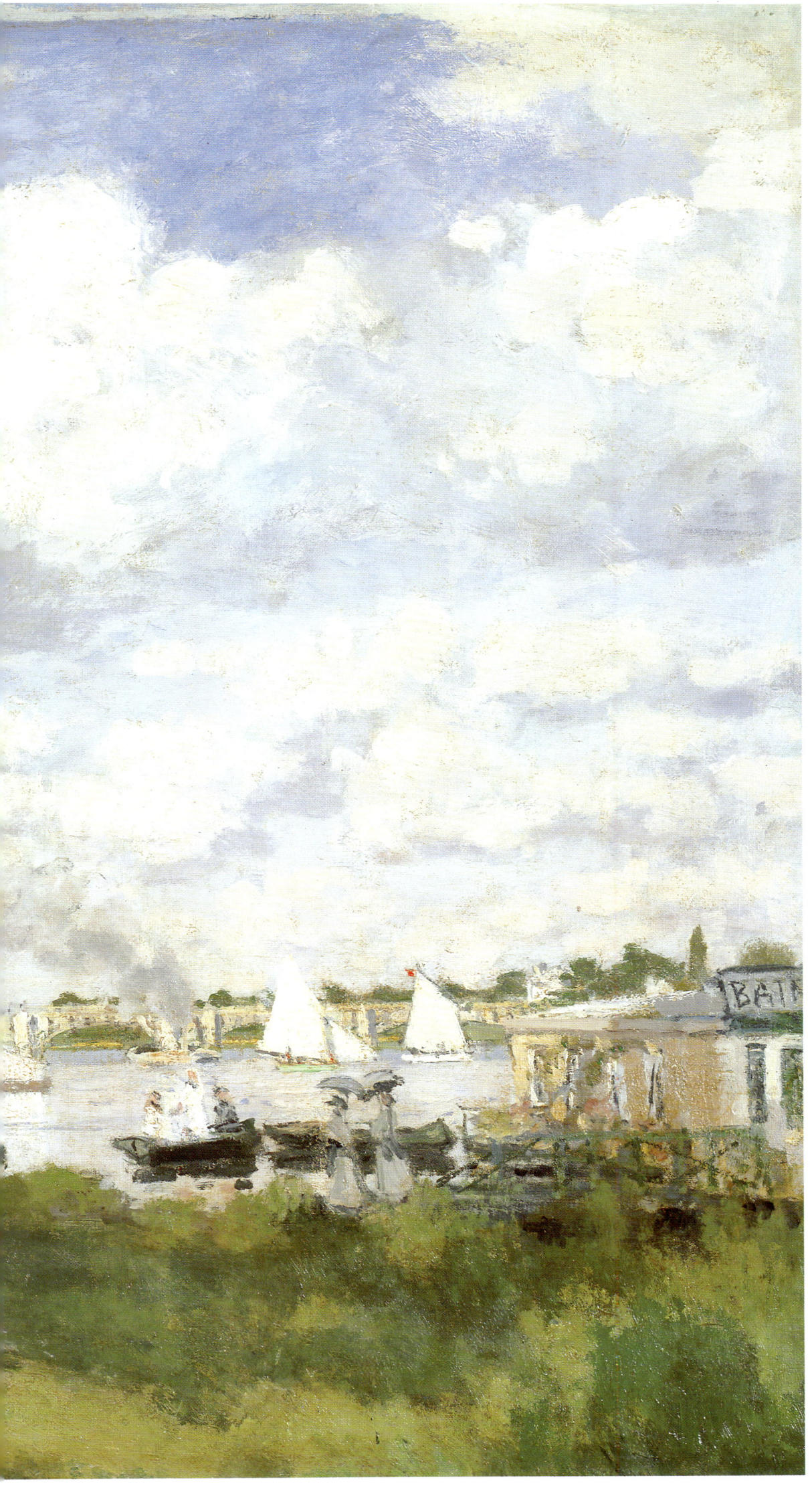

River Basin at Argenteuil 1872
Oil on canvas
23½×31¾ inches (60×80.5 cm)
Musée d'Orsay, Paris

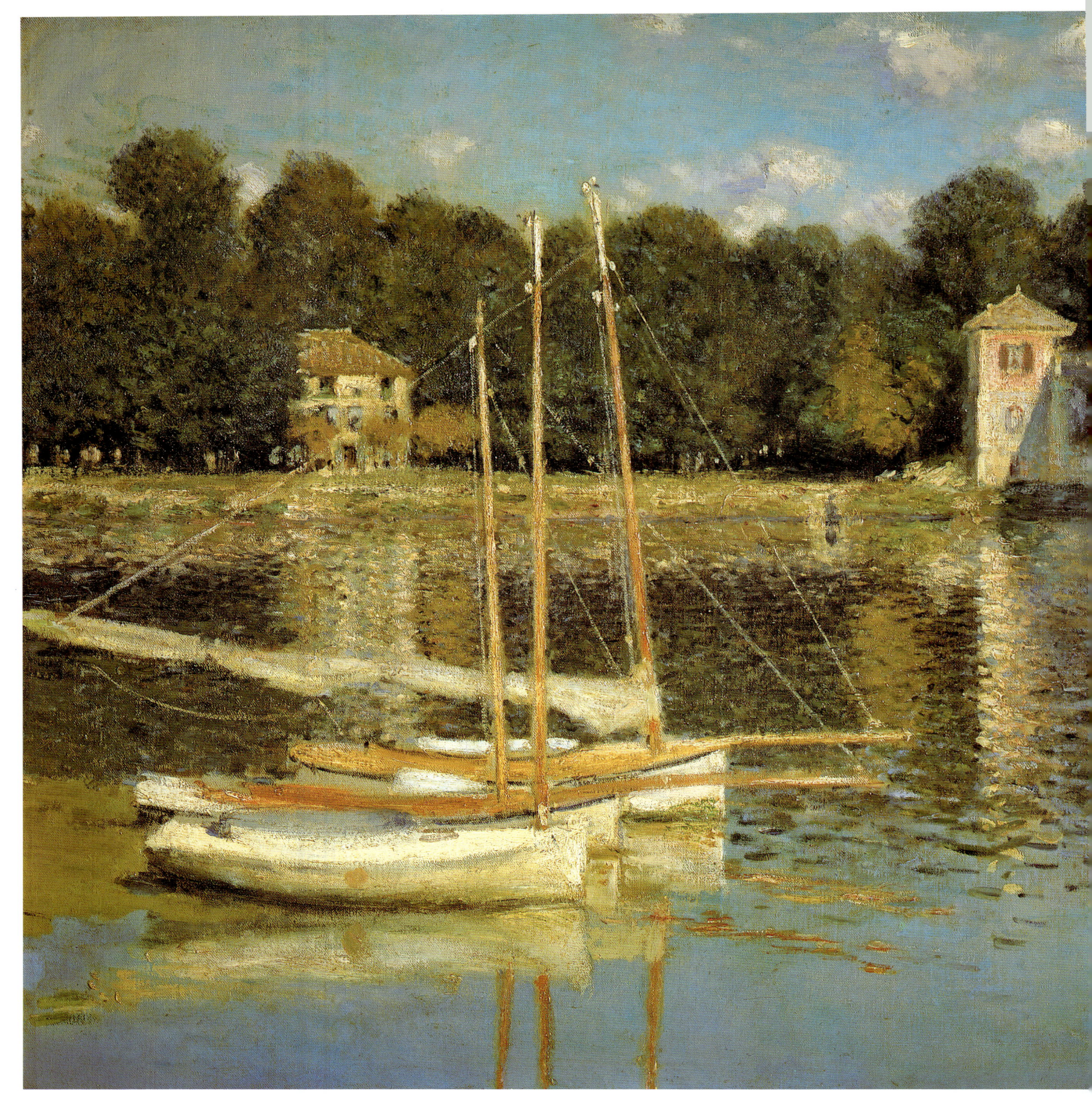

The Bridge at Argenteuil 1874
Oil on canvas
23½×31¾ inches (60×80 cm)
Musée du Louvre, Paris

La Japonaise 1875-76
Oil on canvas
91¼×56 inches (231.6×142.3 cm)
Museum of Fine Arts, Boston, 1951 Purchase Fund

Train in the Snow 1875
Oil on canvas
23¼×30¾ inches (59×78 cm)
Musée Marmottan, Paris

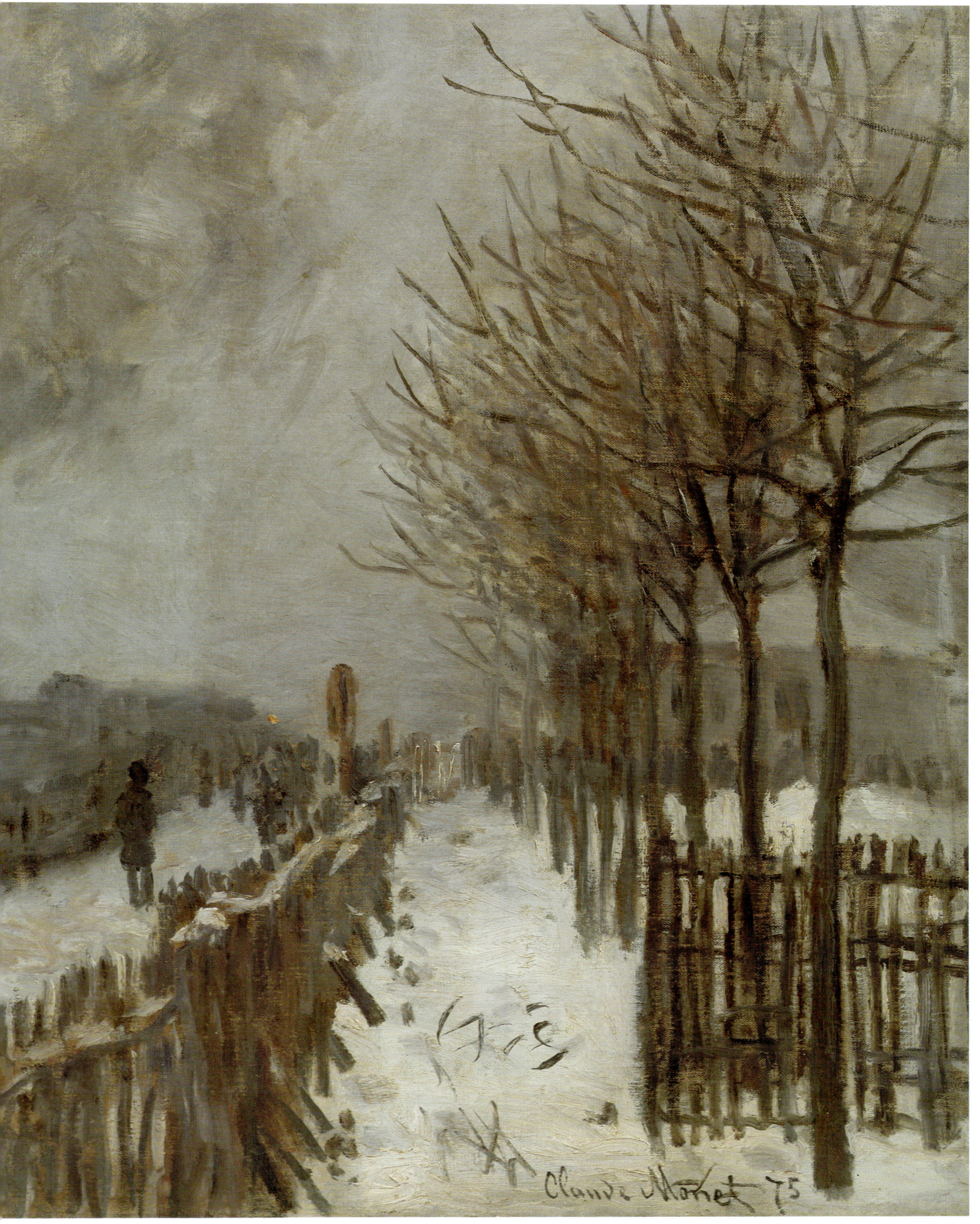

Claude Monet 75

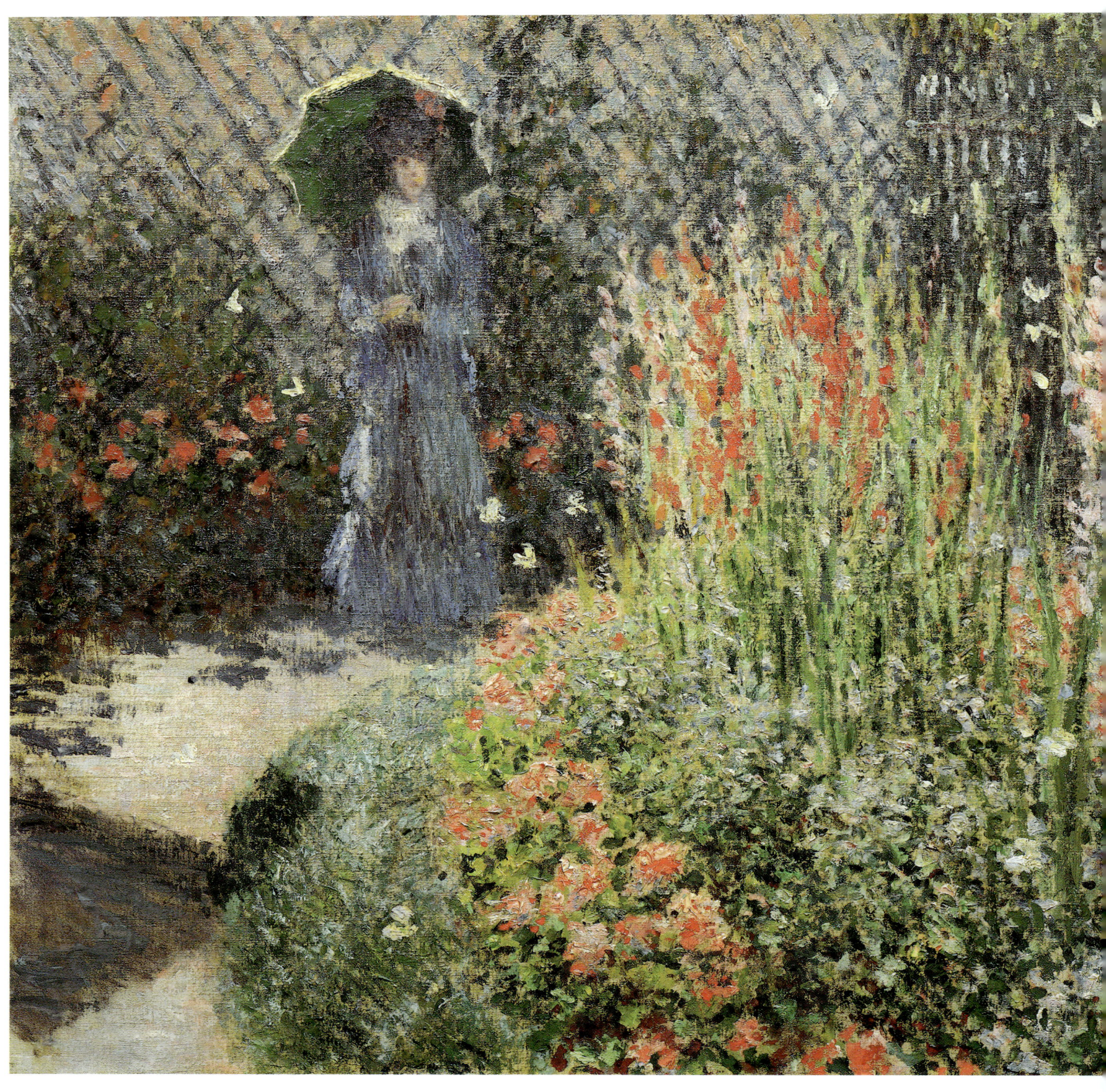

Gladioli 1876
Oil on canvas
21¾×32¼ inches (55×82 cm)
The Detroit Institute of Arts, Detroit

The Hunt 1876
Oil on canvas
67×54 inches (170×137 cm)
Collection Durand-Ruel, Paris

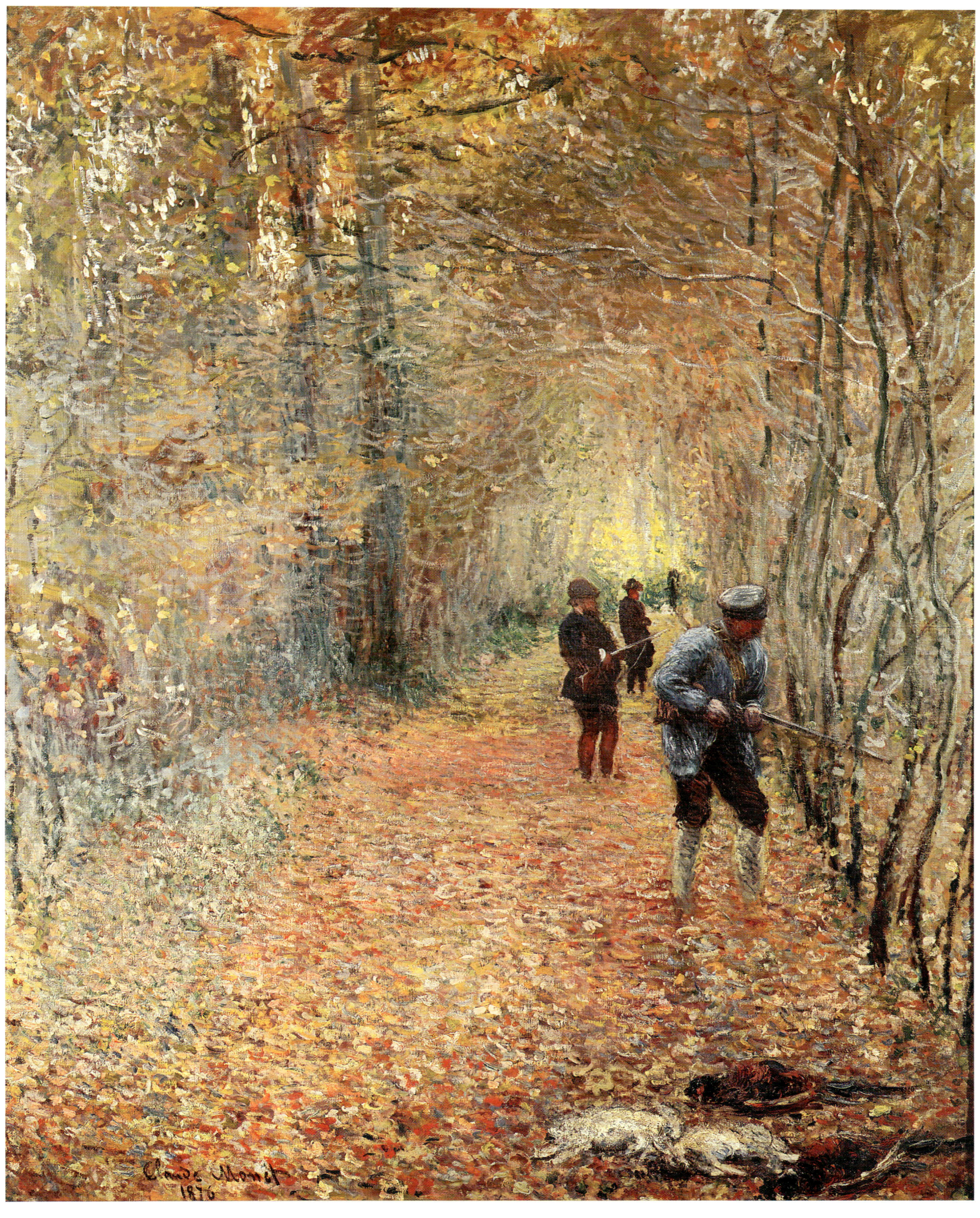

The Gare Saint-Lazare 1877
Oil on canvas
29¾×41 inches (75.5×104 cm)
Musée d'Orsay, Paris

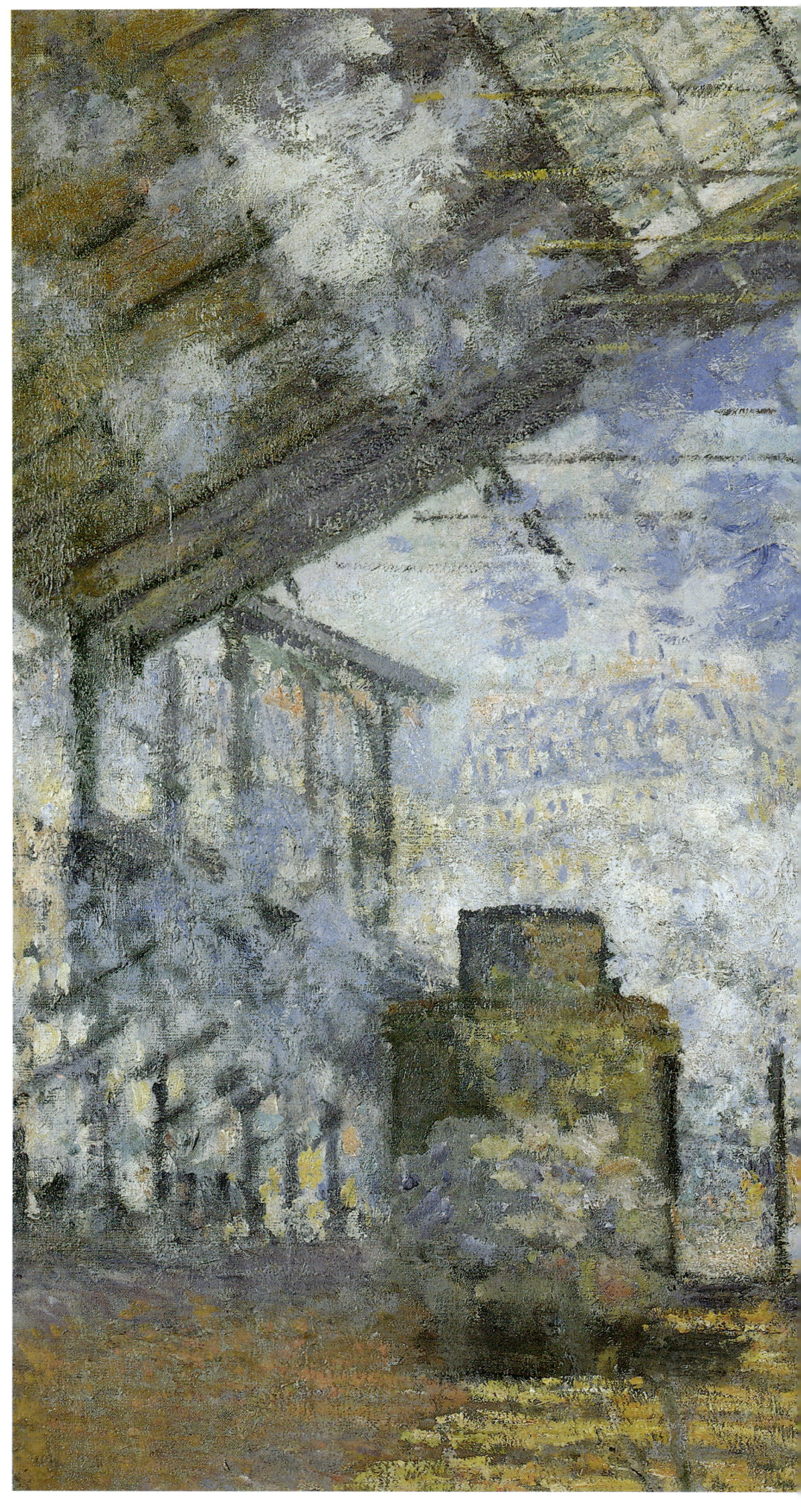

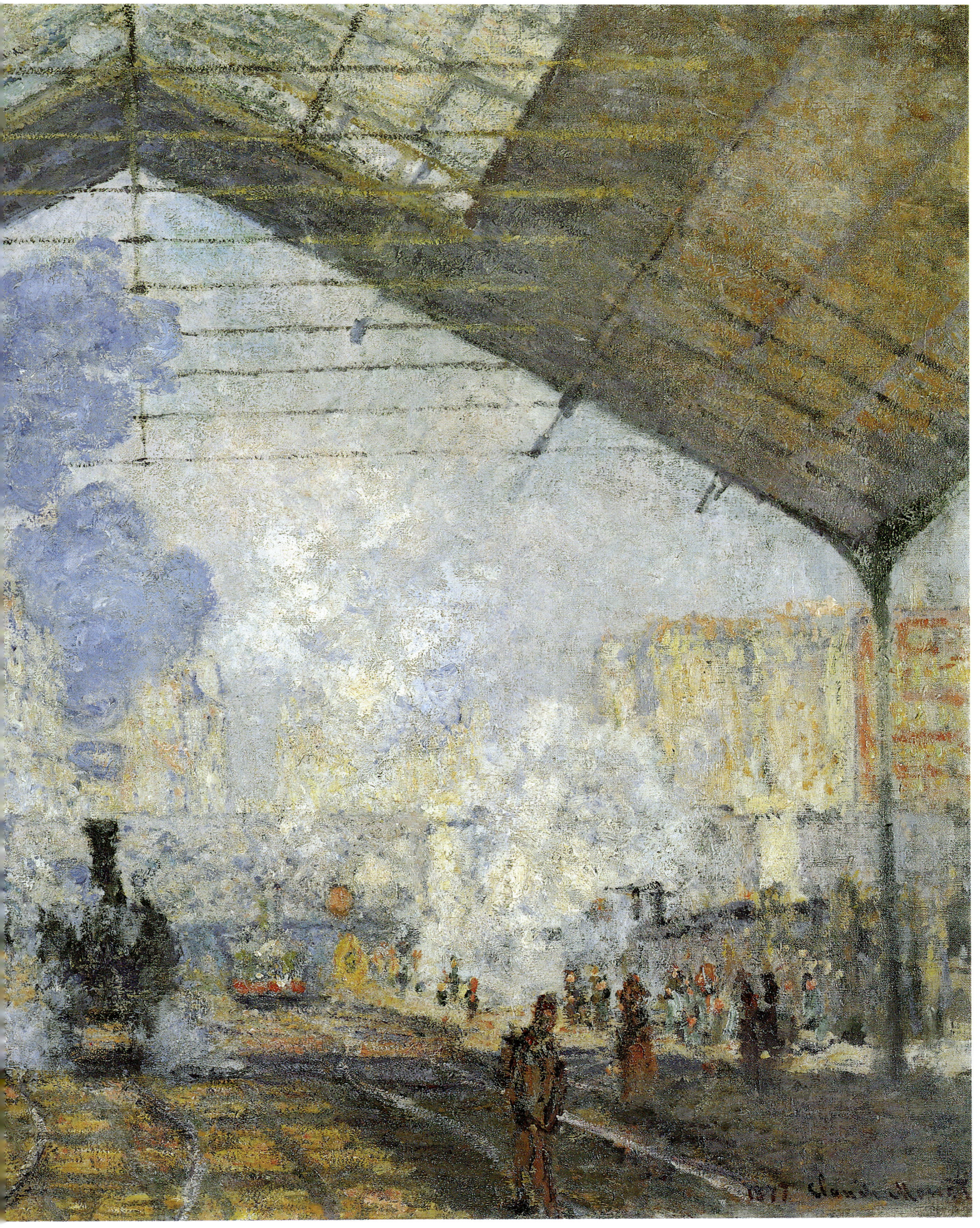

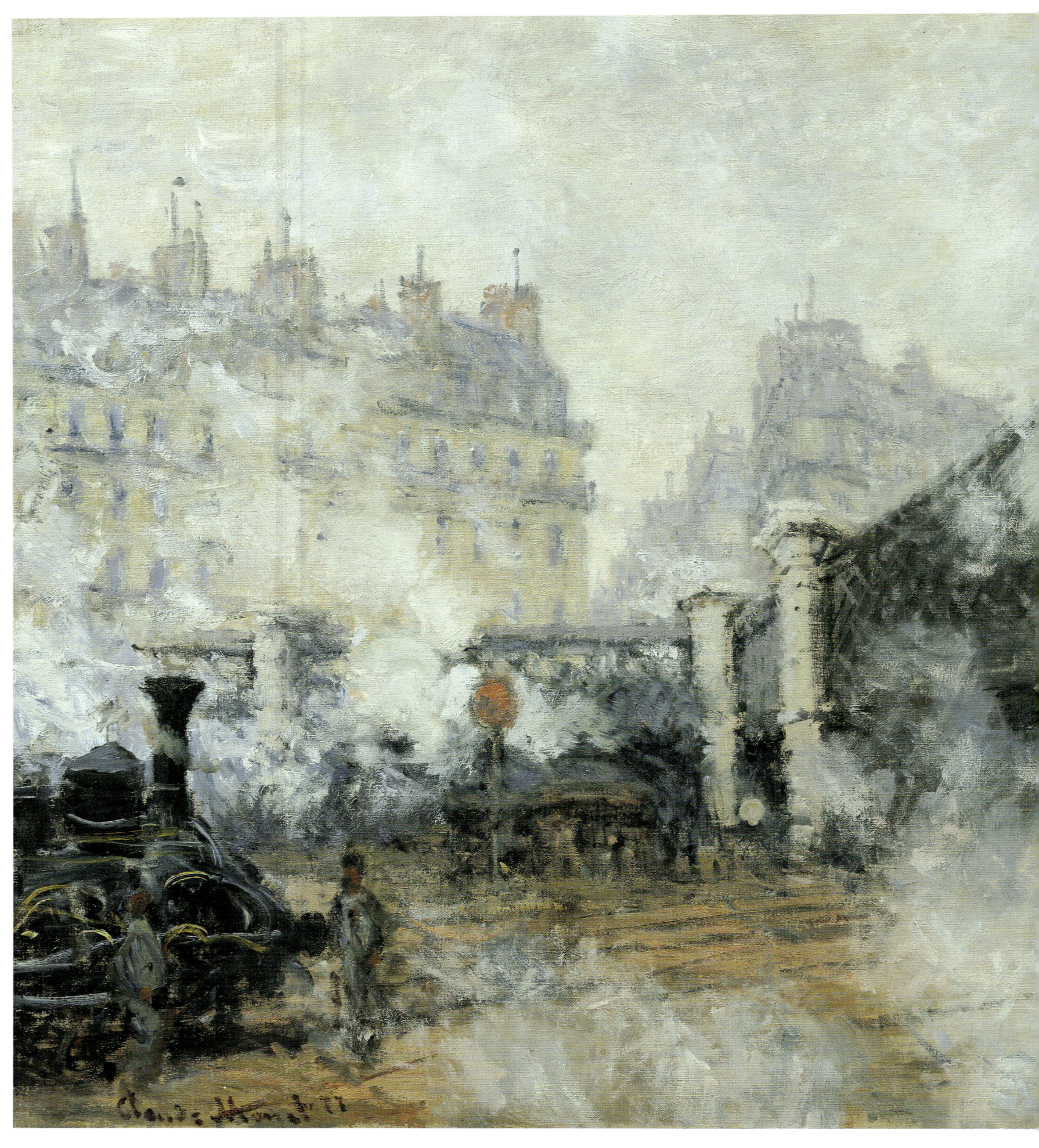

The Pont de l'Europe 1877
Oil on canvas
25¼×38 inches (64×81 cm)
Musée Marmottan, Paris

Camille Monet on her Deathbed 1879
Oil on canvas
35½×26¾ inches (90×68 cm)
Musée d'Orsay, Paris

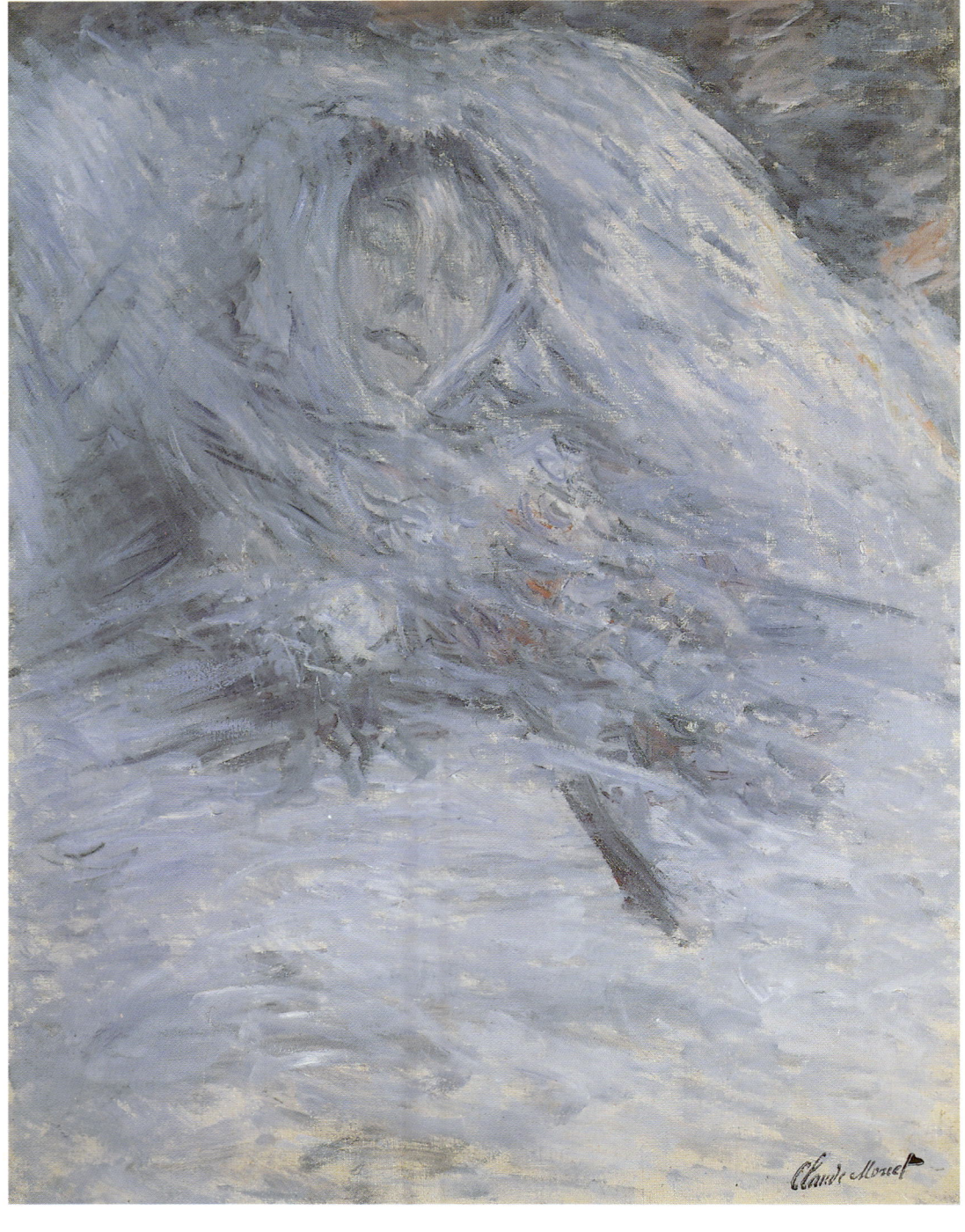

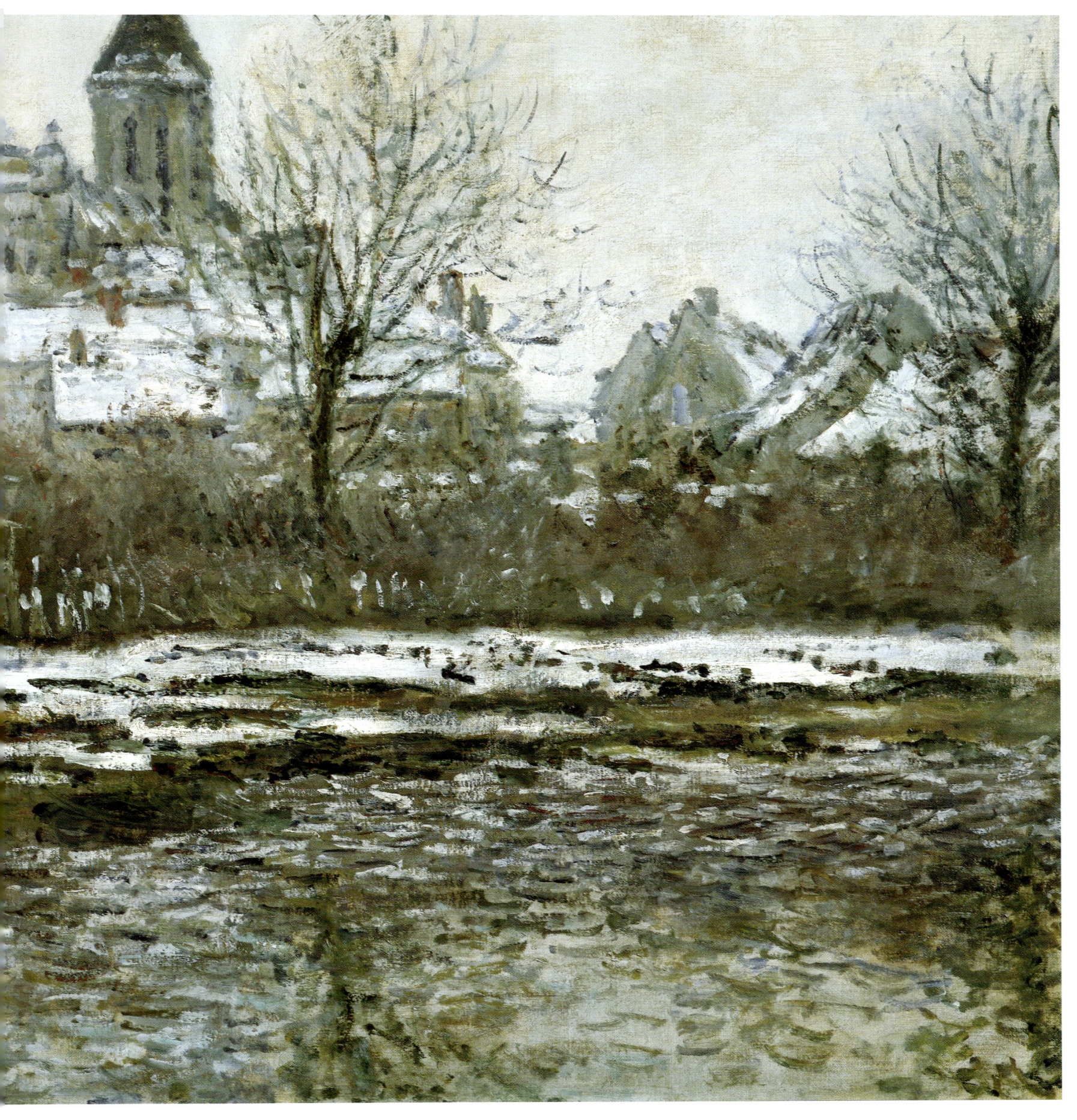

View of Vétheuil, Winter 1879
Oil on canvas
20½×28 inches (52×71 cm)
Musée d'Orsay, Paris

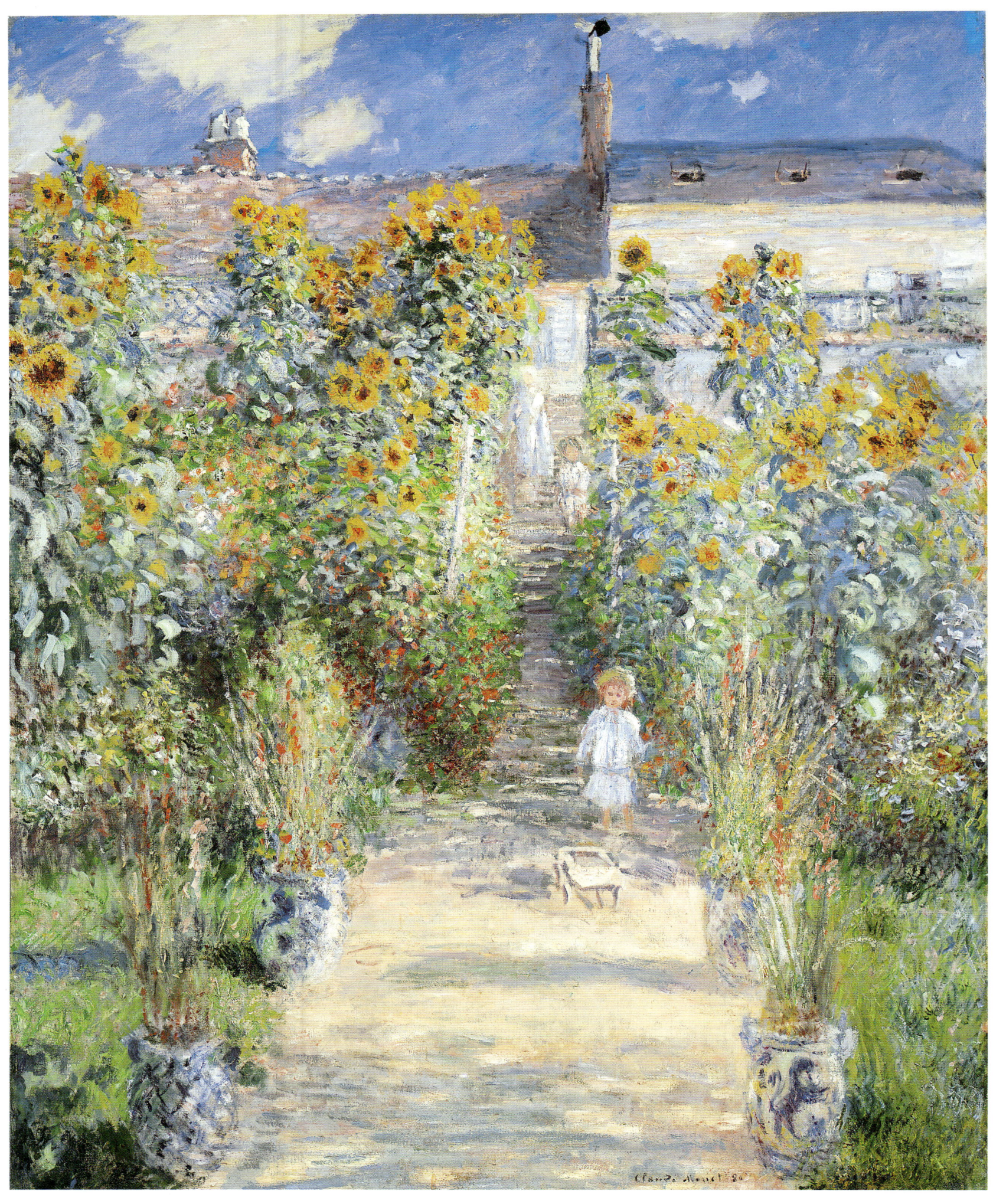

The Artist's Garden at Vétheuil 1881
Oil on canvas
59¾×47¾ inches (151.4×121 cm)
National Gallery of Art, Washington

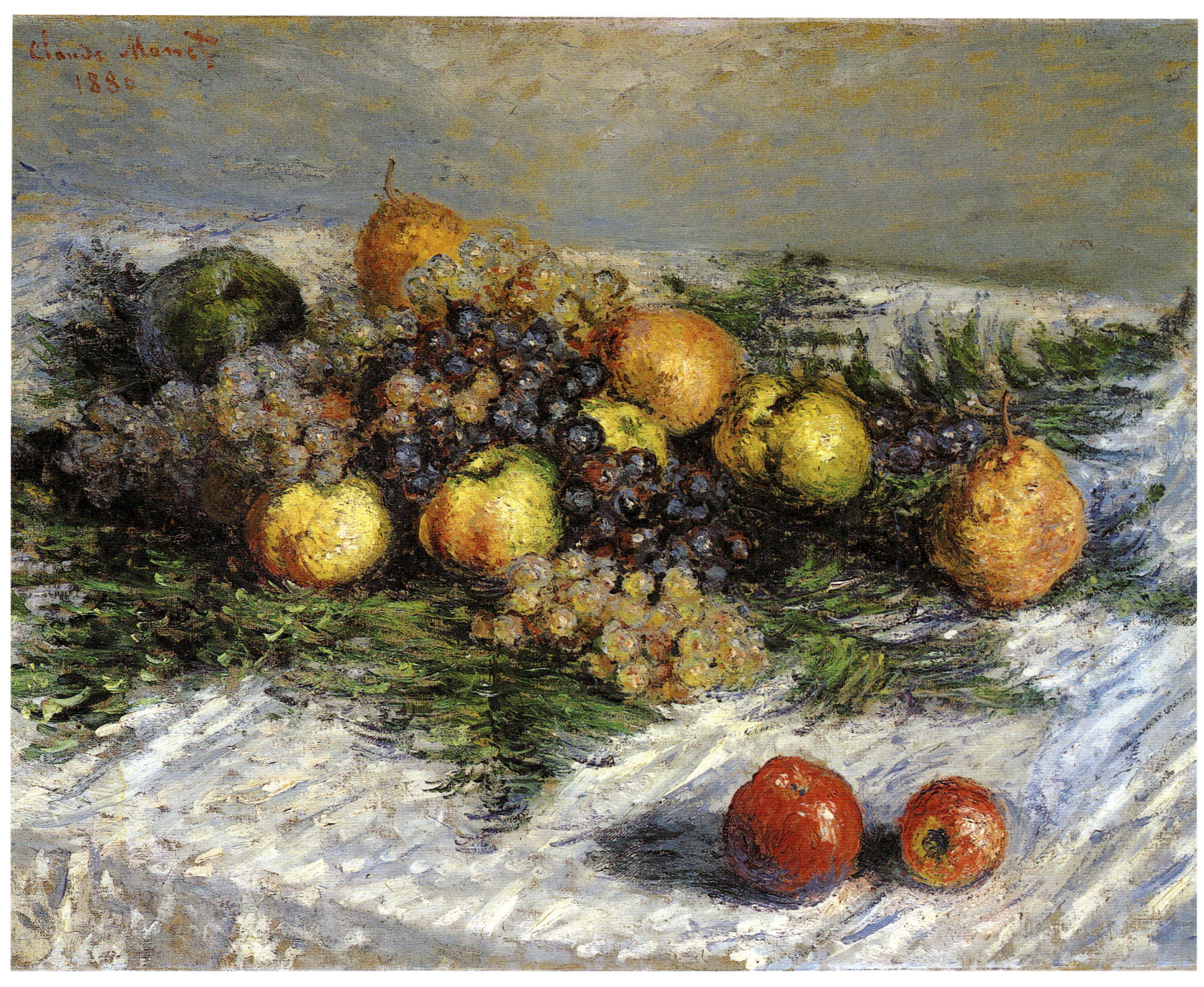

Pears and Grapes 1880
Oil on canvas
25¼×31½ inches (65×81 cm)
Kunsthalle, Hamburg

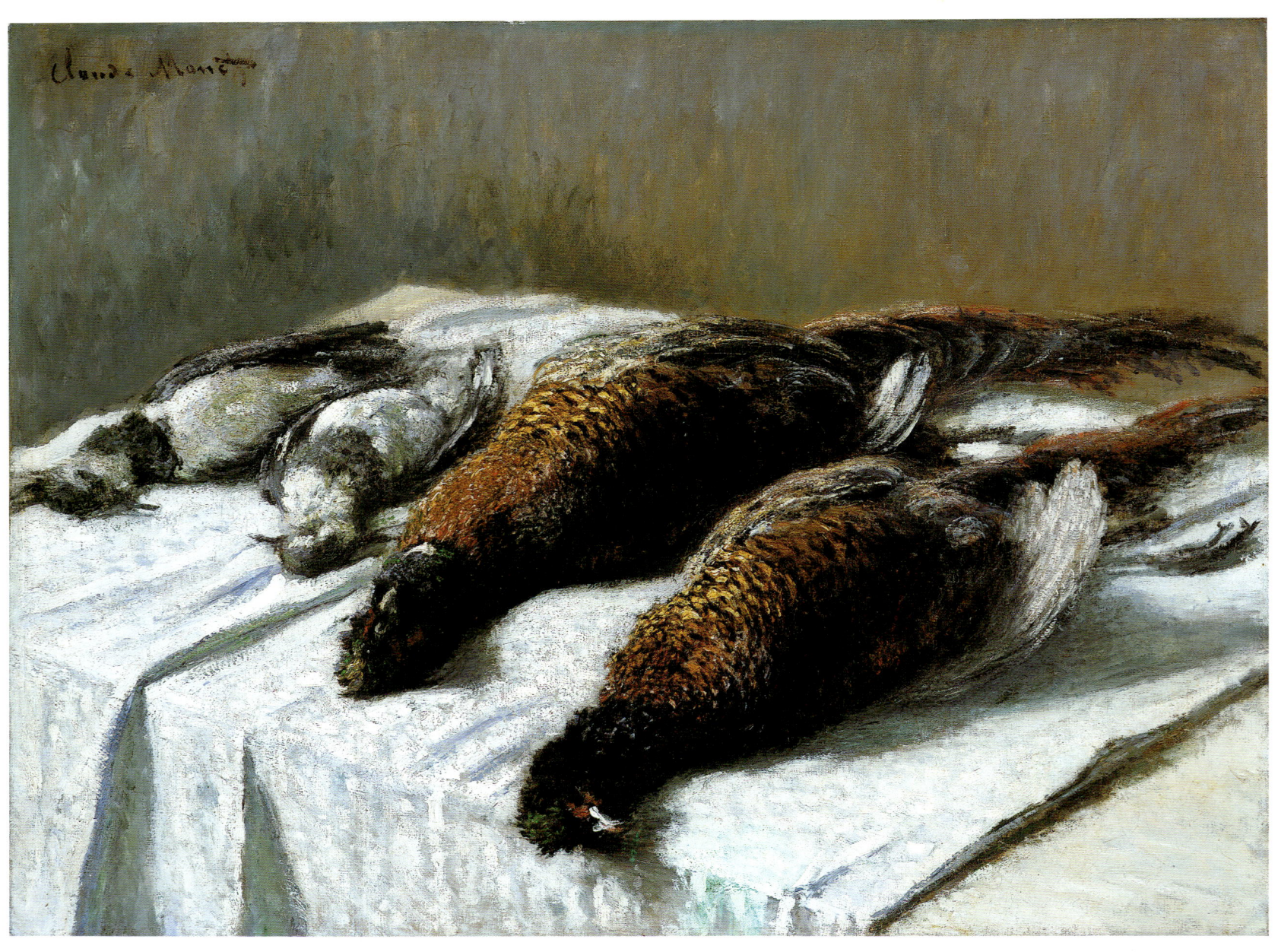

Still Life with Pheasants and Plovers c.1880
Oil on canvas
26¼×35½ inches (67.9×90.2 cm)
The Minneapolis Institute of Arts

Vase of Chrysanthemums 1880
Oil on canvas
39¼×28¼ inches (99.6×73 cm)
National Gallery of Art, Washington

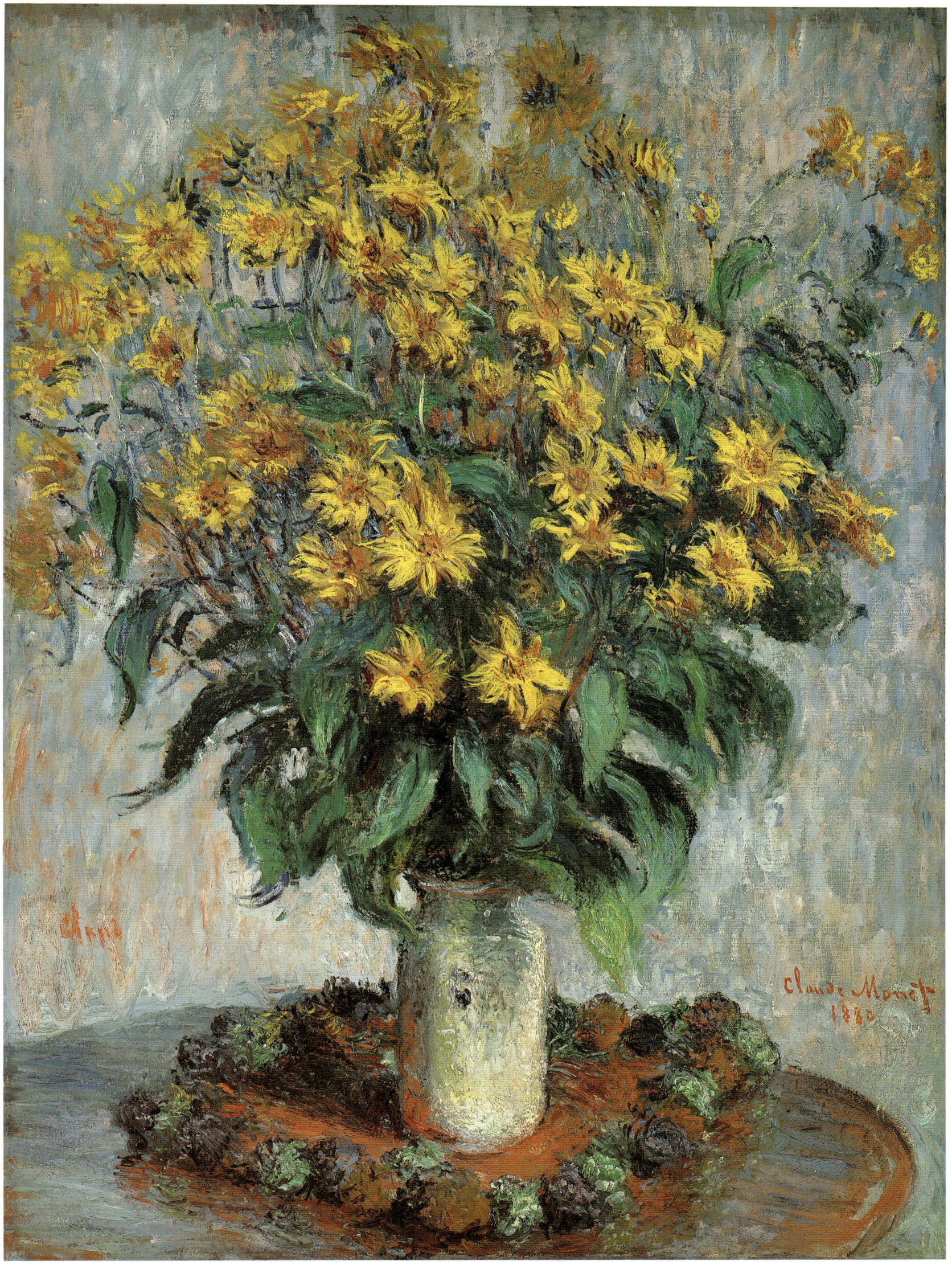

The Church at Varengeville
1882
Oil on canvas
25½×32 inches (65×81 cm)
Barber Institute of Fine Arts, University
of Birmingham

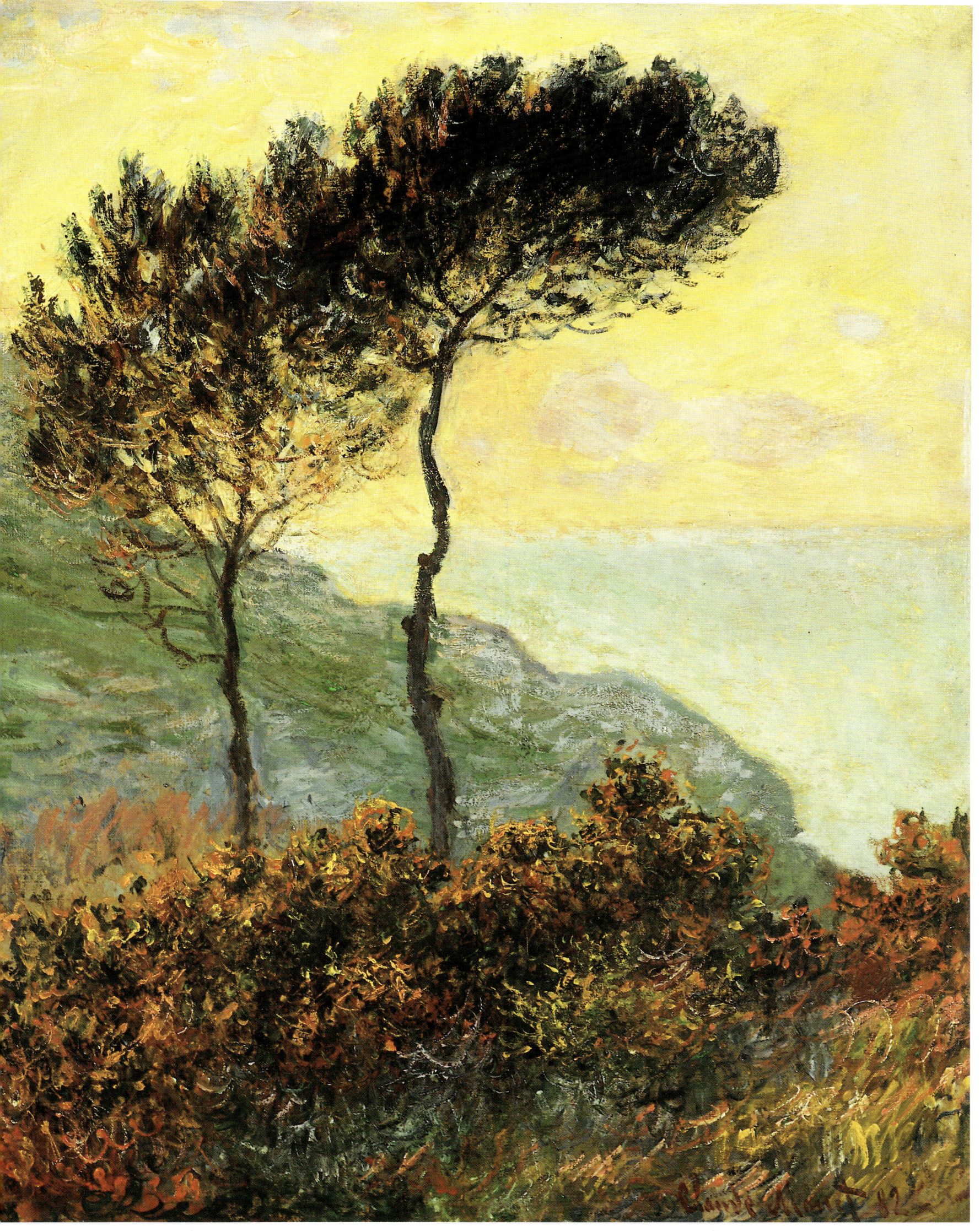

The Cliff Walk, Pourville 1882
Oil on canvas
25¼×31½ inches (65×81 cm)
Art Institute of Chicago

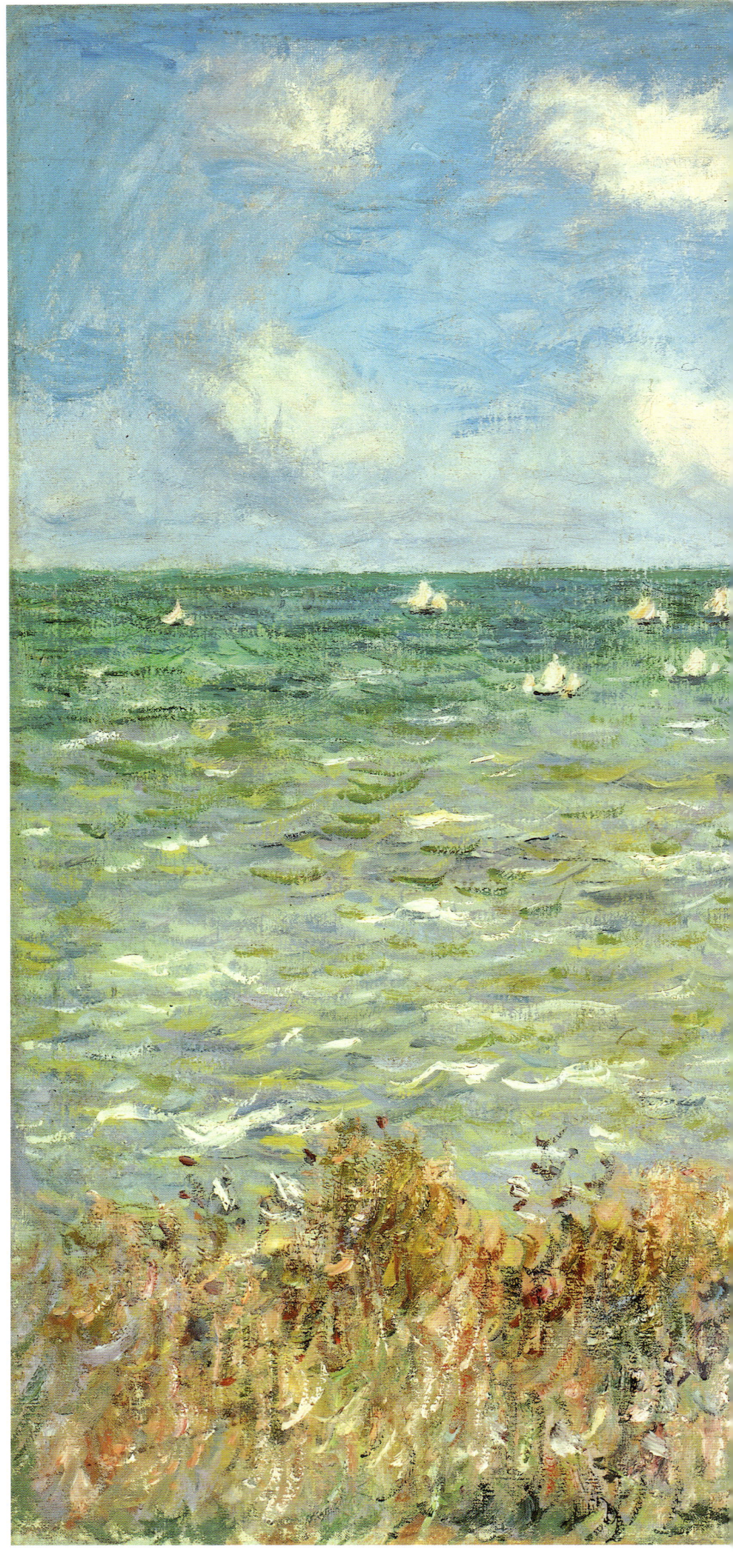

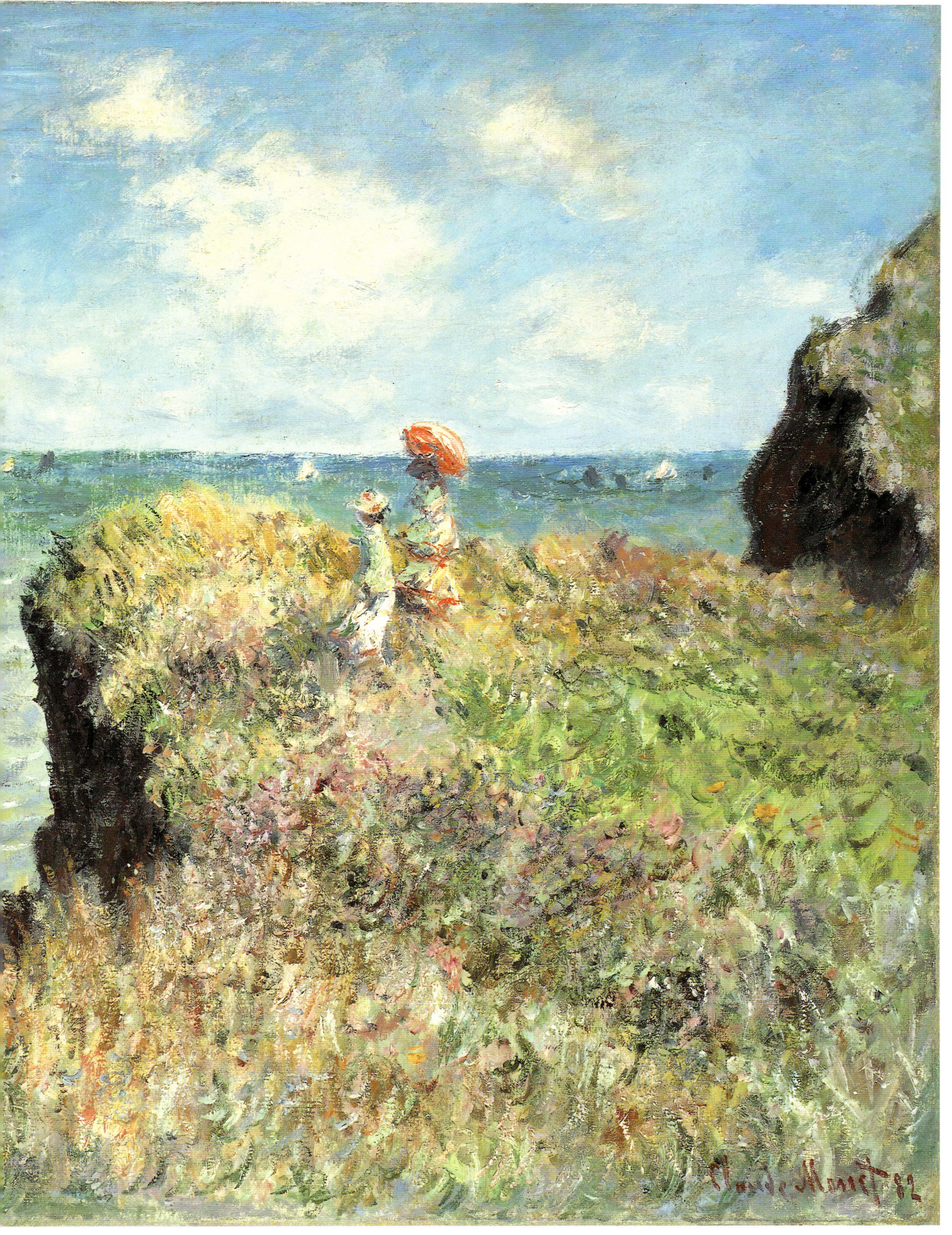

Rough Sea, Etretat 1883
Oil on canvas
32×39¼ inches (81×100 cm)
Musée des Beaux-Arts, Lyons

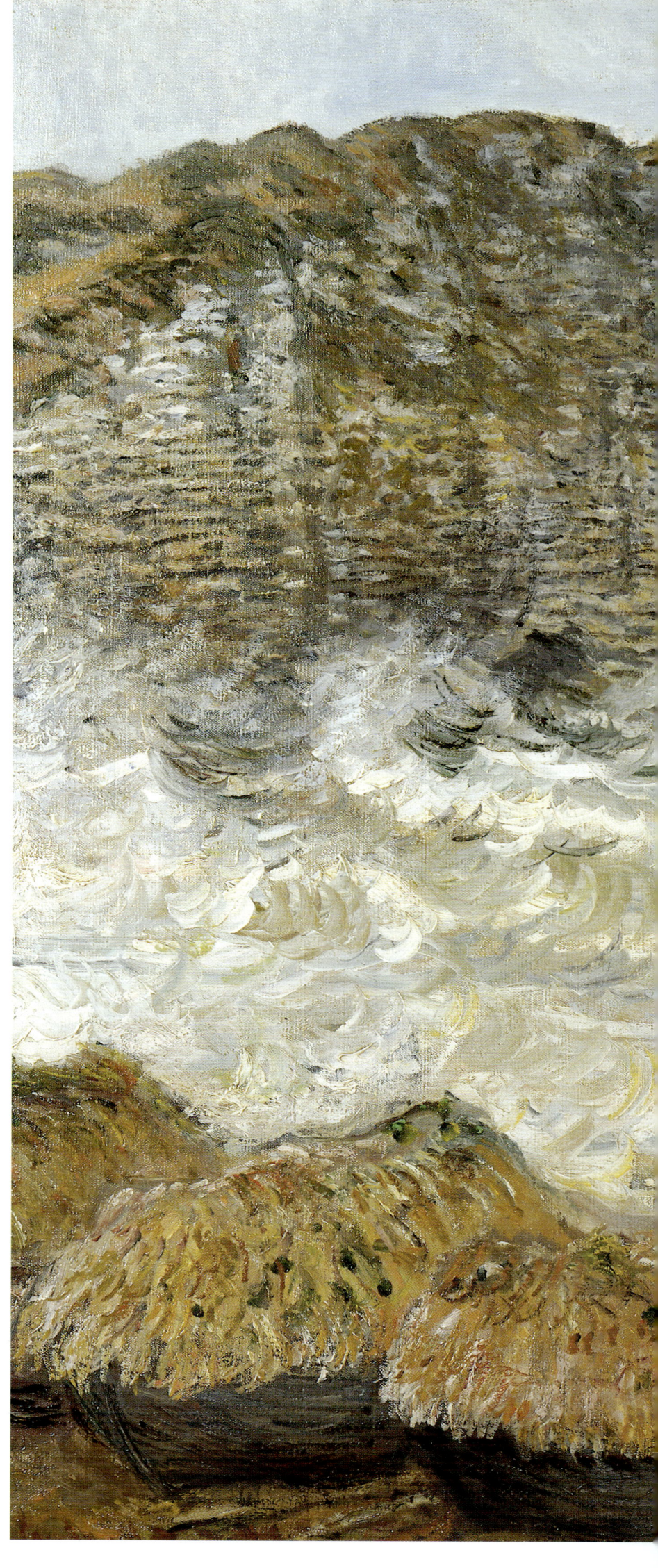

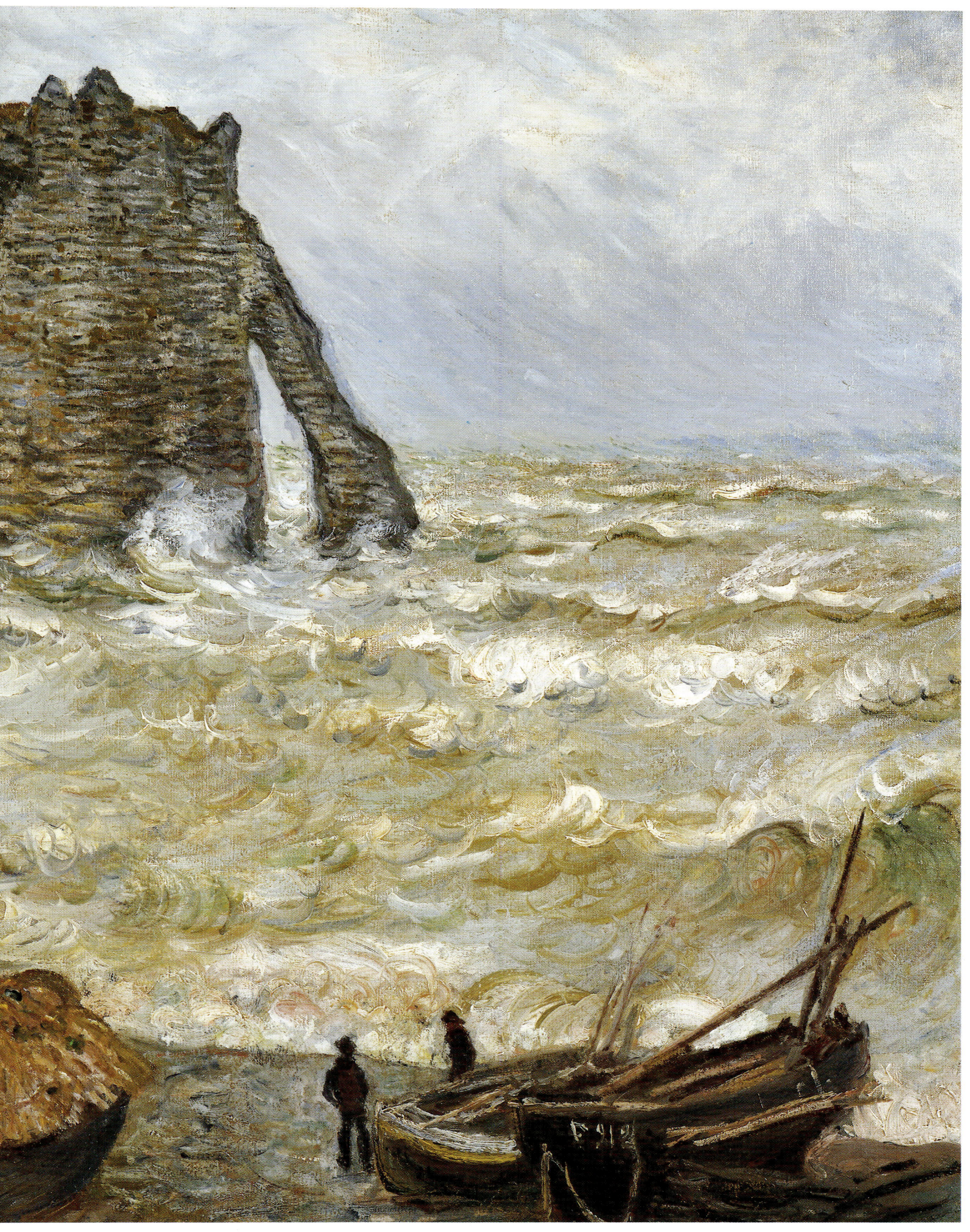

Boat at Giverny c.1887
Oil on canvas
38½×51½ inches (97.8×131.8 cm)
Musée d'Orsay, Paris

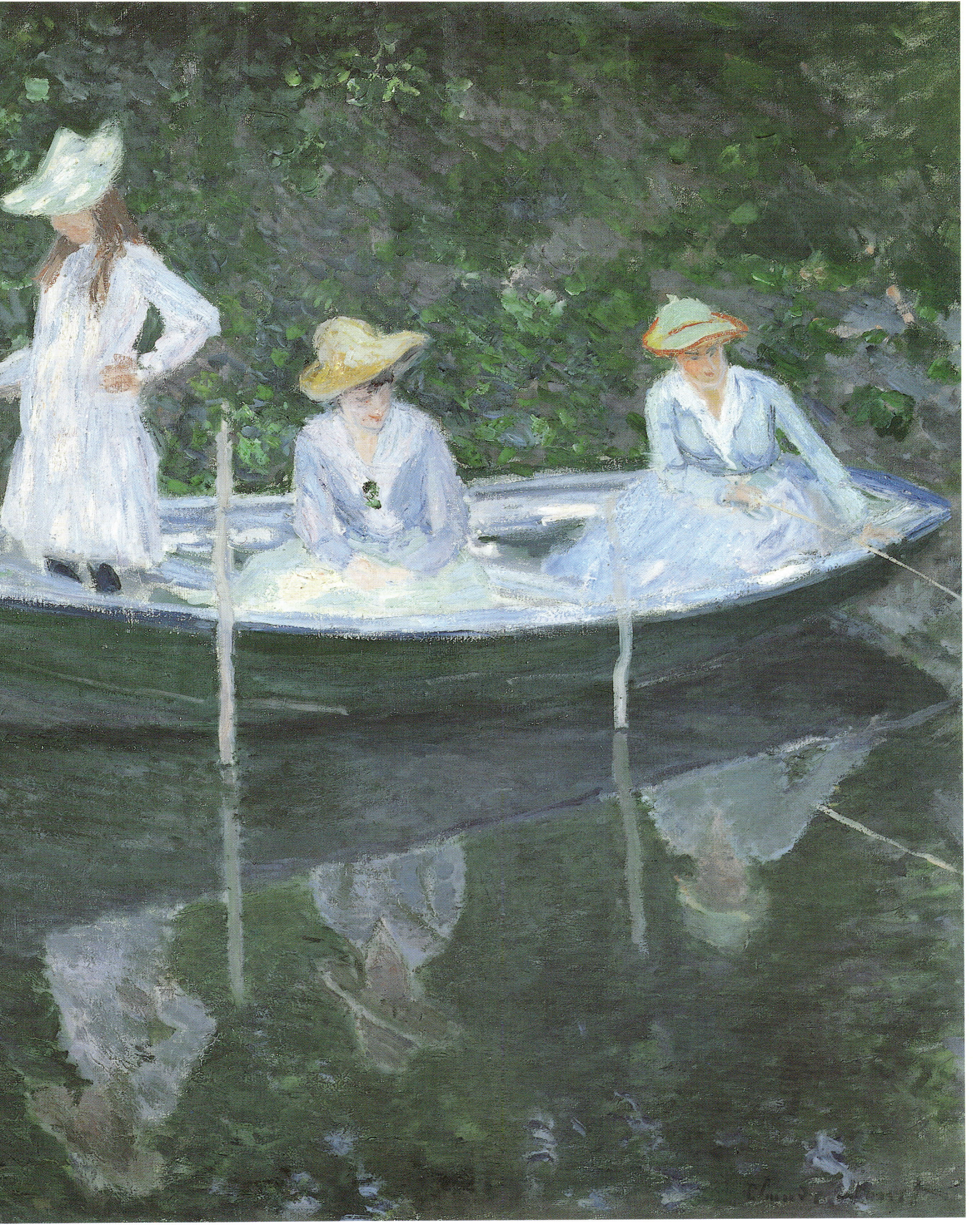

The Pyramides at Port-Coton
1886
Oil on canvas
25½×32 inches (65×81 cm)
Pushkin Museum, Moscow

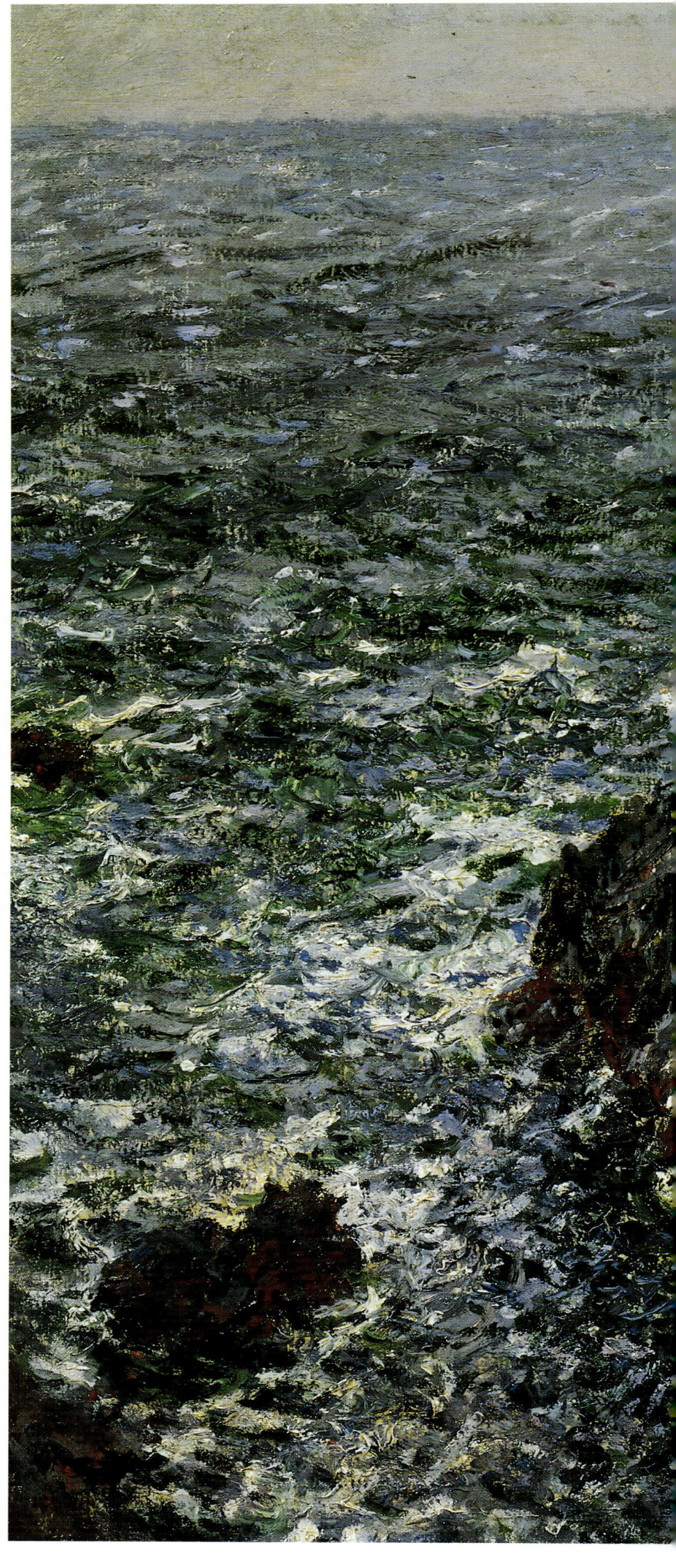

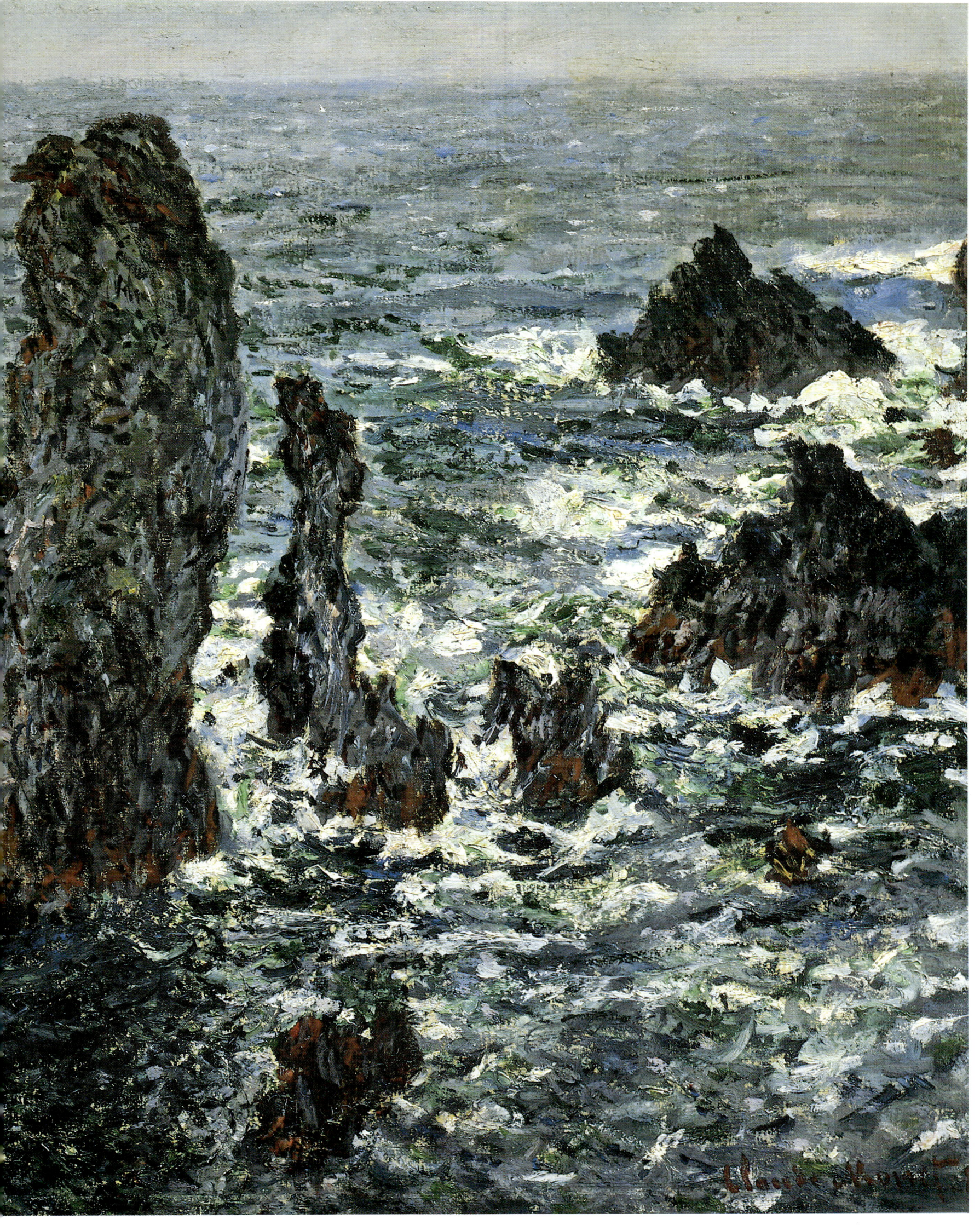

Stone Pine at Antibes 1888
Oil on canvas
25½×32 inches (65×81 cm)
Museum of Fine Arts, Boston,
Juliana Cheney Edwards Collection

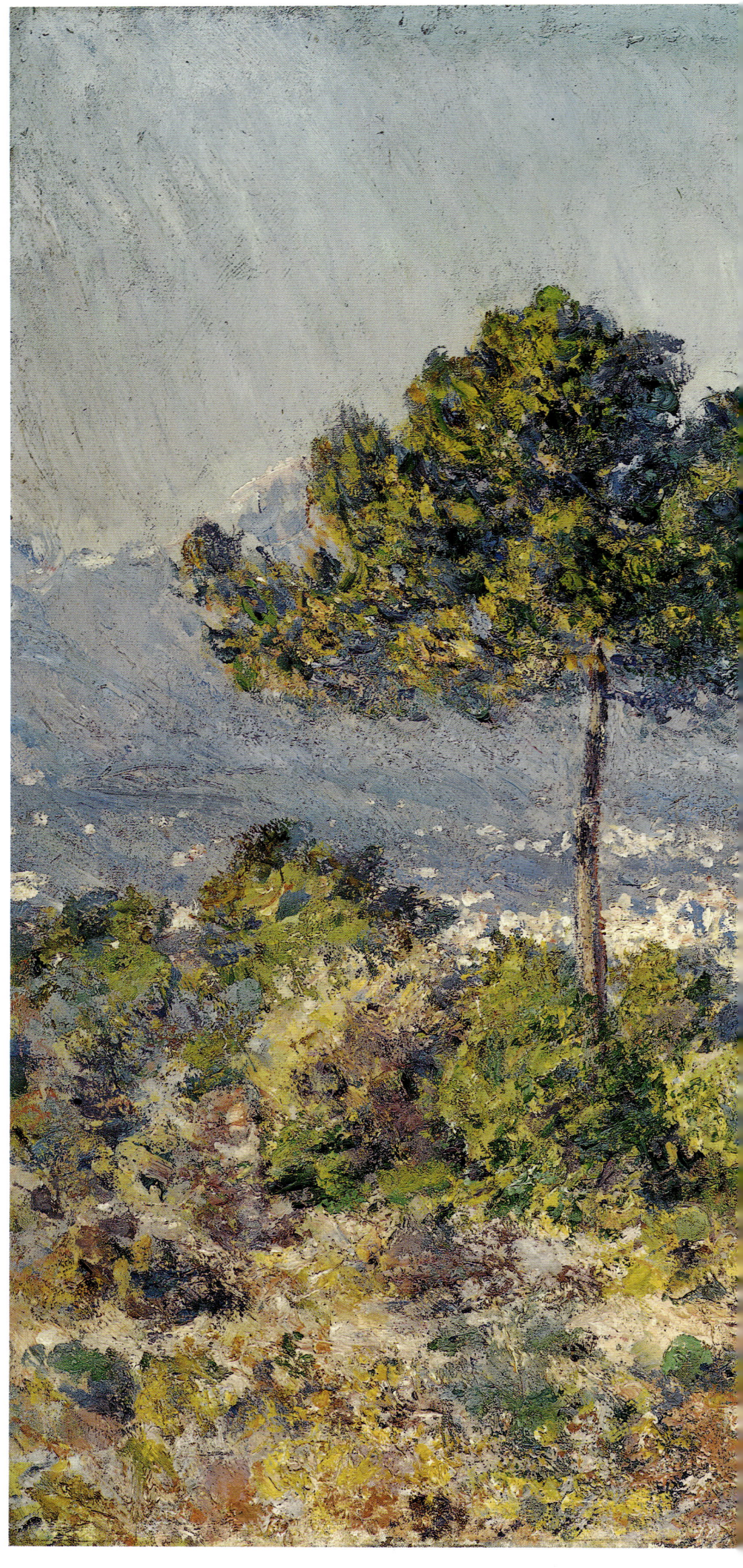

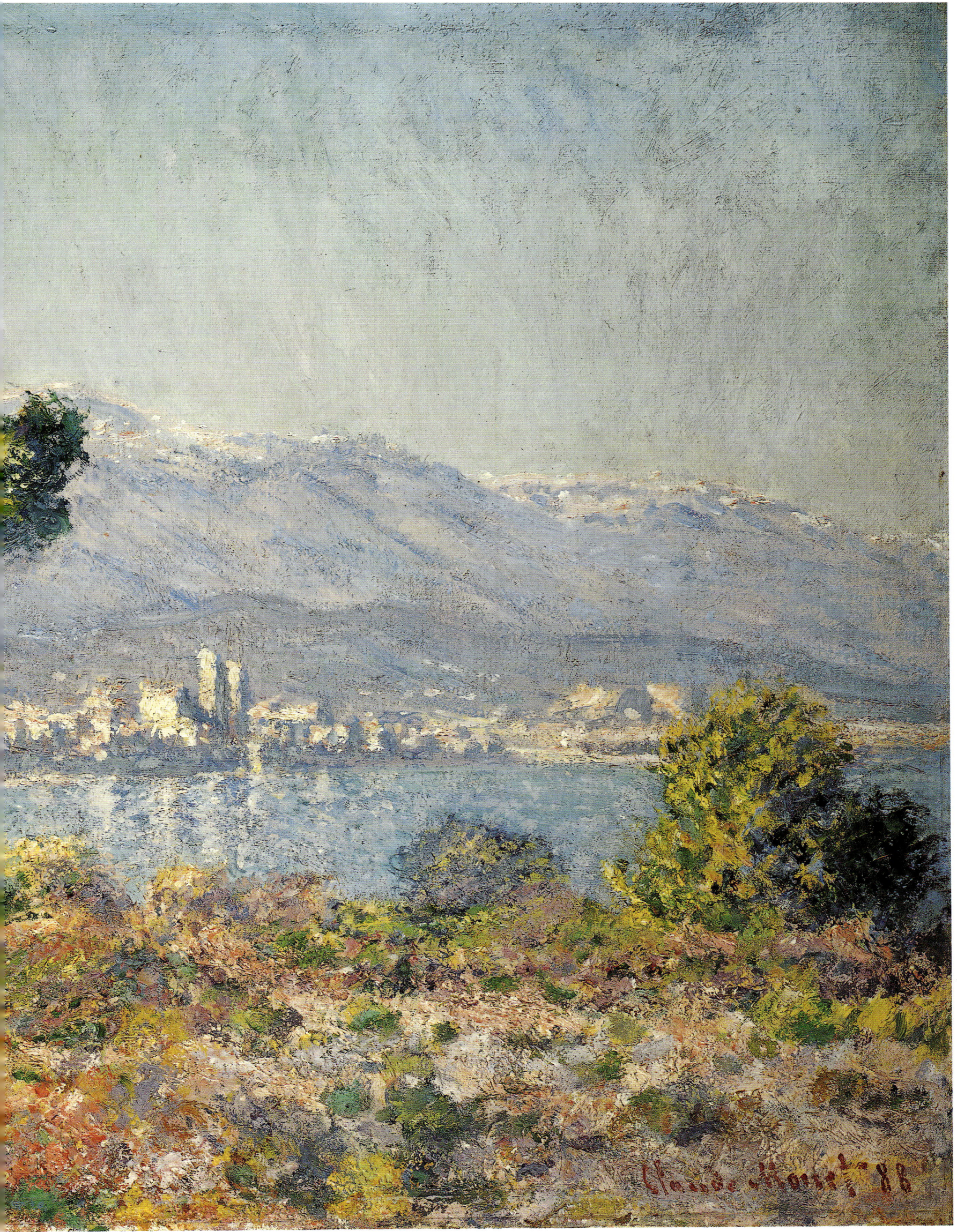

Ravine of the Creuse 1889
Oil on canvas
25½×40 inches (65×92 cm)
Museum of Fine Arts, Boston,
Bequest of David P Kimball in memory of
his wife Clara Bertram Kimball

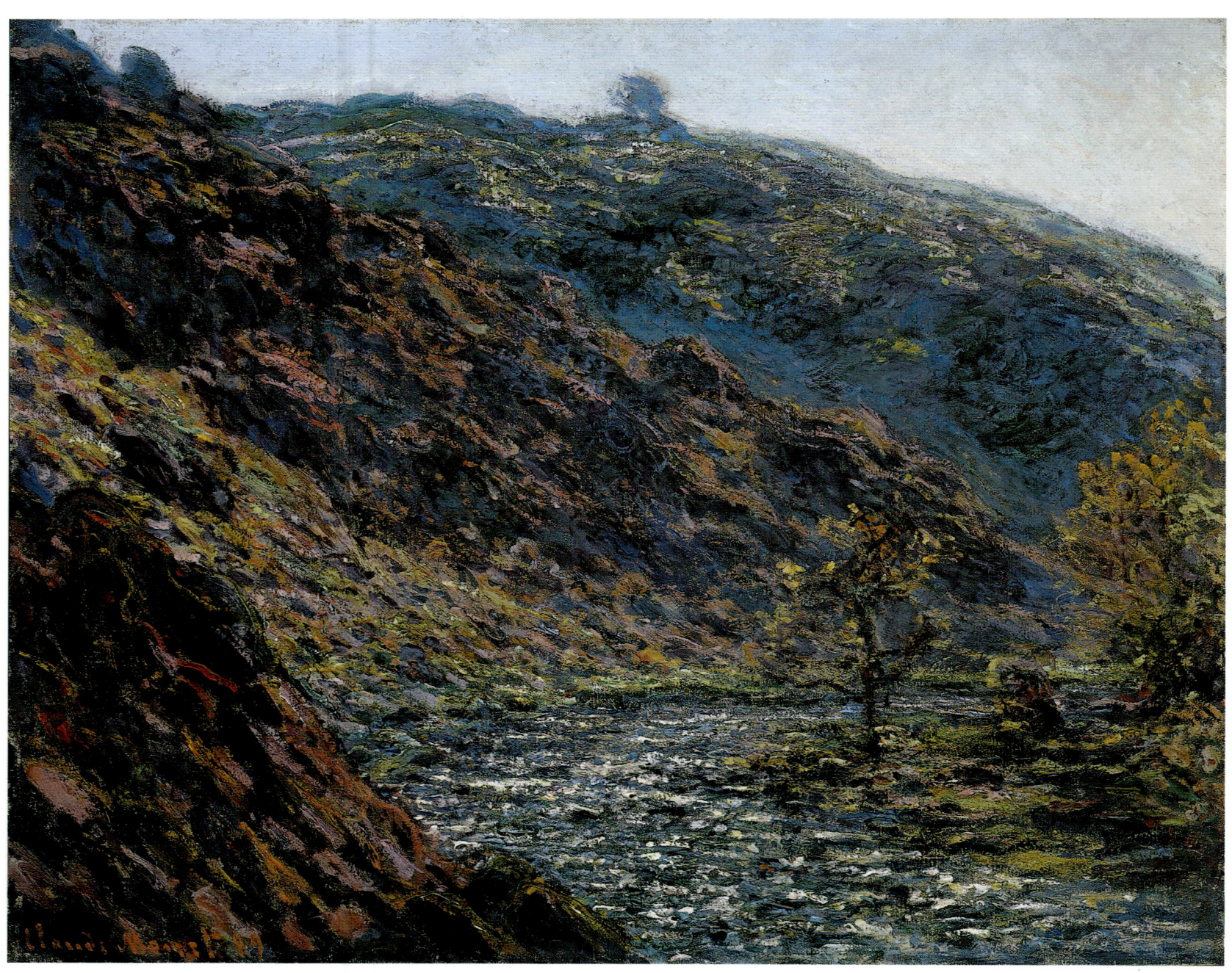

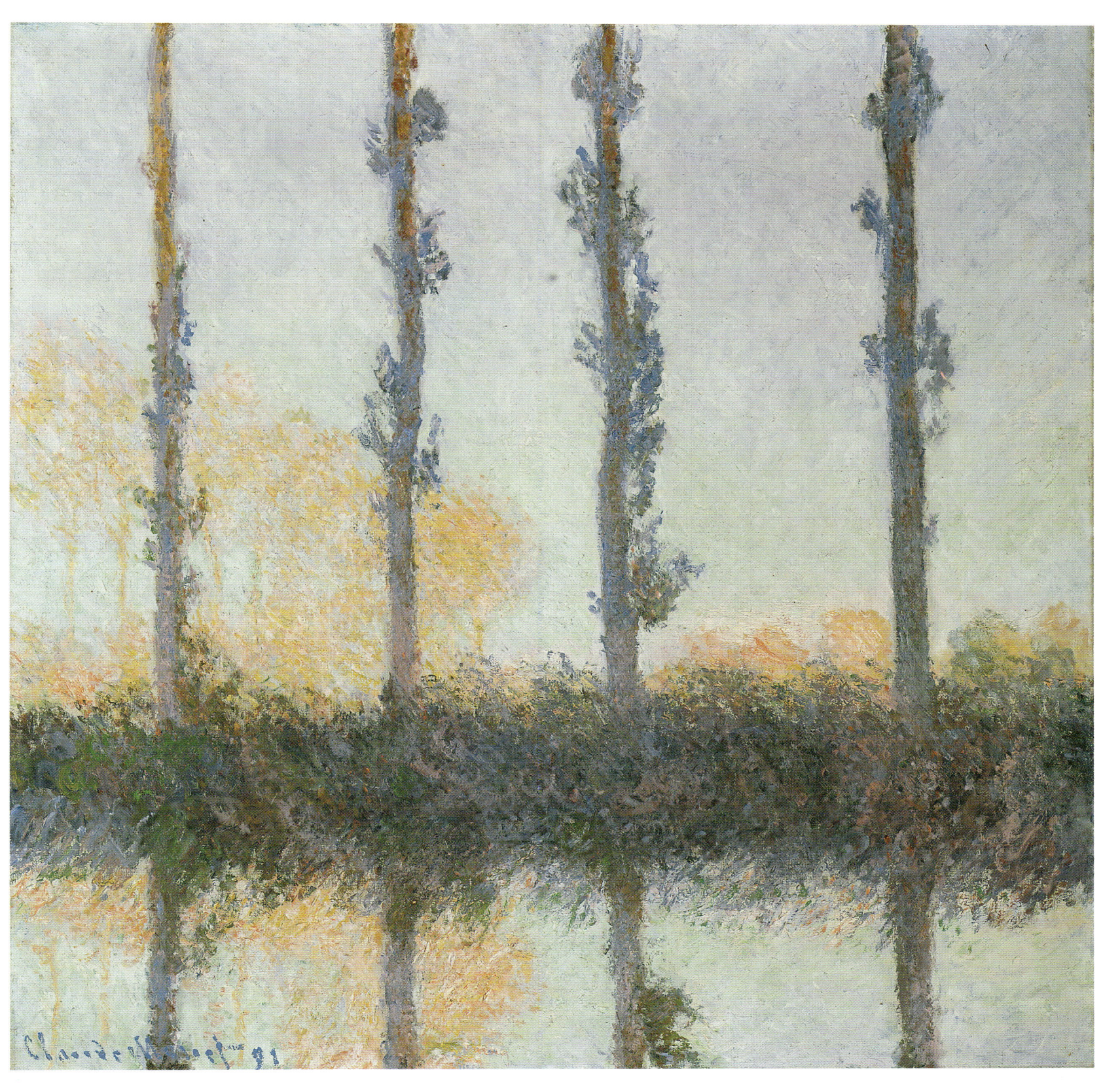

The Four Poplars 1891
Oil on canvas
32¼×32 inches (82×81.5 cm)
Metropolitan Museum of Art, New York

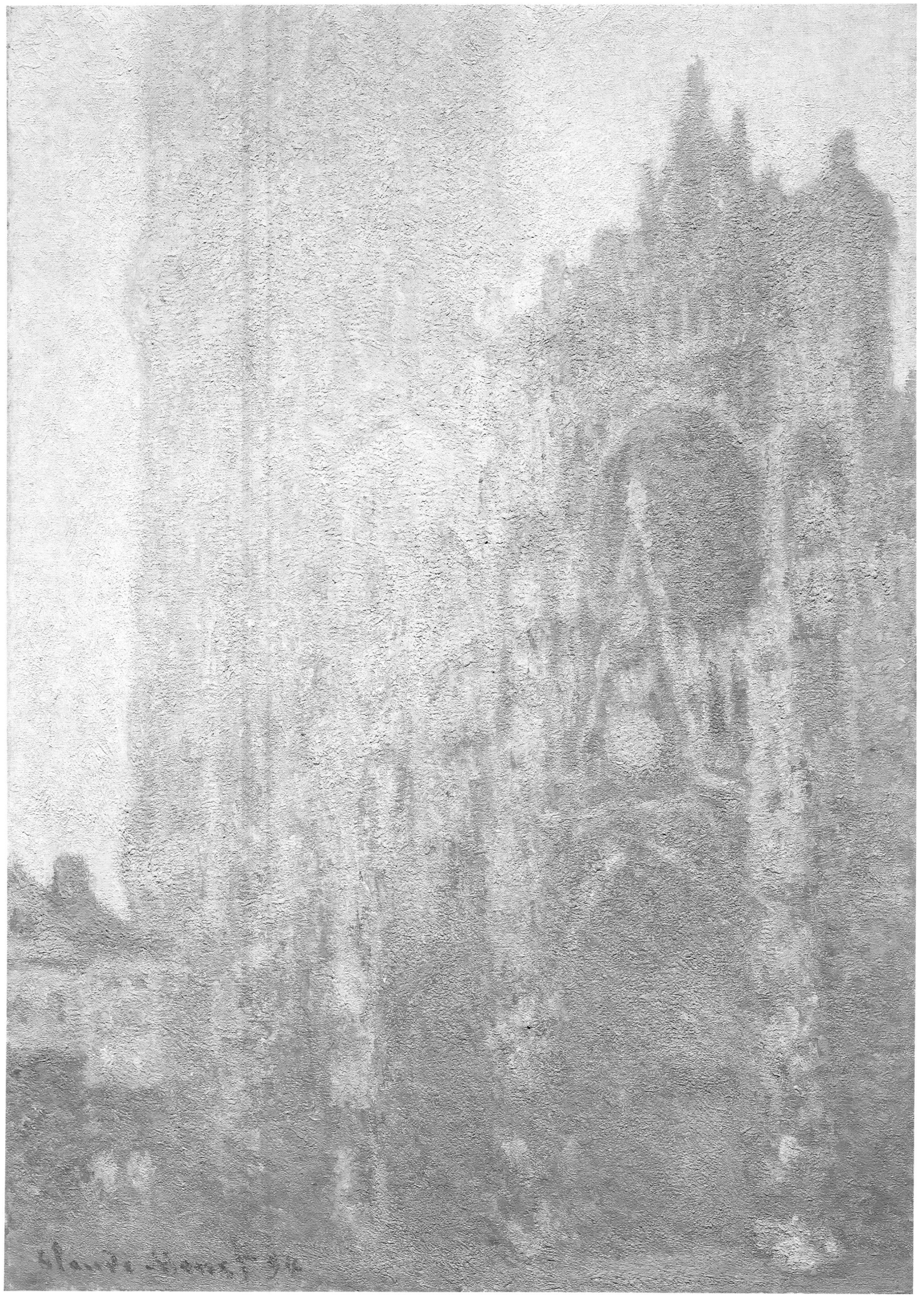

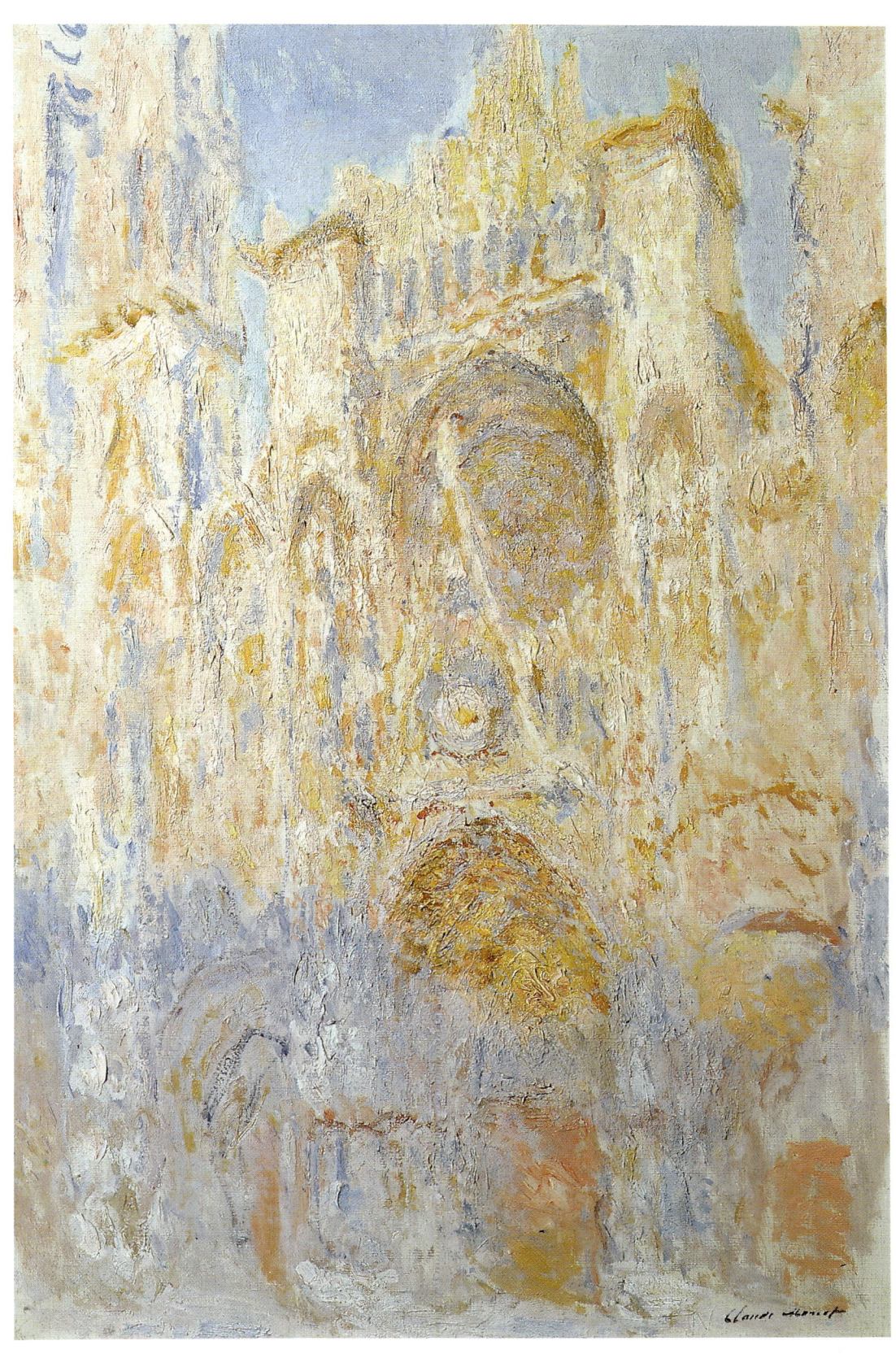

Rouen Cathedral at Sunset
1894
Oil on canvas
39¼×25½ inches (100×65 cm)
Musée Marmottan, Paris

**Rouen Cathedral – Tour
d'Albane, Early Morning**
Oil on canvas
41¾×29 inches (105×73.7 cm)
*Museum of Fine Arts, Boston,
Tompkins Collection*

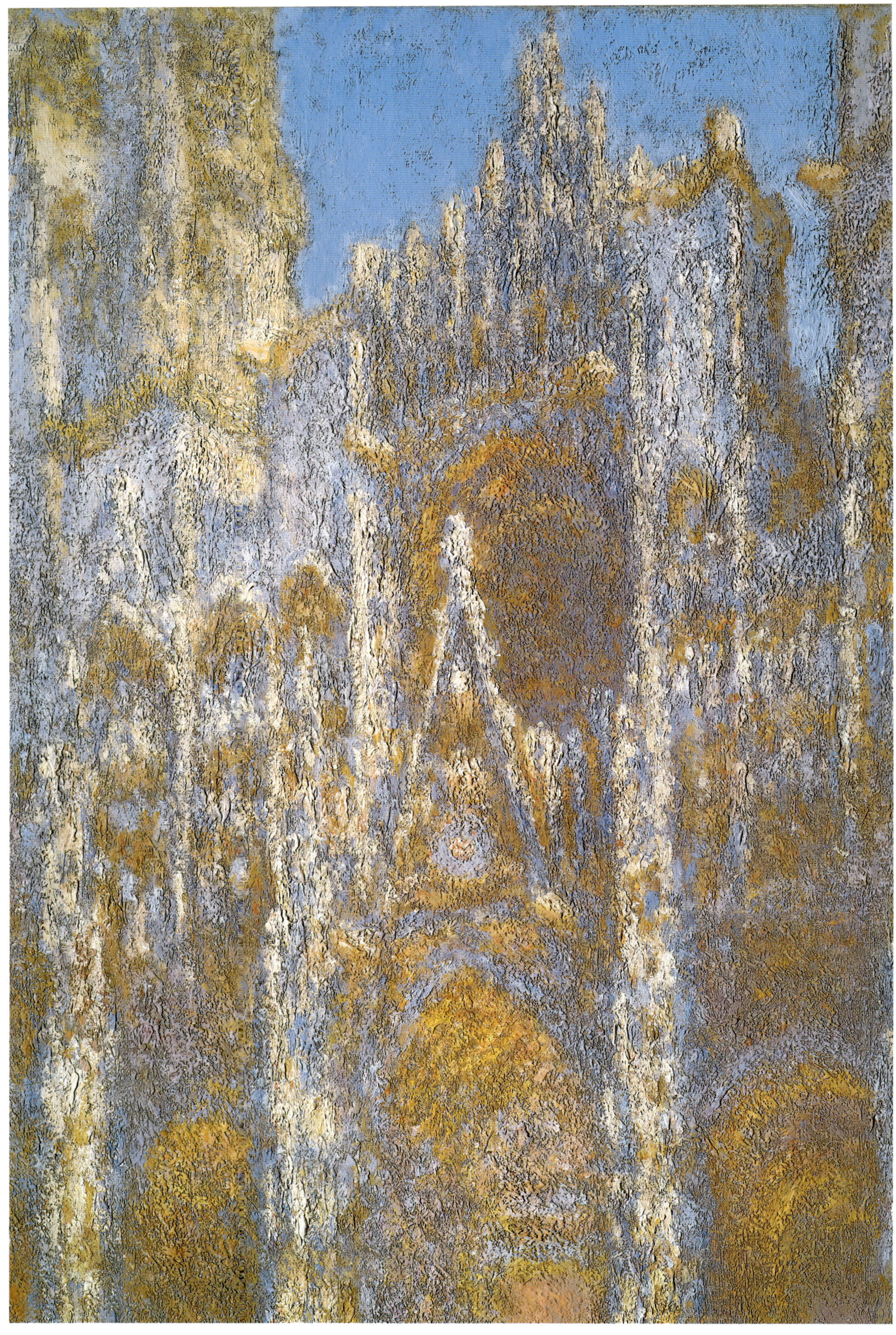

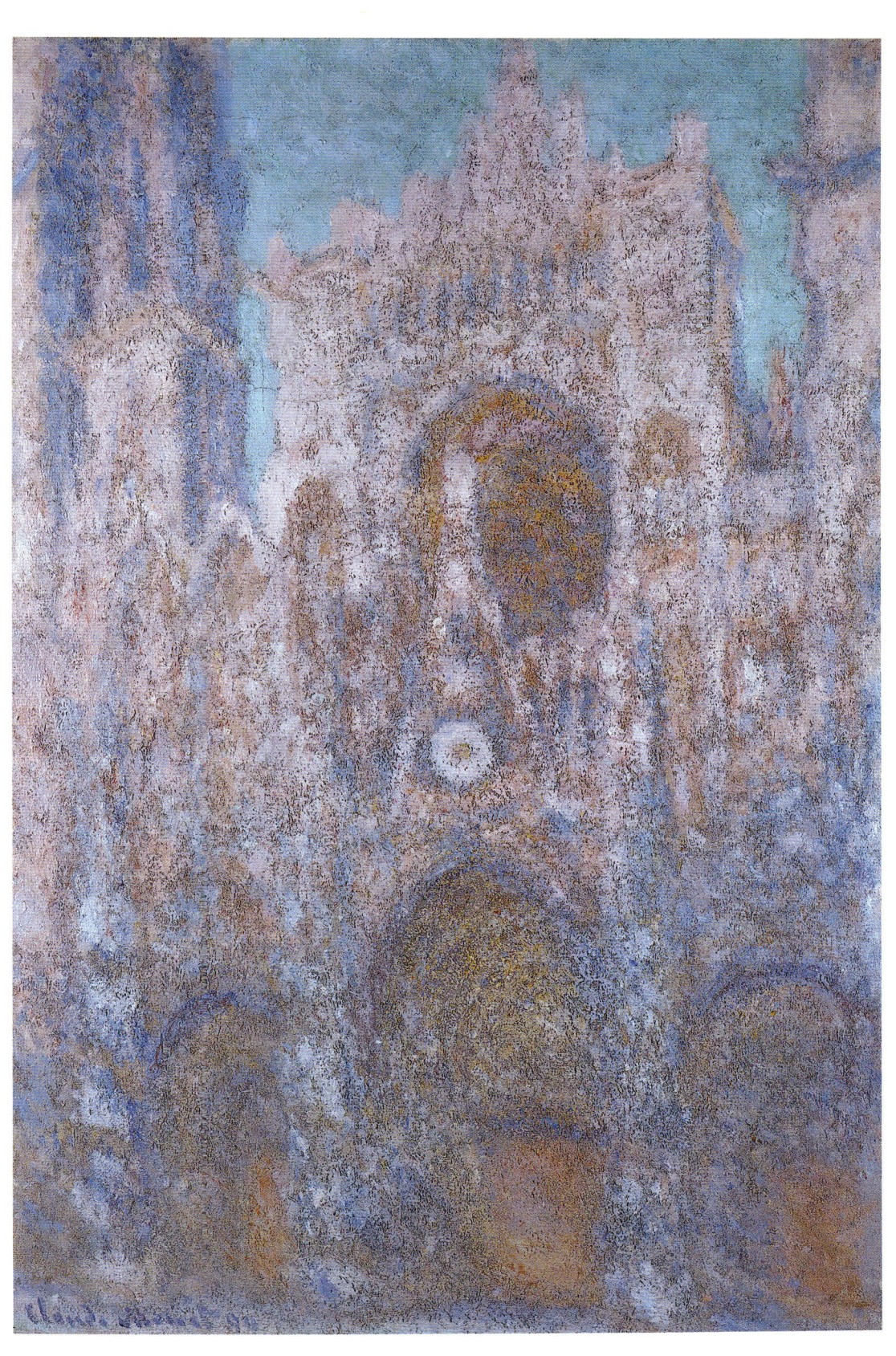

Rouen Cathedral, Facade 1894
Oil on canvas
39×26 inches (100×66 cm)
National Gallery of Wales, Cardiff

Rouen Cathedral, Facade
1892-94
Oil on canvas
39⅝×26 inches (100.6×66 cm)
*Museum of Fine Arts, Boston, Juliana Cheney
Edwards Collection*

Breaking up of the Ice on the Seine, Bennecourt 1893
Oil on canvas
25½×35¼ inches (65×100 cm)
Walker Art Gallery, Liverpool

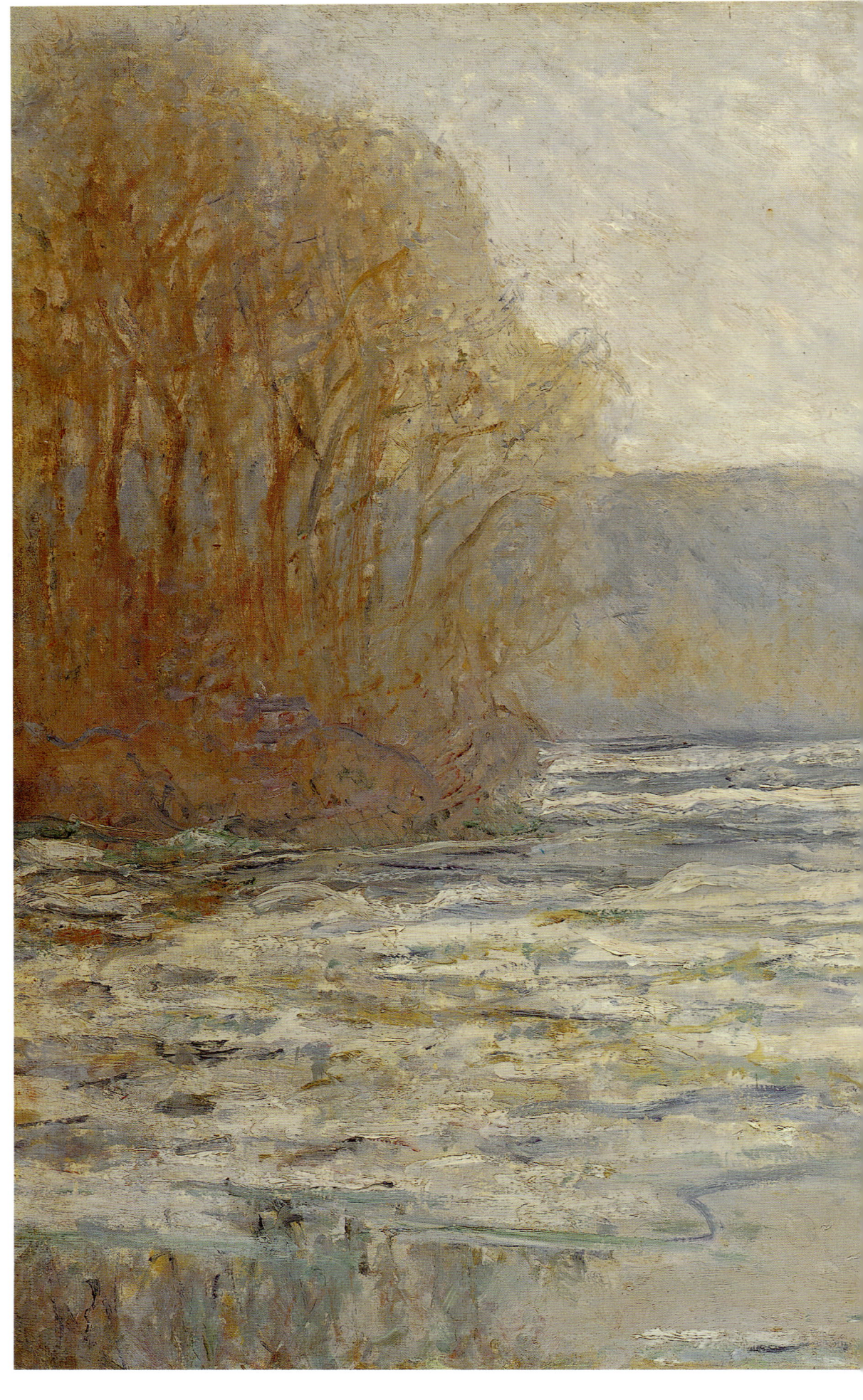

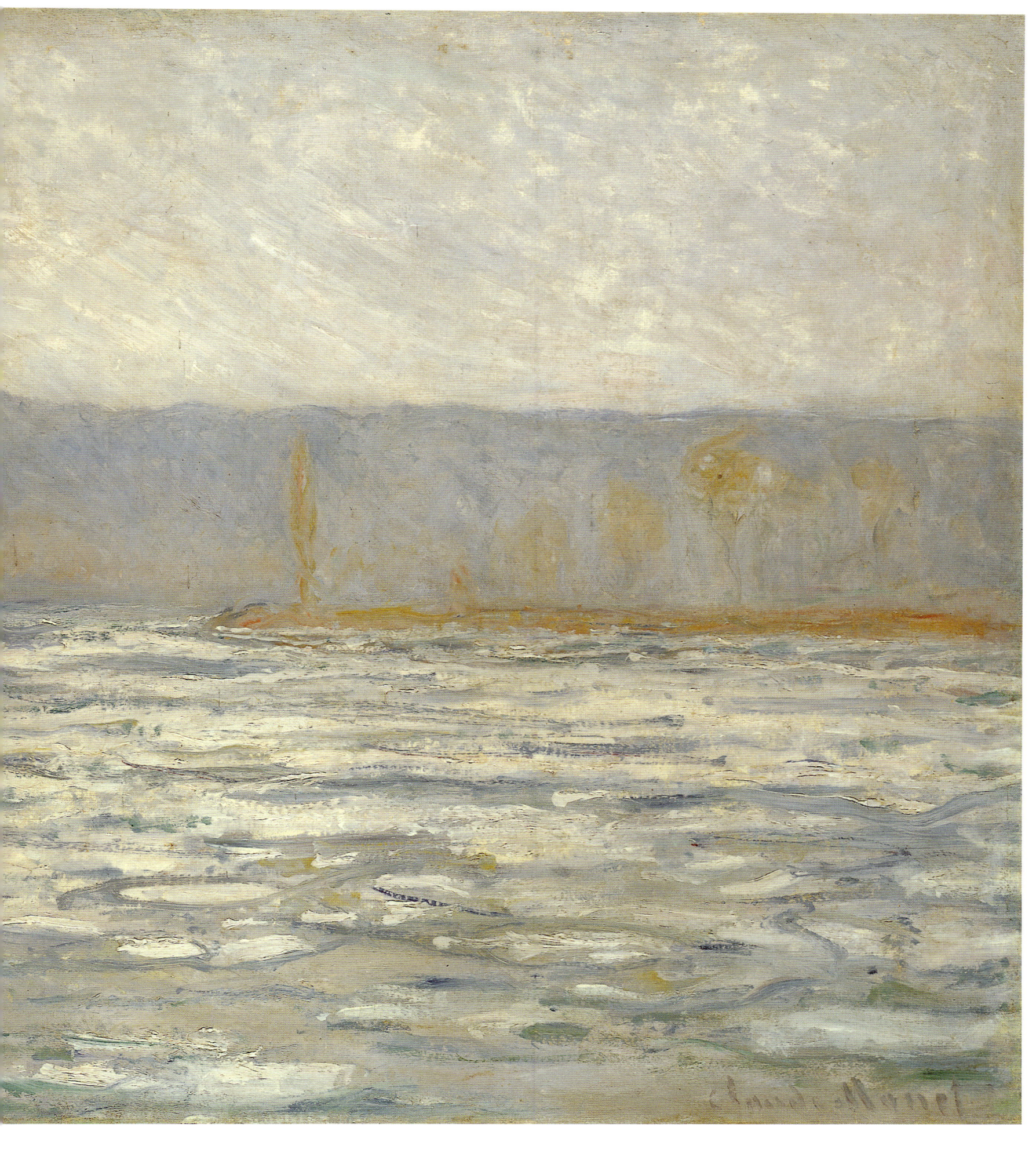

The Japanese Bridge
Oil on canvas
34¾×36¼ inches (88.2×92 cm)
The National Gallery, London

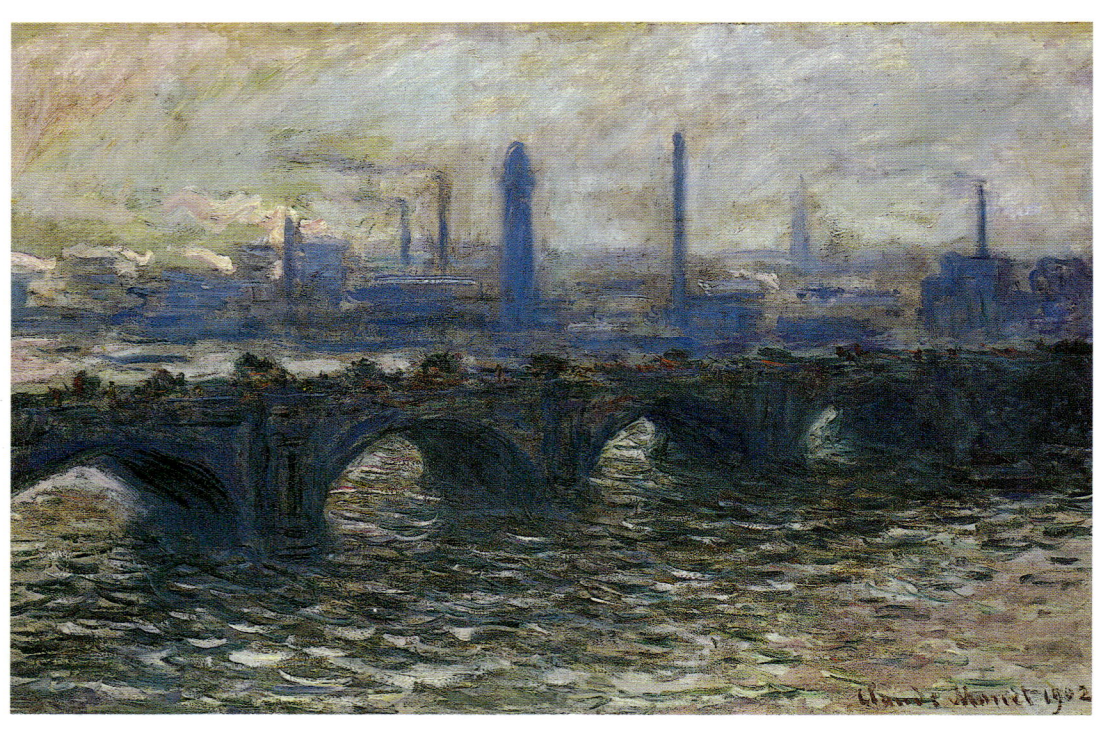

Waterloo Bridge, Overcast Weather 1902
Oil on canvas
25¾×39 inches (66×100 cm)
Kunsthalle, Hamburg

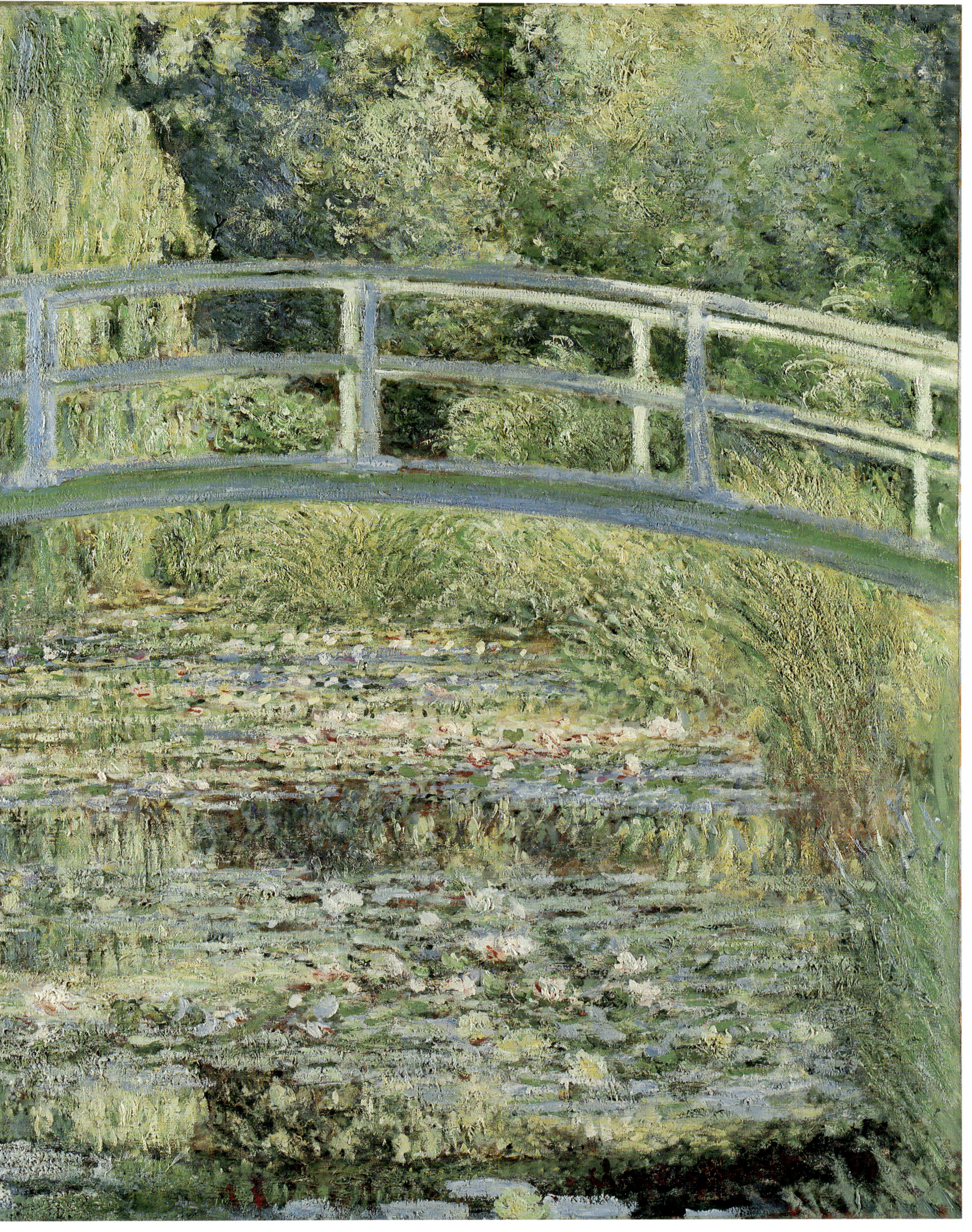

London, Houses of Parliament, Sunset 1903
Oil on canvas
30×36 inches (76.2×91.4 cm)
Private Collection

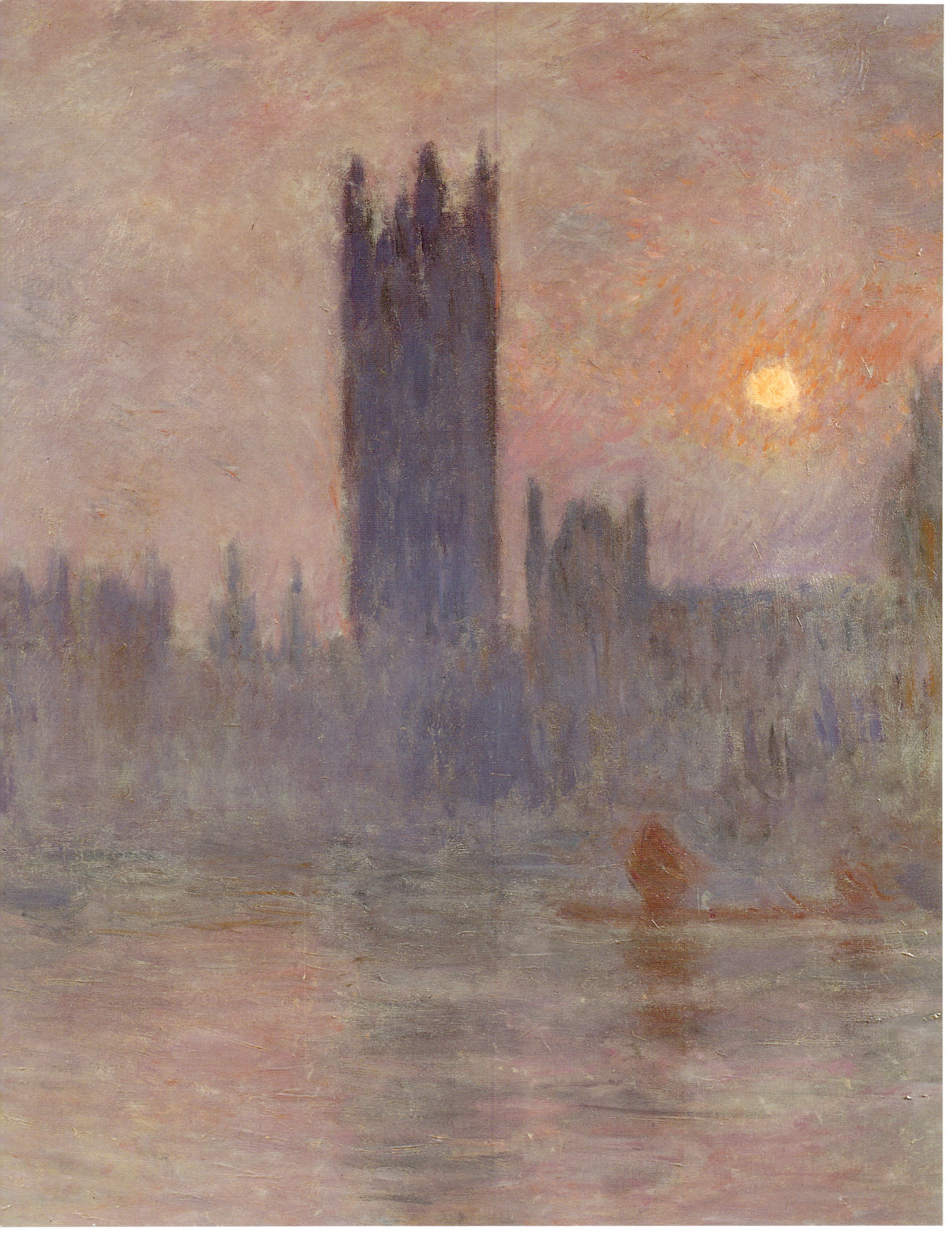

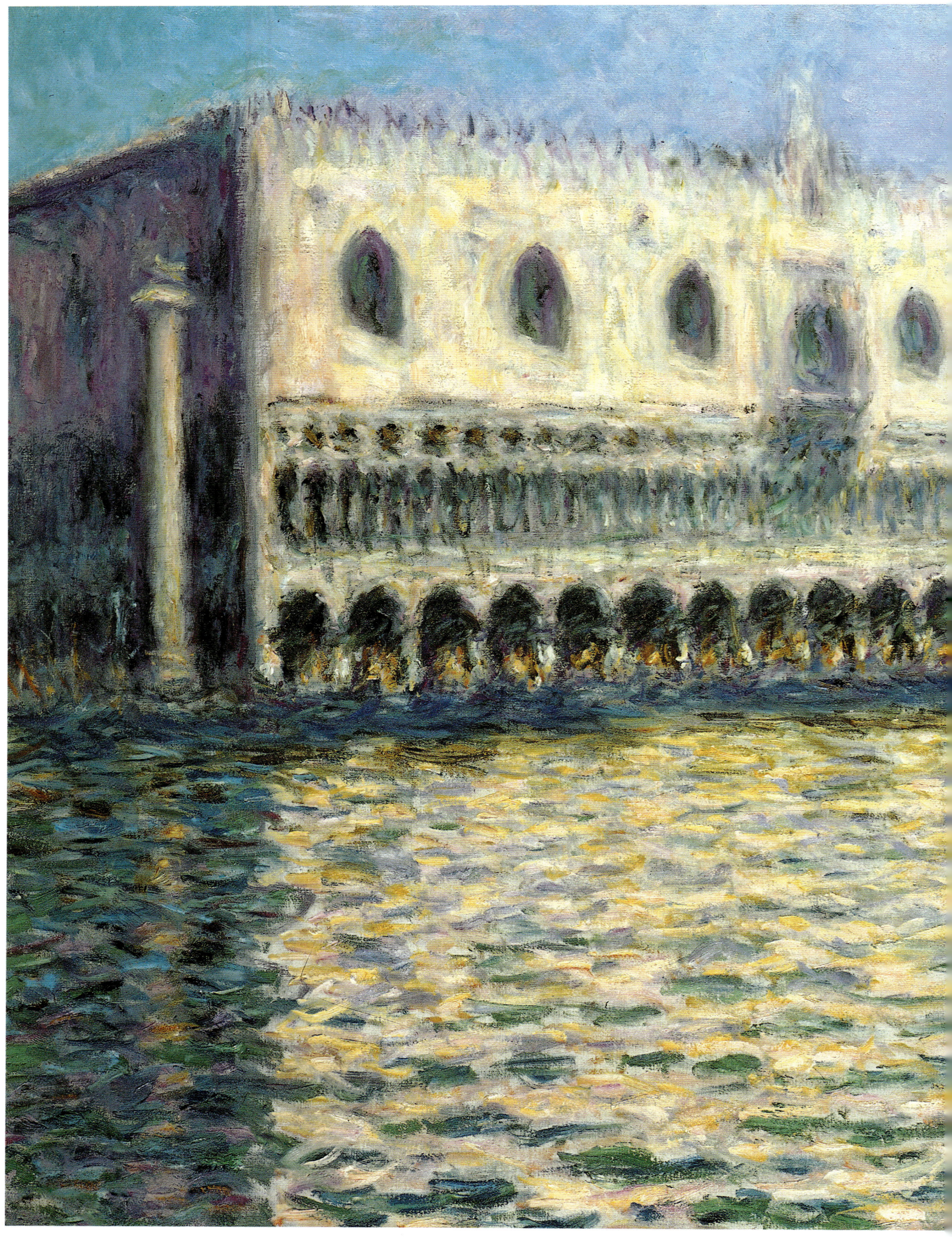

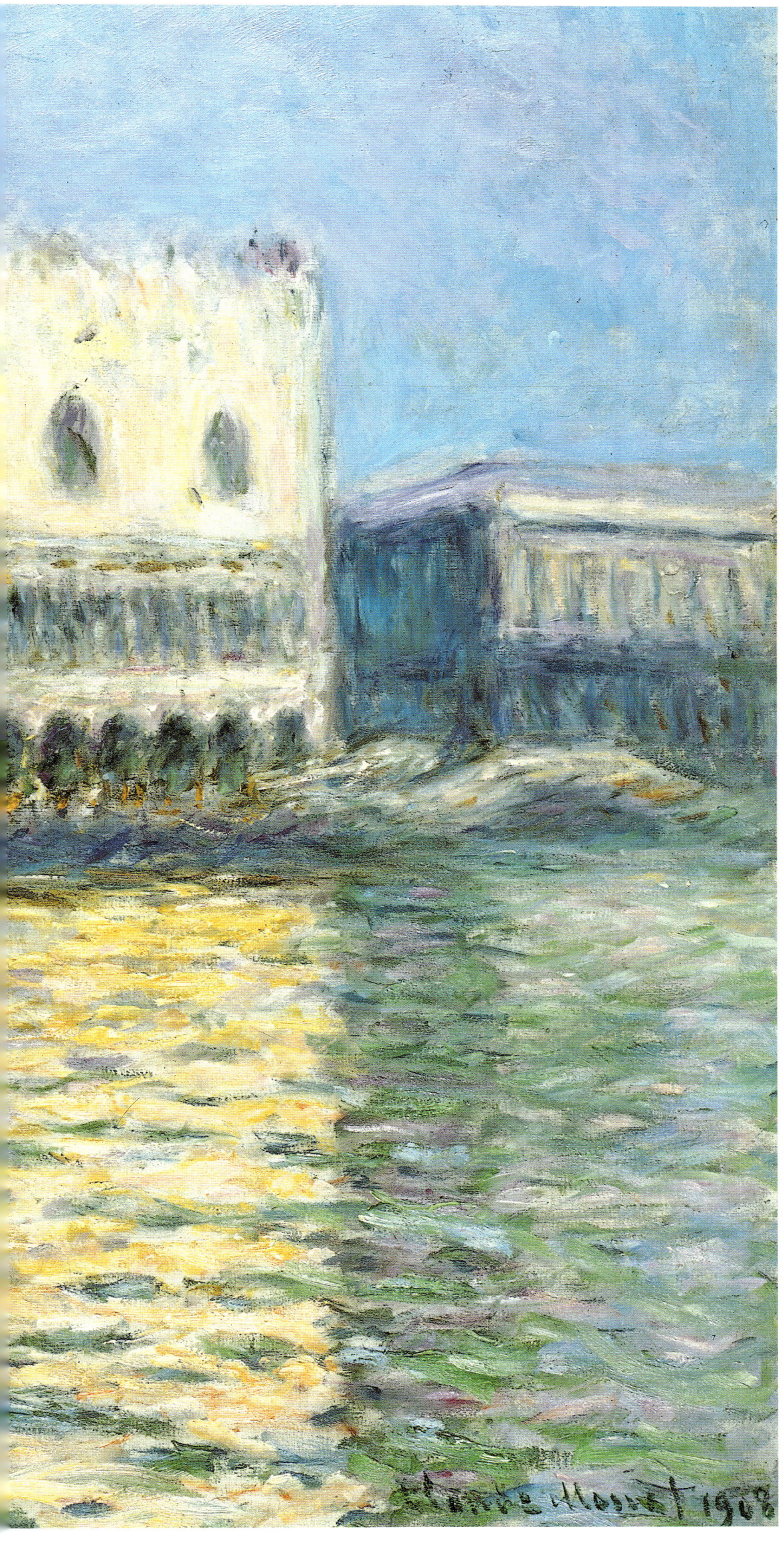

The Doge's Palace at Venice
Oil on canvas
31½×39 inches (81×100 cm)
The Brooklyn Museum, New York

The Grand Canal, Venice
Oil on canvas
29×36½ inches (73.5×92.5 cm)
Museum of Fine Arts, Boston

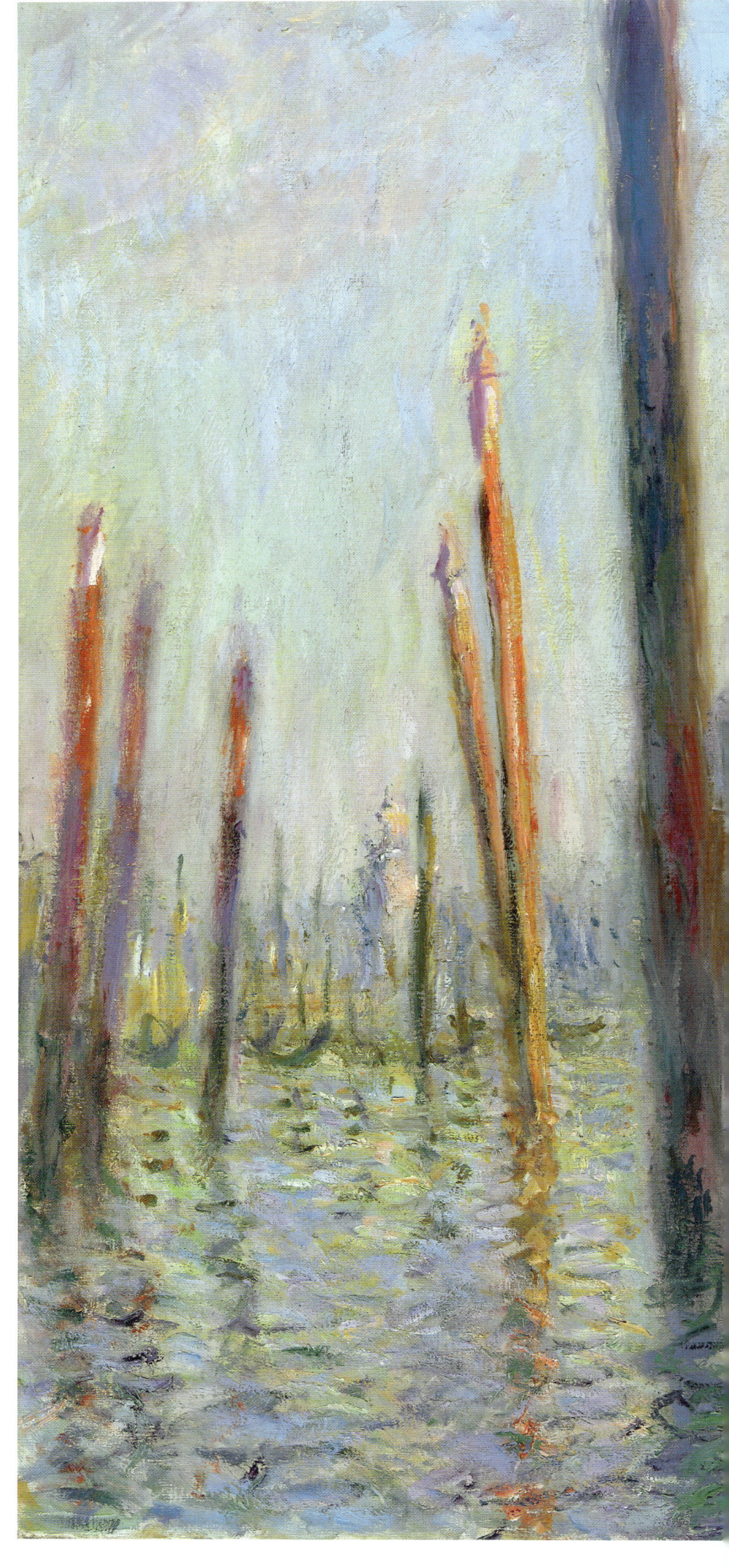

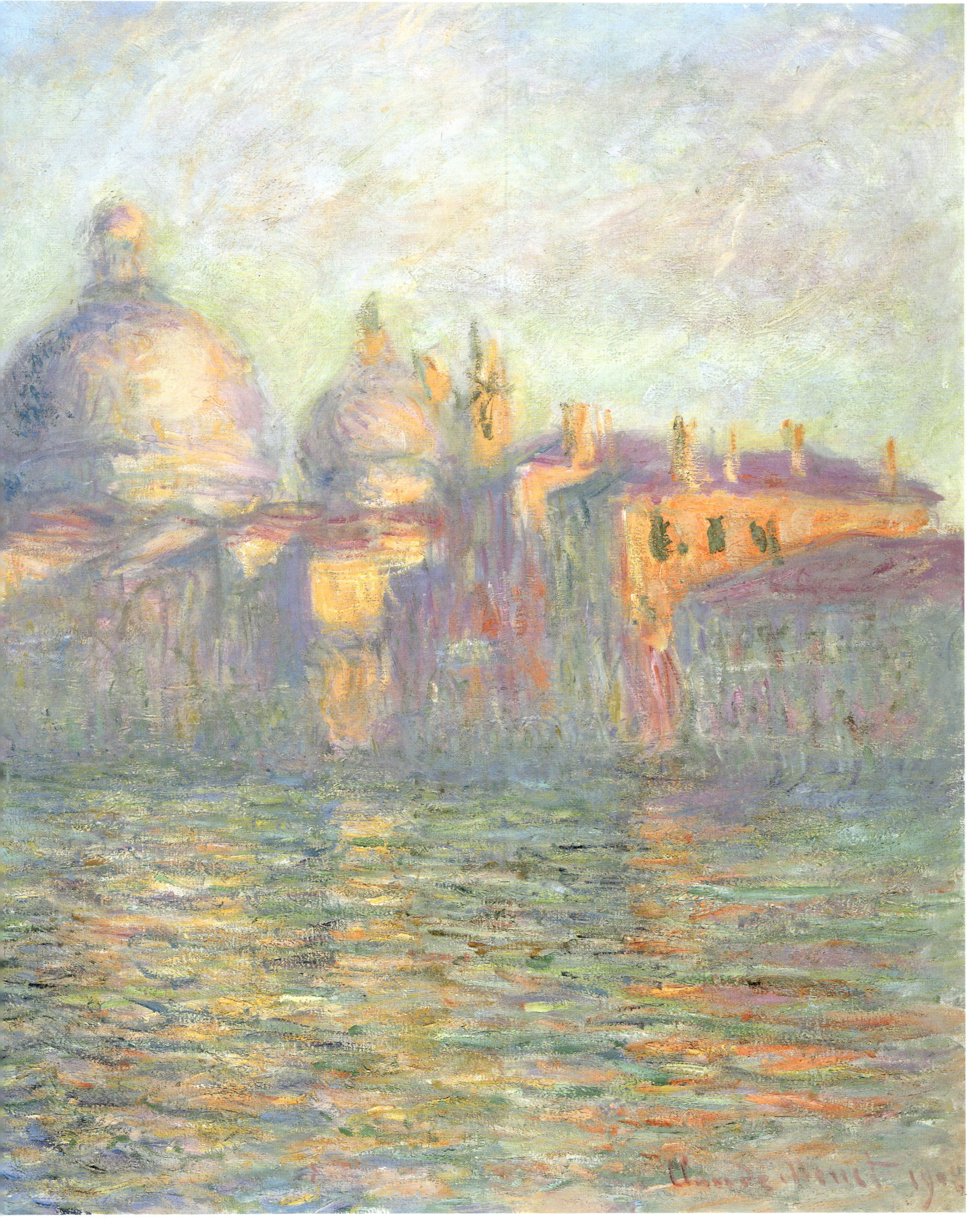

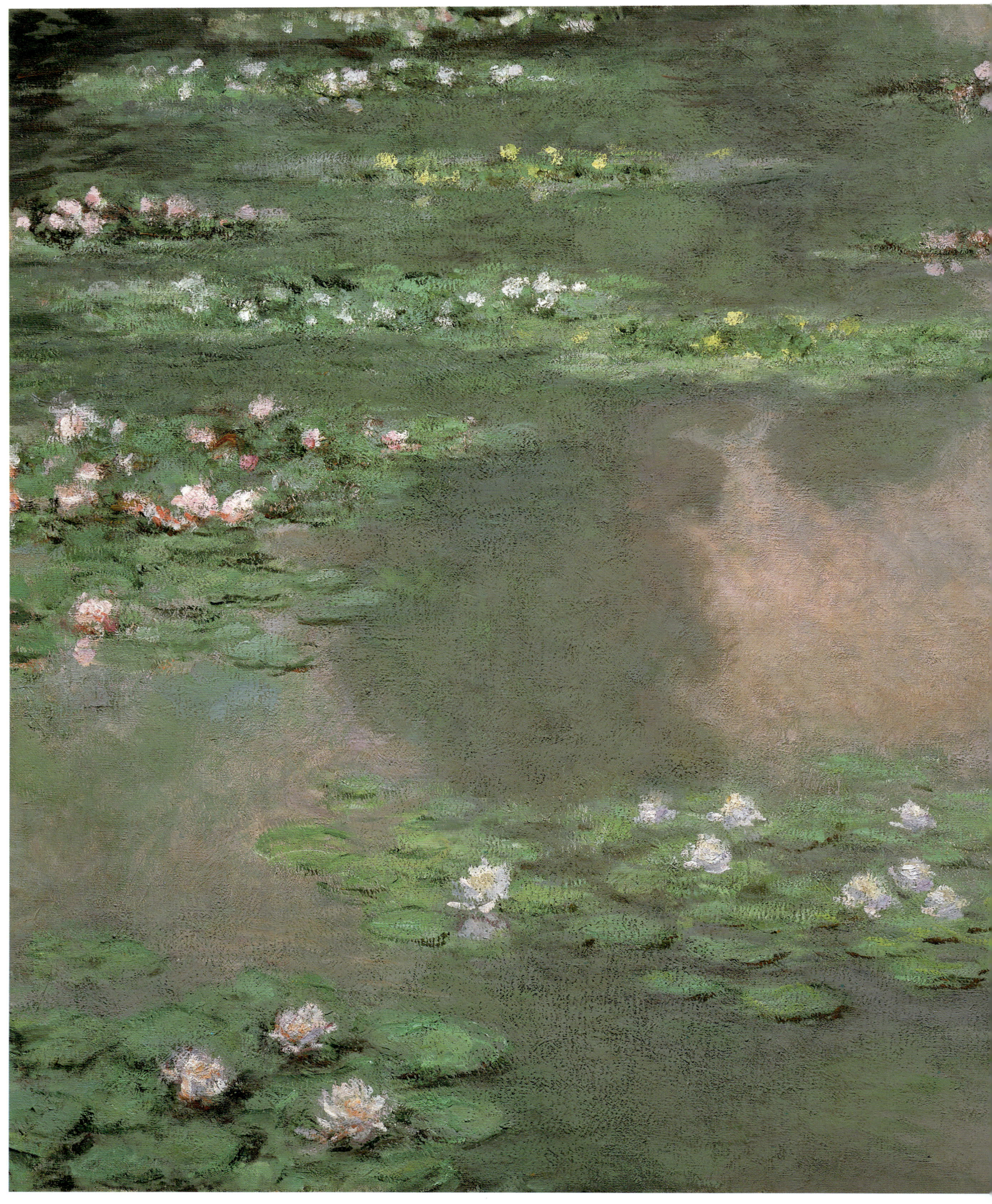

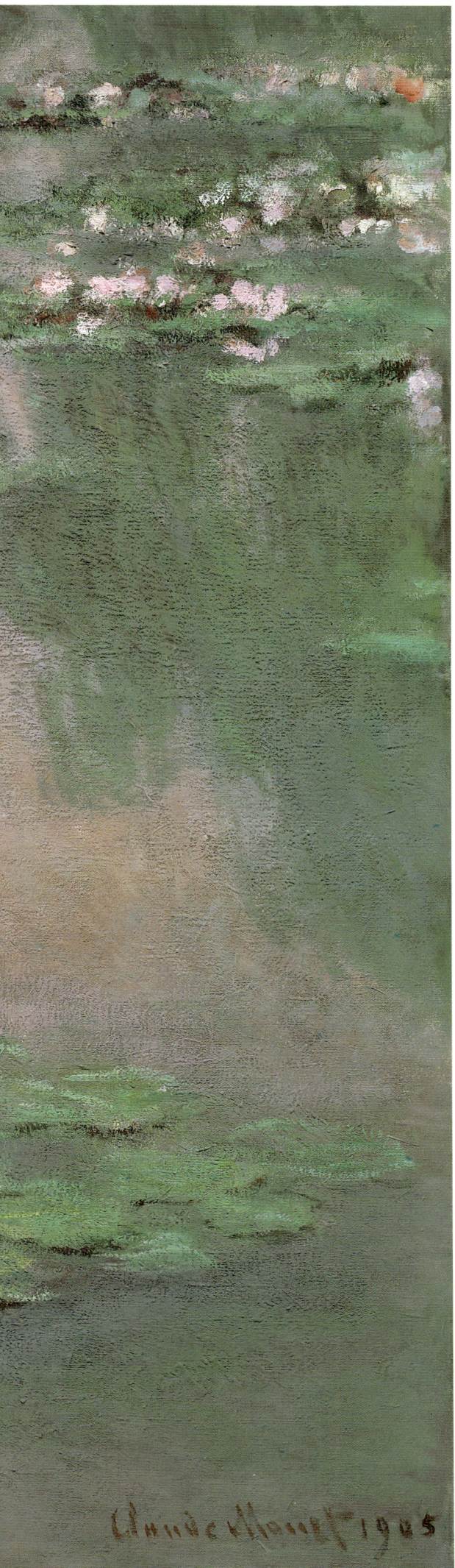

Waterlilies 1905
Oil on canvas
34¾×39 inches (89×100 cm)
Museum of Fine Arts, Boston,
Gift of Edward Jackson Holmes

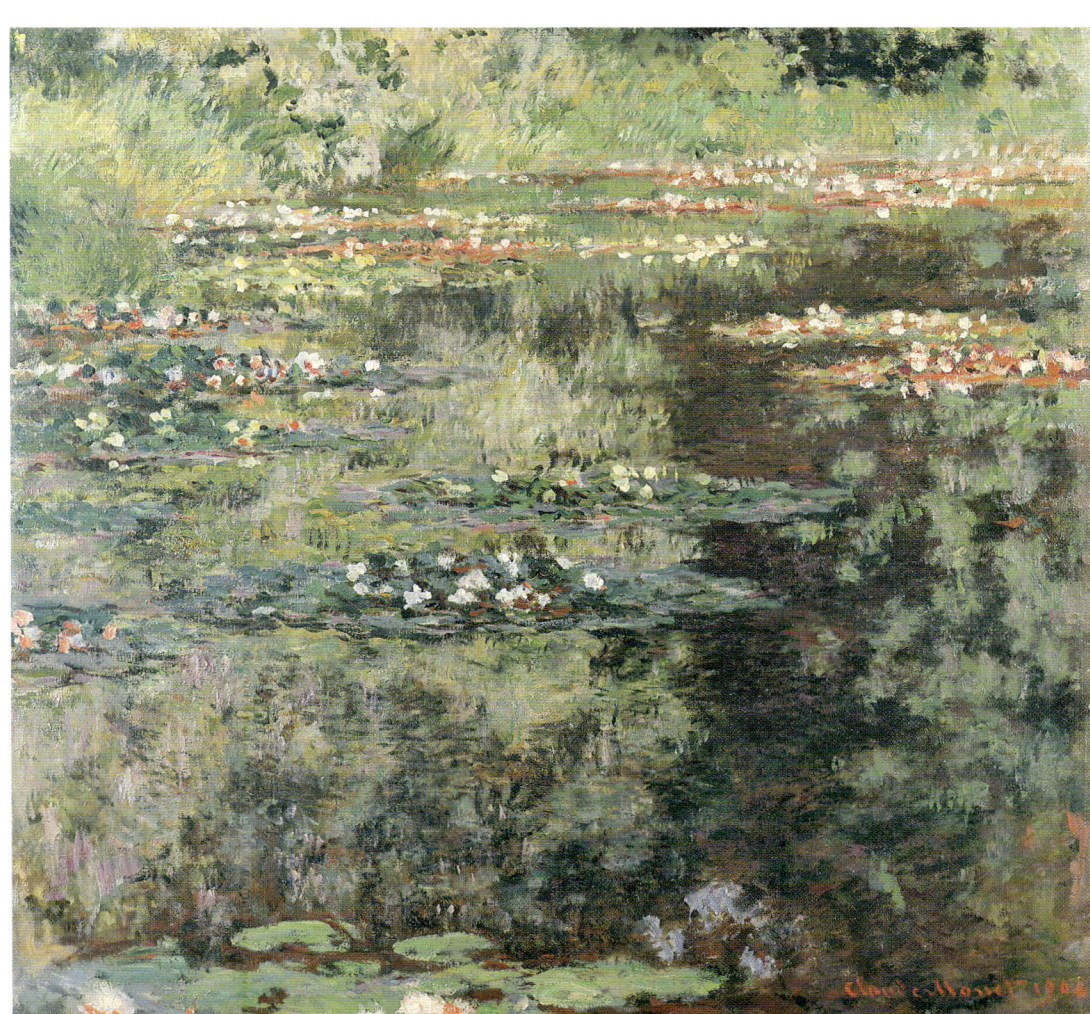

Waterlilies 1904
Oil on canvas
35½×35¾ inches (90×92 cm)
Musée des Beaux-Arts, Caen

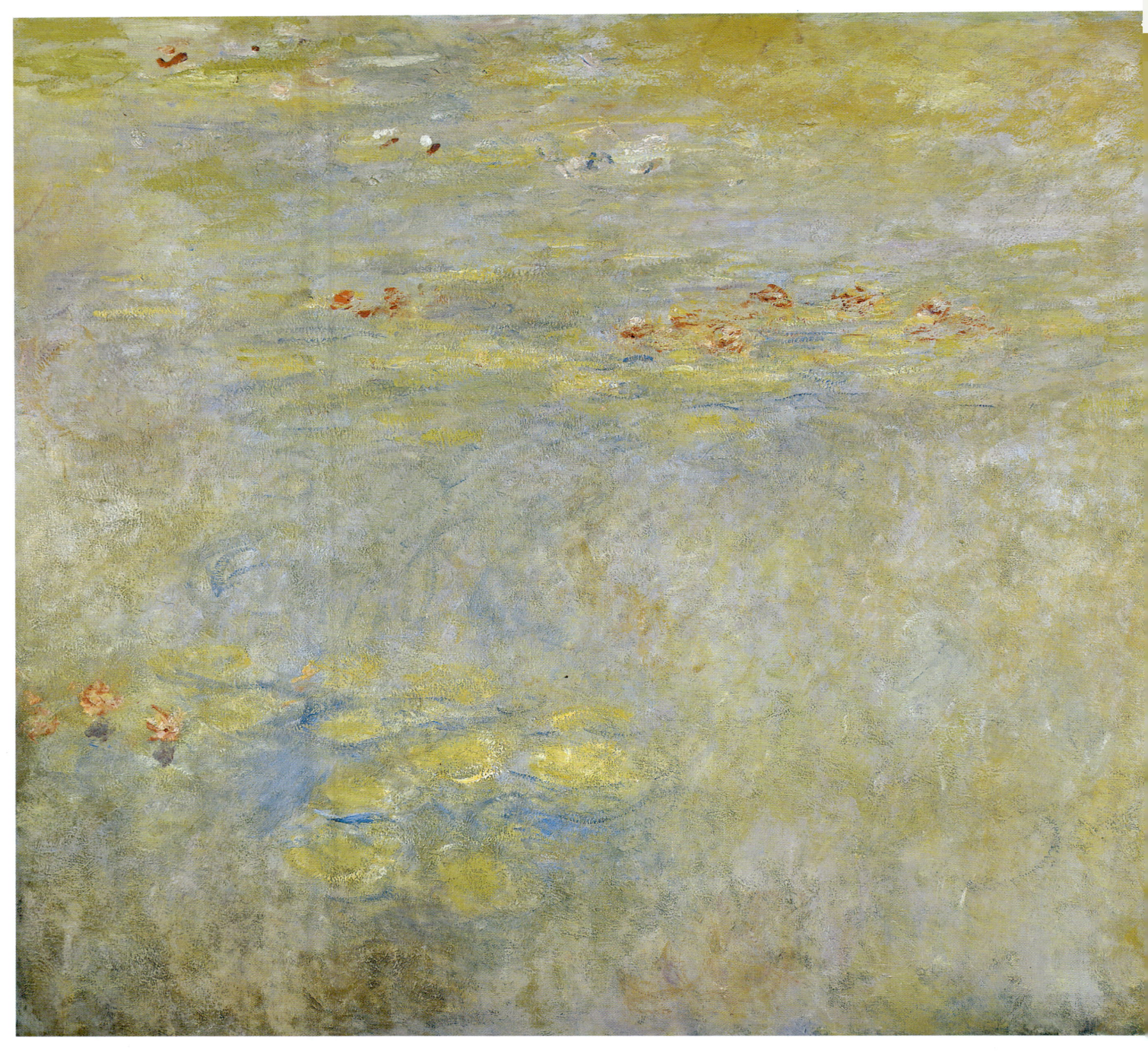

Waterlilies 1916
Oil on canvas
78¾×168 inches (200.7×426.7 cm)
The National Gallery, London

Green Reflection (detail)
c.1916-26
Oil on canvas
78¼×335 inches (200×850 cm) whole
width
Musée de l'Orangerie, Paris

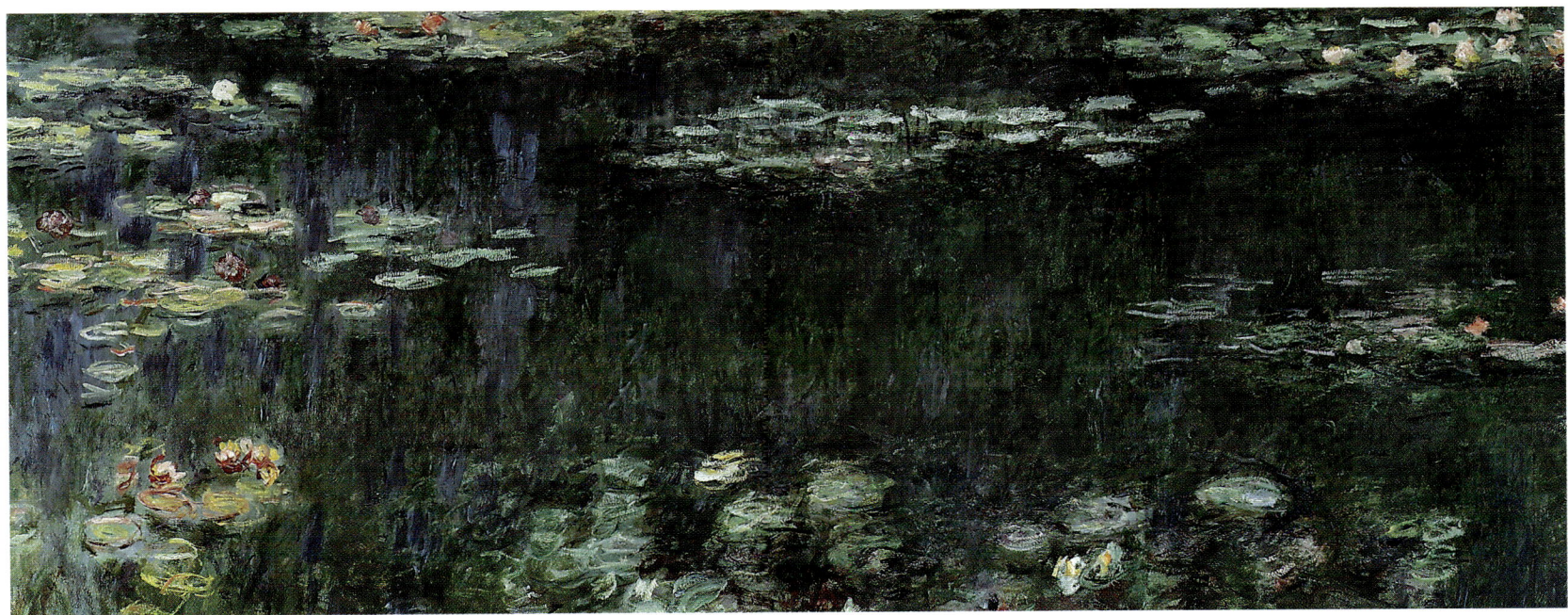

The Japanese Bridge c.1922
Oil on canvas
35×45¾ inches (89×116 cm)
The Minneapolis Institute of Arts

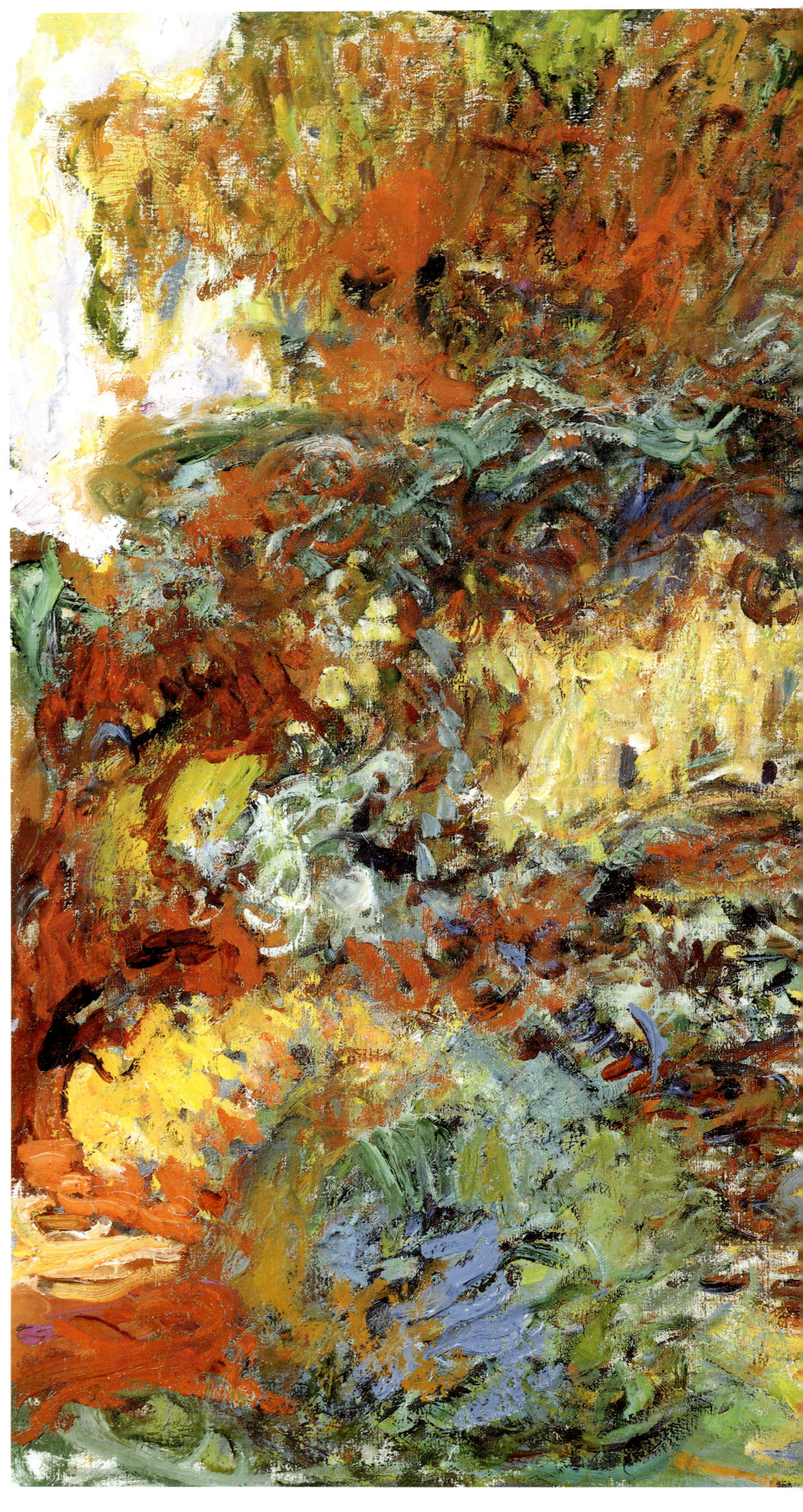

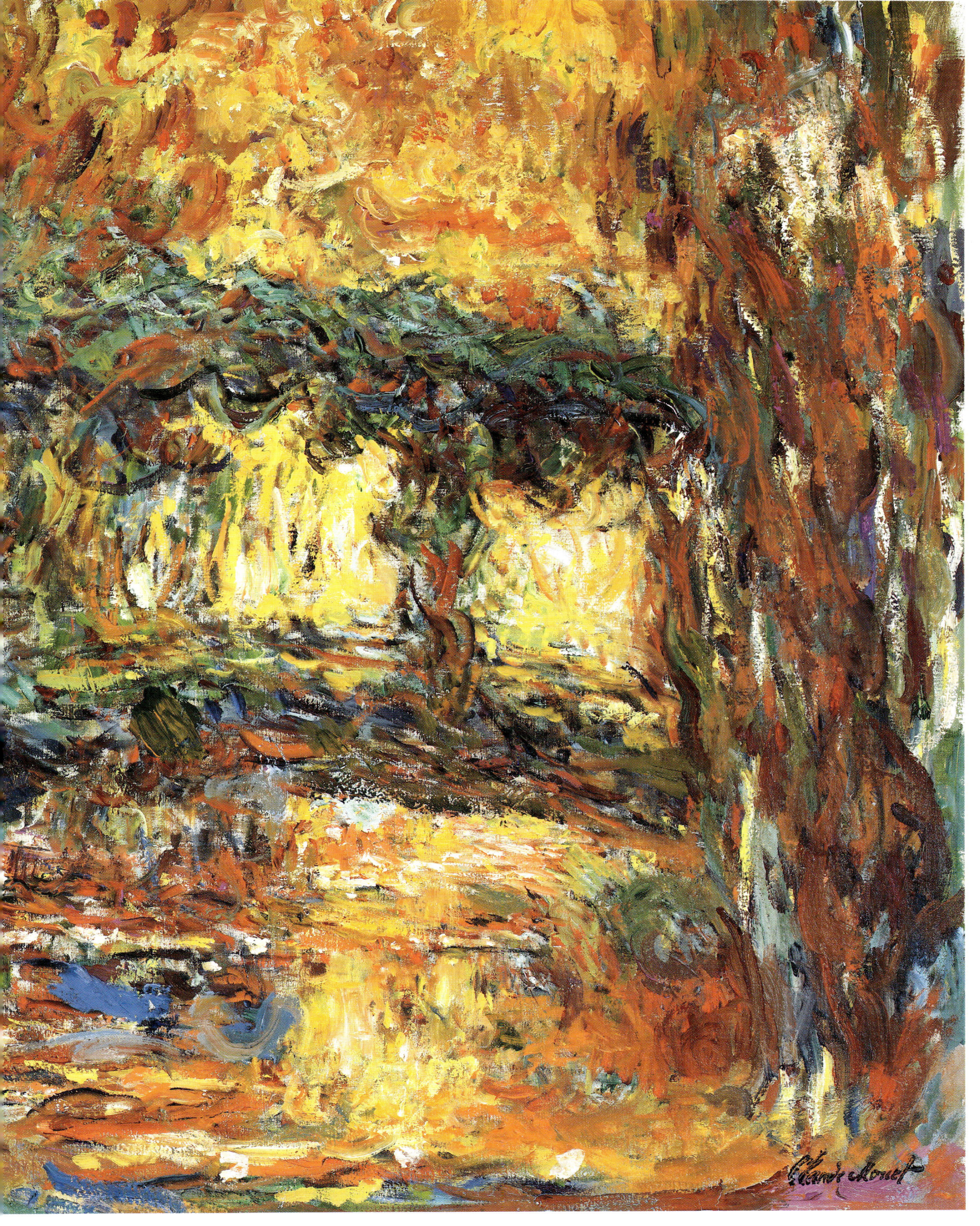

Index

Acknowledgments

The author would like to thank Sue Rose, who designed this book; Helen Dawson, who indexed it; and Jessica Orebi Gann, project editor. We would also like to thank the following institutions, agencies and individuals for permission to reproduce illustrations.

Allen Memorial Art Museum, Oberlin College: page 37 (R T Miller Fund)

The Art Institute of Chicago: page 78-79 (Mr and Mrs Lewis Larned Coburn Memorial Collection)

The Barber Institute of Fine Arts, University of Birmingham: page 78-79

Bayerische Staatsgemäldesammlungen, Munich: page 18(above)

Bibliothèque Nationale, Paris: pages 13(below), 14(below), 15

The Brooklyn Museum, New York: page 100-101 (Gift of A Augustus Healy)

Calouste Gulbenkian Foundation Museum, Lisbon: page 48-49

Founders Society, Detroit Institute of Arts: page 62-63

Document Archives Durand-Ruel: pages 21(above), 65

Collection of the J Paul Getty Museum, Malibu, California: page 54

Collection Haagsgemeentemuseum, The Hague: page 38-39

Kimbell Art Museum, Fort Worth, Texas: page 25

Kunsthalle, Bremen: page 31

Kunsthalle, Hamburg: pages 73, 96

Metropolitan Museum of Art, New York: pages 9 (Wolfe Fund, 1916. Catharine Lorillard Wolfe Collection), 34-35 (Bequest of William Church Osborn, 1951), 89

Courtesy of Frank Milner: page 18(below)

The Minneapolis Institute of Arts: pages 74 (Given by Ann Pierce Rogers in memory of John De Coster Rogers), 108-109 (Bequest of Putnam Dana McMillan)

Musée des Beaux-Arts, Caen: page 105

Musée des Beaux-Arts, Lyon: page 80-81

Musée Eugène Boudin, Honfleur: page 7(below)

Musée du Louvre, Paris/photo RMN: pages 24, 58

Musée Marmottan, Paris/photo Routhier, Studio Lormel: pages 6, 7(top), 46-47, 60-61, 68-69, 91

Musée de l'Orangerie, Paris/photo RMN: page 107

Musée d'Orsay, Paris/photo RMN: pages 8(below), 10, 11(above), 12(below), 32, 33, 41, 44-45, 50-51, 52-53, 56-57, 66-67, 70, 71, 82-83

Musée Petit-Palais, Geneva: page 17(above)

Courtesy of the Museum of Fine Arts, Boston: pages 2-3, (Gift of Edward Jackson Holmes), 20 (Emily L Ainsley Fund), 22 (above, Bigelow collection), 35 (Bequest of John T Spaulding), 59 (1951 Purchase Fund), 86-87 (Juliana Cheney Edwards Collection), 88 (Bequest of David P Kimball in memory of his wife Clara Bertram Kimball), 90 (Tompkins Collection purchased by Arthur Gordon Tompkins Residuary Fund), 92 (Juliana Cheney Edwards Collection), 102-103 (Bequest of Alexander Cochrane), 104-105 (Gift of Edward Jackson Holmes)

The National Gallery, London, reproduced by courtesy of the Trustees: pages 22(below), 40, 42-43, 97, 106-107

National Gallery of Art, Washington: pages 8(above, Ailsa Mellon Bruce Collection), 19(above), 72 (Ailsa Mellon Bruce Collection), 75 (Chester Dale Collection)

Board of Trustees of the National Museums and Galleries on Merseyside (Walker Art Gallery): pages 11(below), 94-95

National Museum of Wales, Cardiff: page 93

Private Collection/Acquavella Galleries, New York: page 98-99

Private Collection/Document Archives Durand-Ruel: page 26

Pushkin Museum, Moscow/SCALA, Florence: pages 28-29, 84-85

Roger-Viollet, Paris: pages 12(above), 13(above), 14(above), 16(above), 17(below), 21(below), 23

Städelsches Kunstinstitut, Frankfurt/ARTOTHEK: page 36

Victoria and Albert Museum, London: page 19(below)

Wadsworth Atheneum, Hartford: page 16(below, Bequest of Anne Parrish Titzell)